Chasing Indiana's Game

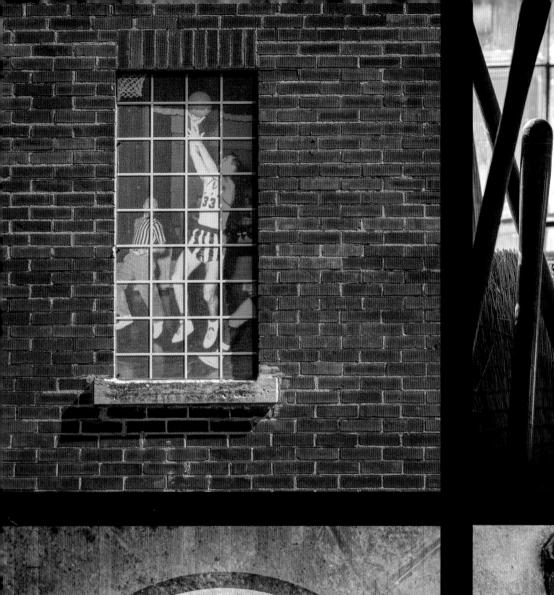
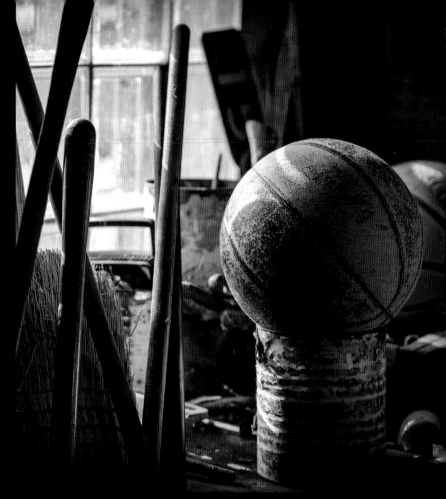

Chasing Indiana's Game

THE HOOSIER HARDWOOD PROJECT

Chris Smith and
Michael E. Keating

INDIANA UNIVERSITY PRESS

This book is a publication of

Indiana University Press
Office of Scholarly Publishing
Herman B Wells Library 350
1320 East 10th Street
Bloomington, Indiana 47405 USA

iupress.indiana.edu

Manufactured in China

Cataloging information is available from the Library of Congress.

ISBN 978-0-253-04815-8 (hardback)
ISBN 978-0-253-04817-2 (web PDF)

1 2 3 4 5 25 24 23 22 21 20

For my dad, Glen E. Smith

—**Chris Smith**

This book is dedicated to those who helped us experience a sense of place in their communities. That experience enabled us to see basketball, in all its iterations, as the common thread linking rural to urban and large to small across the Hoosier state. Indiana's game was documented frame by frame in photographs that reveal the celebration of a sport steeped in tradition amid the fast-paced lifestyle of the twenty-first century.

—**Michael E. Keating**

Contents

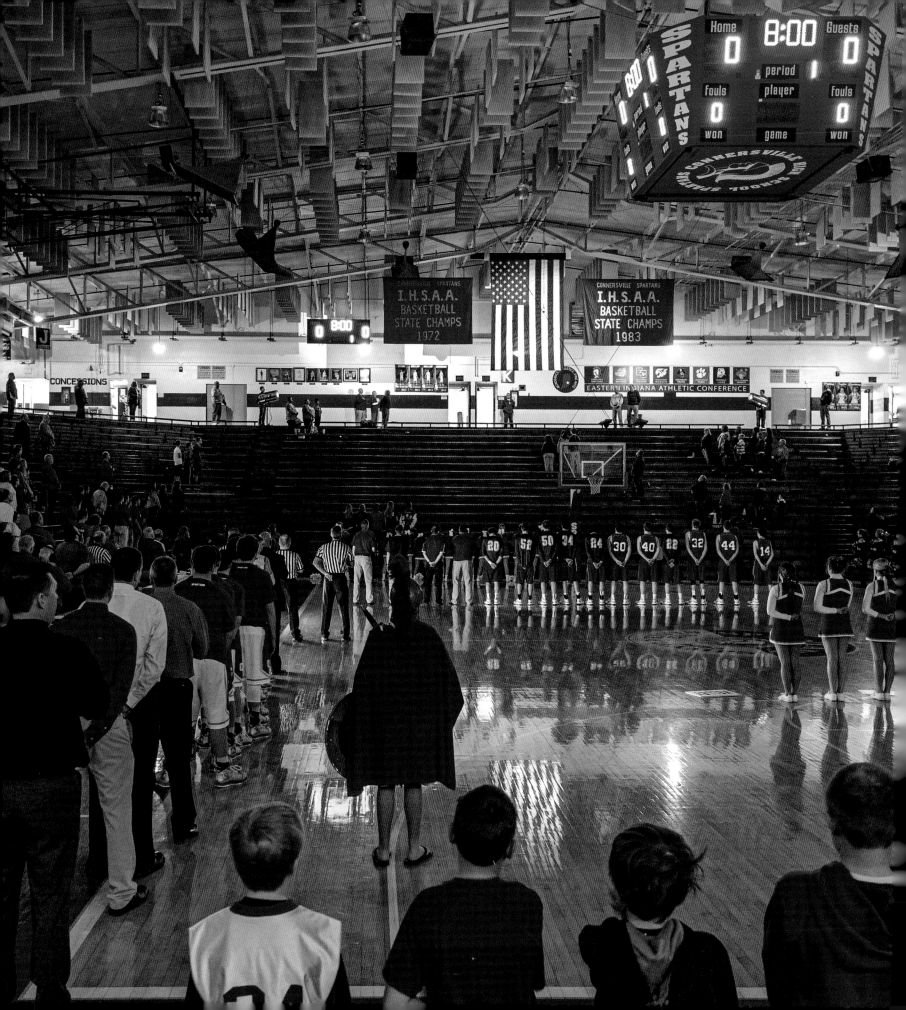

Foreword

In Indiana, basketball is inextricably a part of our state's history, heritage, and identity. From our greatest legends—including the likes of Oscar Robertson, Larry Bird, and John Wooden—who achieved the greatest of successes at the highest levels of the game, to the broad appeal of the film *Hoosiers*, which further increased awareness of the Indiana high school basketball story, Indiana has come to be known for the sport.

But the genesis of that identity began long before Oscar Robertson averaged a triple-double in the NBA, prior to Larry Bird carrying Indiana State University to the 1979 NCAA national championship game, and earlier than John Wooden coaching ten UCLA teams to national titles.

The igniting spark that fueled the phenomenon to become known as "Hoosier Hysteria" really came from hundreds of places around the state at local basketball games on Friday and Saturday nights in celebrated venues—Indiana high school gymnasiums.

In the time when nearly eight hundred communities across our state had their own schools, Indiana high school basketball was a source of community identity. Previous to the consolidation wave that occurred in the 1950s, it seemed that every tiny town, village, or burg had their own school, and no matter the enrollment of those schools, they could almost all pull together a group of local students for a high school basketball team.

These teams gave the locals bragging rights among county rivals and became a unifying bond between community members with little consideration to their differences in race, religion, or social status. Games became the center of the social scene on Friday and Saturday nights.

As the appeal, interest, and passion that high school basketball incited grew in Indiana, another important element was elevated—the gymnasium. In our state, where a high school basketball game once drew a world-record crowd of 41,046 spectators, local high school basketball gyms became figurative places of worship. Before bland, cookie-cutter facilities became common, each gym had its own character, feel, look, and ambiance. Some were goliath, some intimate, some elaborate, and some more Spartan, but each had its own unique characteristics.

The first time I met Chris Smith and Michael Keating, their drive, passion, and creativity were electric. I had already been made aware of their blog, where they posted crisp photographs of gymnasiums they had visited. It was instantly apparent they were onto something impressive.

As their travels continued and their efforts in the project deepened, their work captured the attention of more and more basketball-crazed Hoosiers. Their latest adventures and blog posts always uncovered another piece of Indiana's history: a lesson in geography, the origins of mascots, a timeline of school consolidations, or the architectural stylings particular to a certain era or area. Awaiting new posts and photos on their website or Facebook page became a daily, if not hourly, vigil. Among their growing crowd of fans, it wasn't "Where's Waldo?" but "Where are Chris and Michael heading now?"

Along the way, a permanent exhibition of a sampling of their photos in the Indiana Basketball Hall of Fame museum in New Castle became our most attention-grabbing exhibit—a true must-see phenomenon. Visitors would enter our facility asking "Where are the photos? I've been told I have to see them." The reaction of a lady who had no knowledge of her photo being taken at a game, let alone being included in our exhibit, is particularly memorable for me.

Chris and Michael's photos—some popping with crisp colors, sharp facial expressions, and the ecstasy of victory and others in black and white, exposing a larger expanse of a facility or a close-up on the tears of de-

feat—mesmerizingly capture the essence of Indiana high school basketball and the people and places that have been so special in our state.

I believe, especially in the digital age we now live in, that the work Chris and Michael have produced in the past handful of years is among the most meaningful and highest impact efforts to permanently showcase Indiana's high school basketball venues and their importance in our state's story.

"Basketball as art" is how I've come to succinctly describe their project, and I believe on the following pages you will observe the painstaking efforts they have taken to eloquently capture their subjects. As impressed as you will be with their photography, their work is as geographically, socially, and historically diverse as you could find in our state.

To Chris and Michael, I offer sincere thanks for sharing the view through your lenses of experiences so uniquely Hoosier. What an amazing and unrivaled view you have provided.

—CHRIS MAY
Executive Director, Indiana Basketball Hall of Fame, New Castle

Chasing Indiana's Game

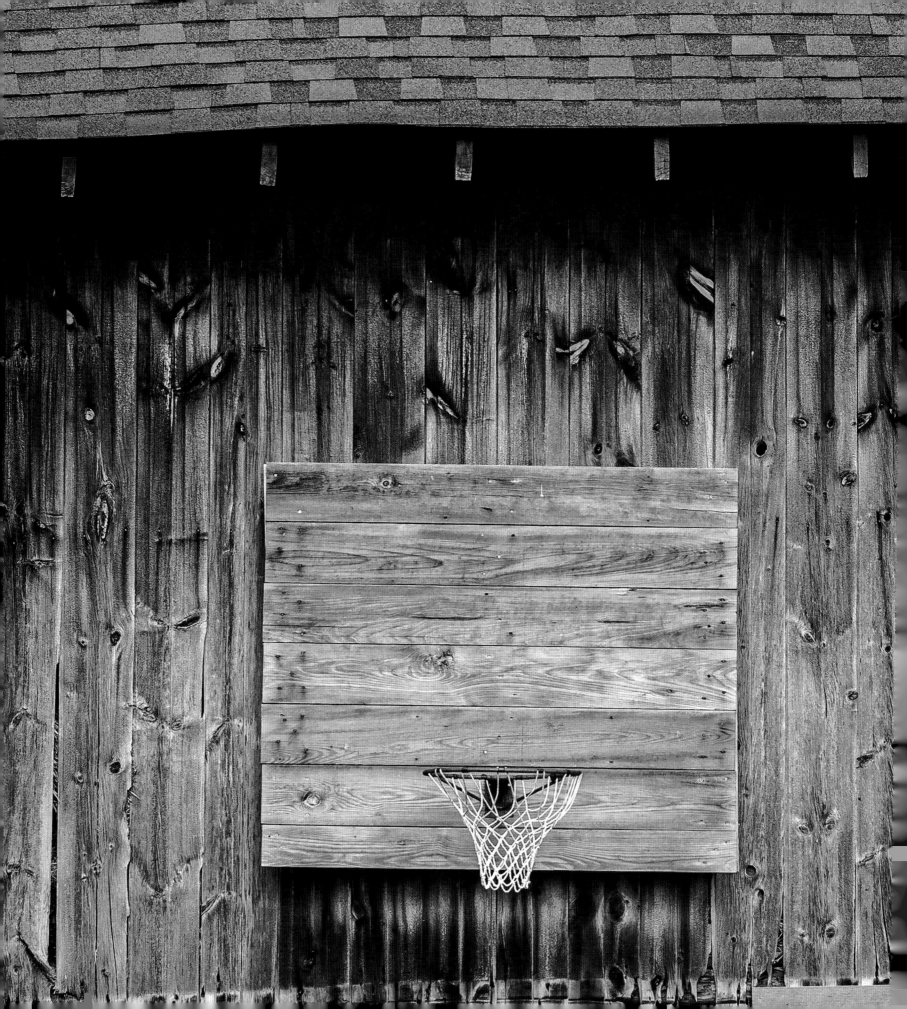

Introduction

AFTER ONE CUP OF COFFEE IT WAS PRETTY MUCH A DONE deal. Crowded around a laptop displaying a map of Indiana on a small table in the corner of the restaurant, we made the decision to photograph a "few old Hoosier basketball gyms." It was that simple. And now, six years later, fifty thousand miles on, we have photographed more than three hundred of those gyms. Along the way we have watched countless hours of basketball and encountered many folks who truly believe that this game is fixed to the soul of our state.

Our intent was innocent and our view of the project was naïve—we thought nobody had ever travelled this route before. If we had known that thousands of pages had been dedicated to Indiana high school basketball our conversation that night over coffee might have gone differently.

We started slowly, using Aurora as our home base, moving south and west along the Ohio River. We scoured county maps, contacted historical societies, reached out to high school athletic directors, and talked to every local who could direct us to the next gym.

First drawn to the architecture of these buildings, we quickly discovered that this story was about more than just brick and mortar or maple and shellac. Told over and over how important these places were to

their communities, we began to embrace the "game on Saturday, church on Sunday" mantra, believing both to be transcendent experiences.

There were many milestones along the way, both inside and outside the photographic process. Public exposure in the way of exhibitions at the Indiana Historical Society and the Indiana Basketball Hall of Fame showed us the value of our work on a regional level. Publication of the pictures in the *New York Times Lens* blog provided a whole different level of interest that not only extended from coast to coast but to Washington, DC, where some of our photos now hang in the offices of an Indiana senator. A conversation had also begun through social media, where followers shared basketball stories and suggested venues. Our desire to "photograph a few old Hoosier gyms" had expanded into unexpected areas.

Inside the project something else was happening—we were beginning to dig deeper into this story, moving past the obvious to something more meaningful. It happened in small ways at first, through individual photos—the Jac-Cen-Del Lady Eagles kneeling in the locker room before a tournament game, young Brady Lamb shooting hoops in the old Vernon Blue Devil gym where his grandfather played, and Spence Schnaitter reunited with Madison's 1950 state championship trophy.

3

Then came extended sojourns. Matt Werner led us through the basketball history of LaPorte County, including a meeting with members of the 1966 state champ Elston Red Devils in the confines of the old Michigan City gym. Thanks to Sam Alford's guidance we connected with his first scorekeeper, Gary Shouse, in the remains of the old Decker gym, now Shouse's sawmill. And on the way to meet up with Greg Humnicky in South Bend we sat down with Hall of Famer Jim Powers, who played for John Wooden at South Bend Central and Indiana State—or, as he would summarize, "I was one of Wooden's boys." Humnicky, a former player, coach, athletic director, and teacher then took us on a whirlwind tour of South Bend area gyms—leading us to ten in three days. Also included was time to photograph two state championship coaches and witness the found treasure of the old South Bend Adams center circle, hidden away in storage for years. A trip to Gary helped us see what a fall from grace looks like—abandoned schools and gyms gone to ruin. And finally, a weekend spent in tiny Dugger watching a town wrestle with the loss of their school hammered home the importance of this game and the communities that embrace it.

Before long we had photographed gyms outlining the entire state—Whiting, Michigan City, Angola, Butler, Richmond, Lawrenceburg, Vevay, Jeffersonville, New Albany, Tell City, Mount Vernon (Posey), Vincennes, Terre Haute, and Covington. Gyms hosting rivalry or tournament games became our targets from October through March, ticking names off our personal most wanted lists like autumn leaves tumbling to the ground.

We also searched out hidden architectural gems—gyms built under President Franklin Roosevelt's WPA (Works Progress Administration) in the 1930s or sunken gyms (including Connersville, New Castle, and Edinburgh) designed by Evansville architect Ralph Legeman. These monuments to Hoosier Hysteria helped solidify the belief that although basketball was not born in Indiana the game has certainly found a welcoming home here.

This book, then, is a pause in our process, a temporary roadside rest if you like. We may have travelled the state, photographed hundreds of gyms and games, and talked with scores of players, coaches, and fans, but as we have discovered all too often, there is always one more gym and one more game around the next corner or over that next hill.

And finally, we'll answer the question that's most often asked of us: What is your favorite gym? That's easy. It's the one we just photographed. Or maybe the one we have yet to see.

—CHRIS SMITH and MICHAEL E. KEATING
Southern Indiana, 2020

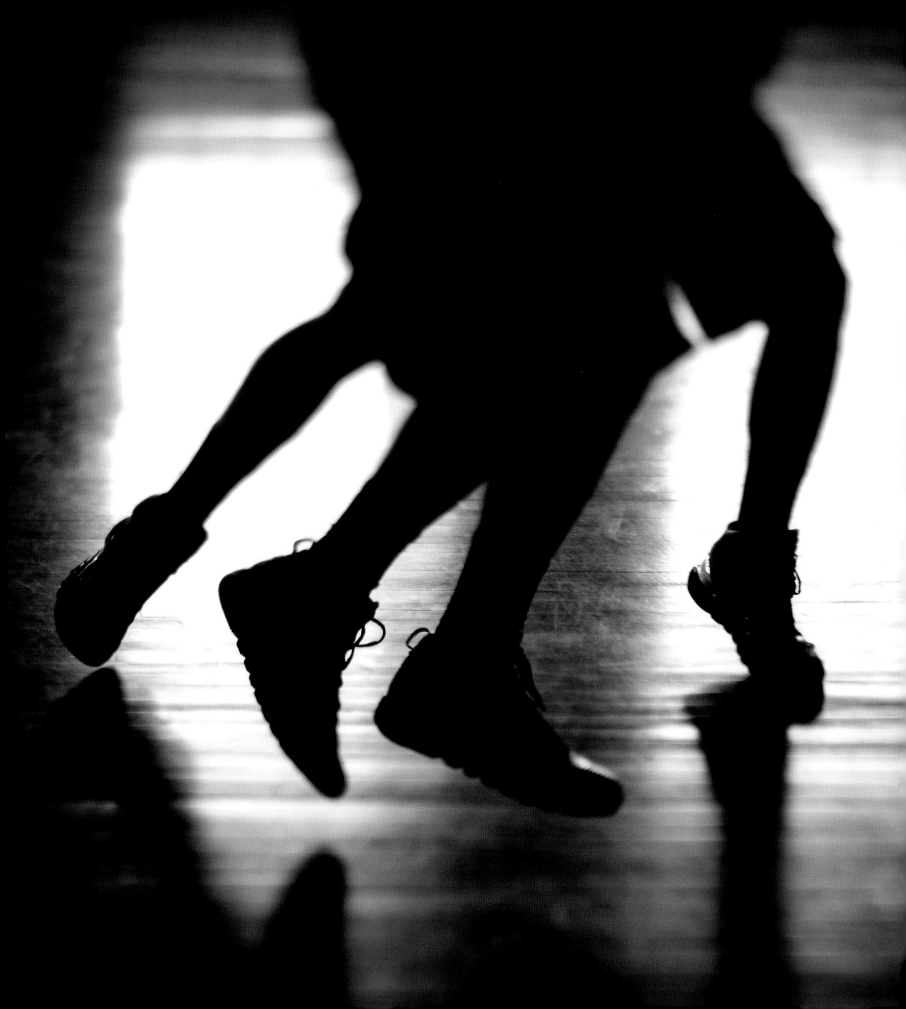

CHRIS SMITH PHOTOGRAPHS

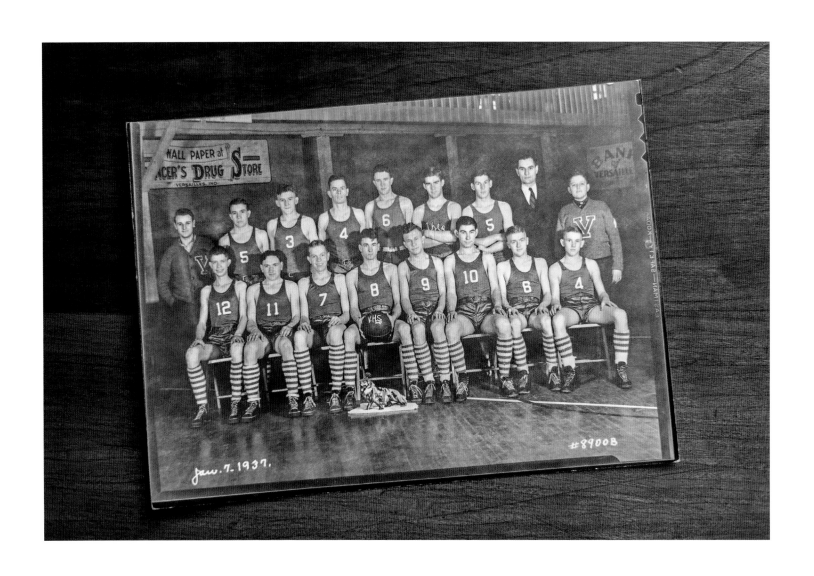

1936–37 Versailles Frenchies basketball team. 2013

Hidden away, the old picture had spent years moving from one box to another, one house to the next, until it made its way to a frame on the shelf above my desk. I'm not quite sure what singled it out, what caught my attention to move it from storage to display, but I knew my dad was in the back row, far left, nearly seventeen years old. Thankfully someone had written the date, "Jan. 7, 1937" on the bottom corner. Banners in the background advertised sponsors—the Bank of Versailles and Wallpaper at Spencer's Drug Store—but with my dad gone and the players who gathered for their formal team portrait unknown, any other stories the photo could tell were lost.

At some point I imagine that we all try to connect with our past, to understand a little more about who we are and where we come from. And maybe that's why this photo piqued my interest. Maybe that's why I felt that a journey to the places and people who've been touched by this game, Indiana's game, was my next move.

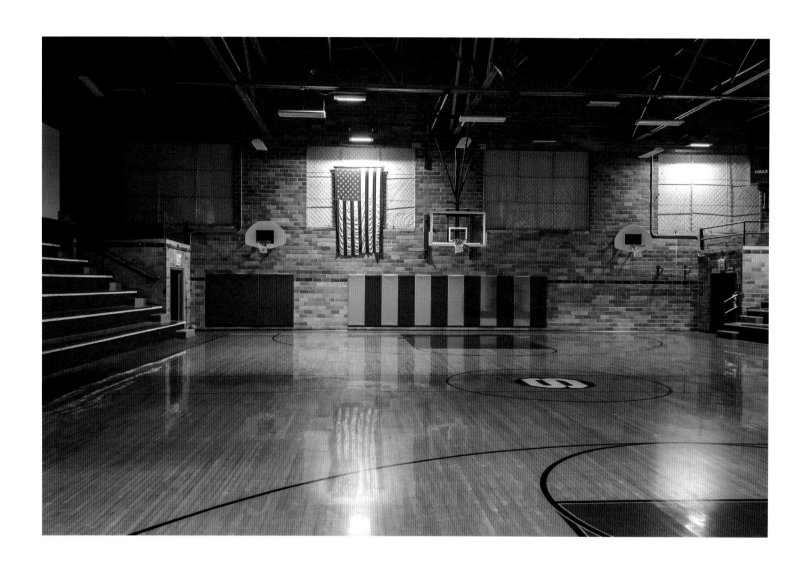

Spiceland Yellow Jackets / Stingers home court. 2016

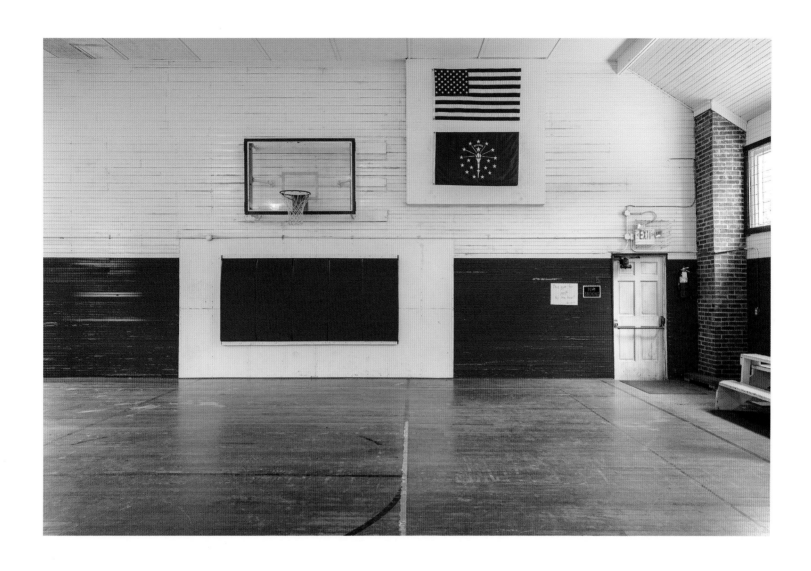

Economy gym, former home of the Cardinals. 2015

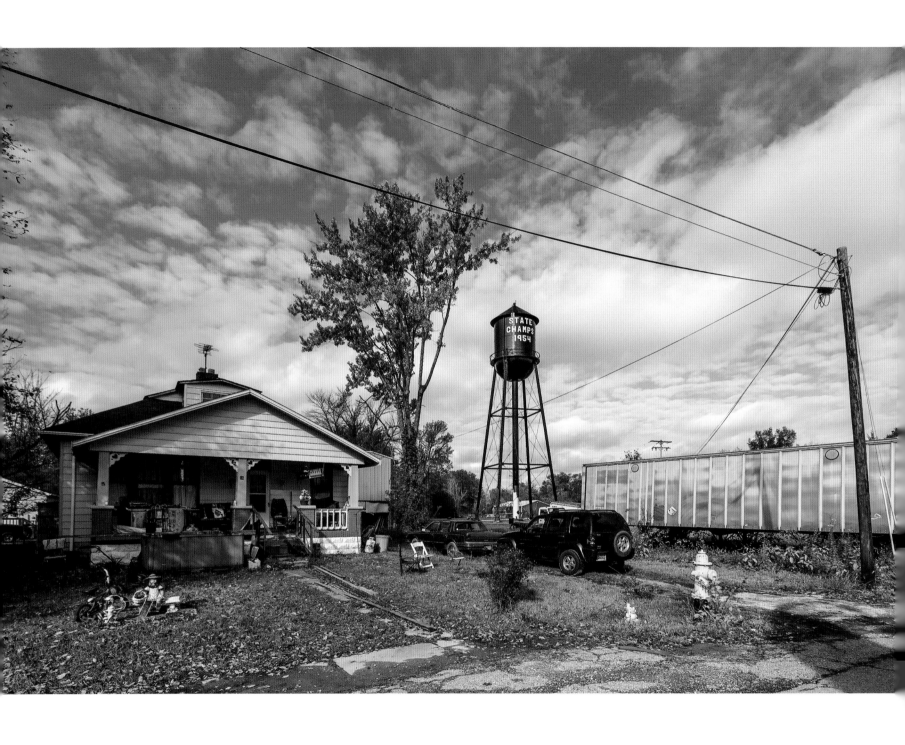

The STATE CHAMPS 1954 water tower, Milan. 2017

I was a suburban boy who thought he could be a ballplayer. I read *The Sports Illustrated Book of Basketball* religiously, had the February 1966 issue of *SI* with Rick Mount on the cover stored in my bookcase, and shot hoops on my blacktop driveway, more often than not chasing the ball into the street after a missed shot. My high school was big (over two thousand), so my chances of actually making the freshman or Junior Varsity (JV) teams were remote—but that didn't stop me from trying. After missing the cuts I played intramural basketball for a couple of seasons, wearing out Catholic and middle school courts, but my interest waned and I turned to other sports. Coming back infrequently, I was now a spectator, rooting on our varsity team or simply hoping that UCLA would lose to somebody.

In the summers I spent weeks at my grandmother's farm in southeast Indiana, ten miles from Milan. My grandmother kept her sausage, bacon, and beef stored in the Milan food locker in the shadow of the old black water tower, and once a week I made the trip to bring those delicacies home. The sizzle of meat in an iron skillet is as memorable as the sound of cicadas in late August. But I don't think I ever noticed the white letters stenciled on the water tower above my head until years later—STATE CHAMPS 1954. They were there at Chris Volz Motors too, those Mighty Men of Milan, showcased for all in a wall-sized photo, looking down on new Chevrolets, Oldsmobiles, and Cadillacs.

By 2013 I had expanded my work as a corporate and advertising photographer to include documentary work, and after publishing stories on the ferrymen of the Ohio River and the last family farmers of my county, I turned my attention to the old photograph that became the inspiration for this project. Michael, having recently retired as a newspaper photojournalist and being a native Hoosier, was a willing partner.

Our "research" consisted of stopping at restaurants, bars, and schools in every small town we visited. Everyone seemed to know someone who played ball or the location of the local gym, old or new. And if that wasn't enough, we would always be asked the question, "Have you been to ____?" and the answer would lead us on to our next discovery. We met Spence Schnaitter and Loretah Blake, took a tour of the shuttered Anderson gym, and saw rivalry games from one corner of the state to the other. We saw a gym being built and many more decaying, met old ball players who grew up playing in barns, heard stories about blacktop battles, and sat with one of Wooden's boys. We have embraced our state's history through this game, the good and the bad, and have come to understand a little more about why basketball is so important to those who have played.

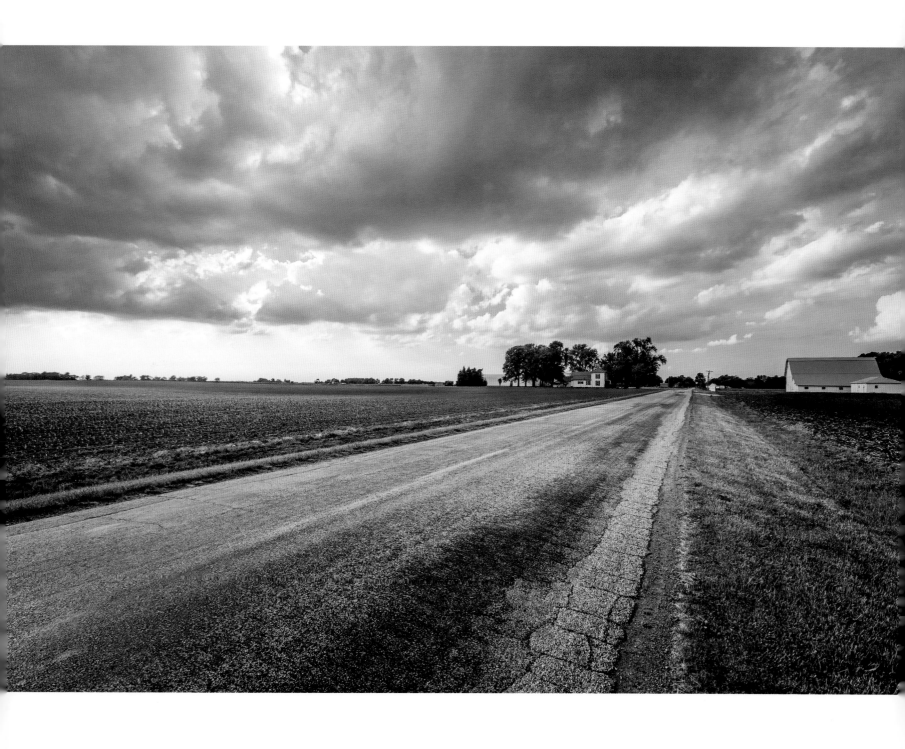

The road to New Richmond. 2018

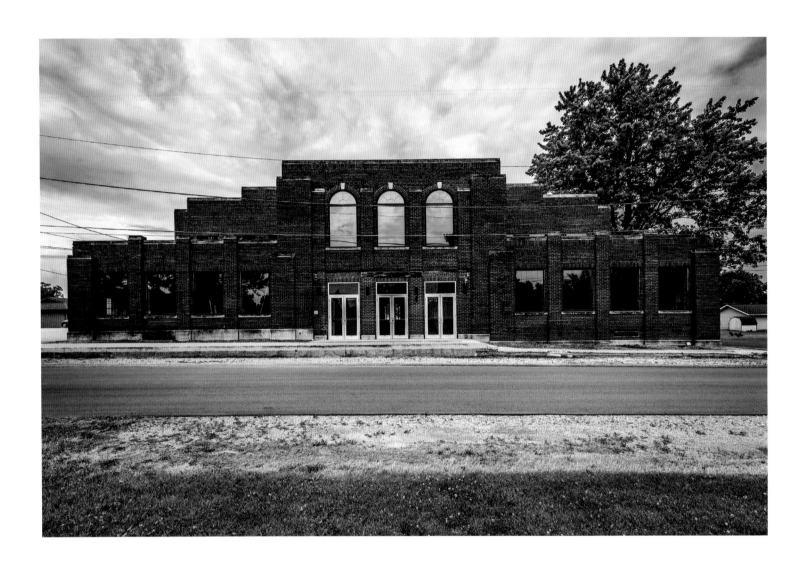

Butler gymnasium, home of the Windmills. 2017

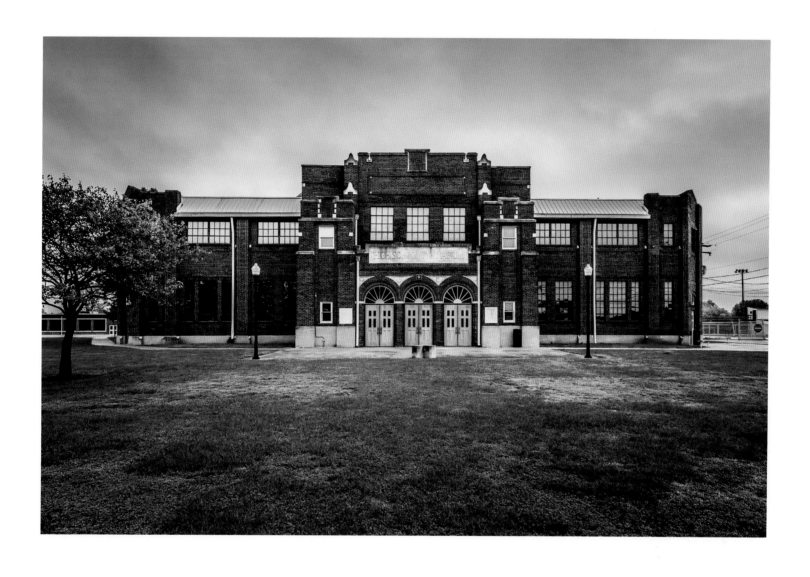

Glenn M. Curtis Memorial Gymnasium, named after
the Hall of Fame coach and home to John Wooden and
the 1927 state champ Artesians, Martinsville. 2017

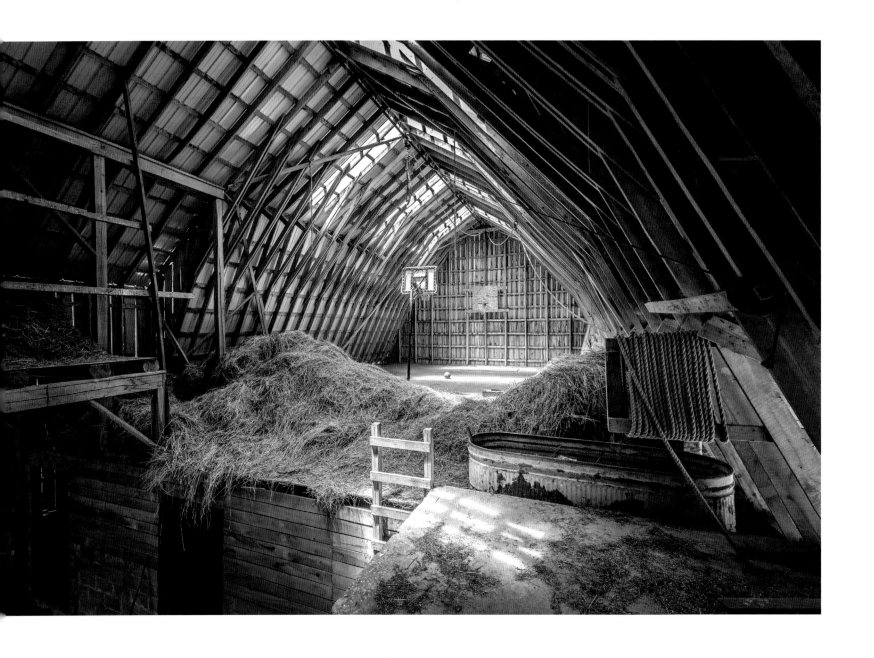

Amish barn near Bear Branch. 2017

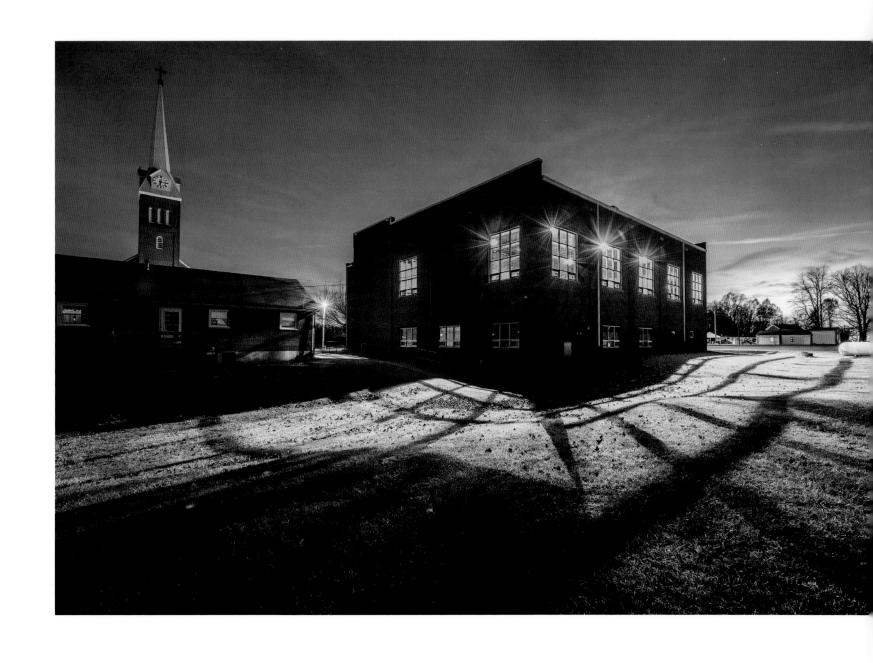

Monday night men's league, Immaculate
Conception gym, Millhousen. 2017

At AJ's Diner on Main Street in Vevay all fingers pointed us in the same direction: "You gotta go to the Fillin' Station in Madison and talk to John Kinman." Little did we know that the Fillin' Station was a liquor store located at the northern end of the bridge that carries US 421 across the Ohio River and that John Kinman, the owner, was a local basketball legend.

Our journey to Indiana's basketball past was only weeks old, and what lay ahead was still an unknown. But stumbling into AJ's was a guide to what we would discover over the course of the next six years—talk to the locals about basketball, and you will find the heroes, gyms, and tales that fill the chapters in the book of Hoosier Hysteria.

And in that book John Kinman can lay claim to his own page. During the 1967–68 season, junior Kinman scored more than 20 points a game for the Vevay Warriors. As a senior for the newly consolidated Switzerland County Pacers (formed when Vevay and Patriot combined forces), John averaged 28.9 points a game (all without the help of the 3-point shot) and was southeast Indiana's free throw champ. Recruited nationally by more than thirty schools, John decided on Georgia Tech, eventually transferring to Mercer University before returning home to graduate from Indiana University. If you ask any of the patrons at AJ's why you should talk with John about his place in local basketball lore the answer is likely to be, "John Kinman—he was a baller."

John Kinman in the old Vevay Warrior gym. 2013

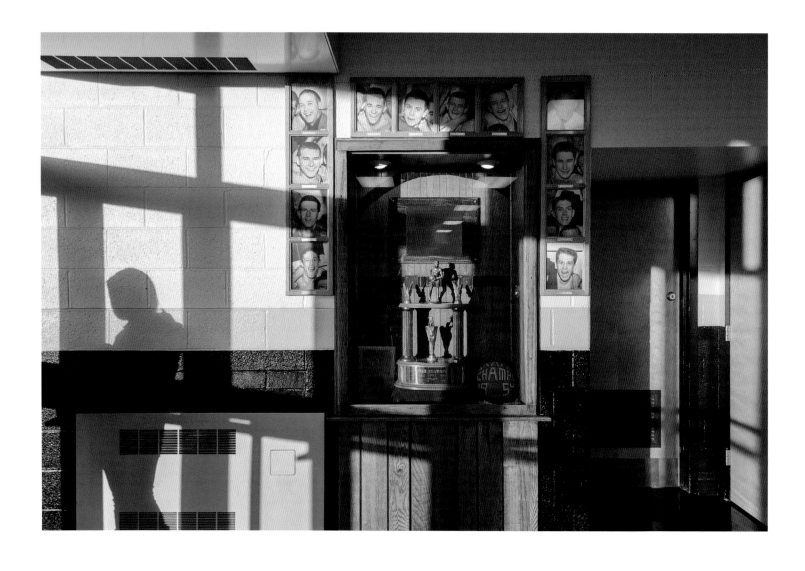

1954 state championship trophy framed by the
Mighty Men of Milan. Milan gym lobby. 2015

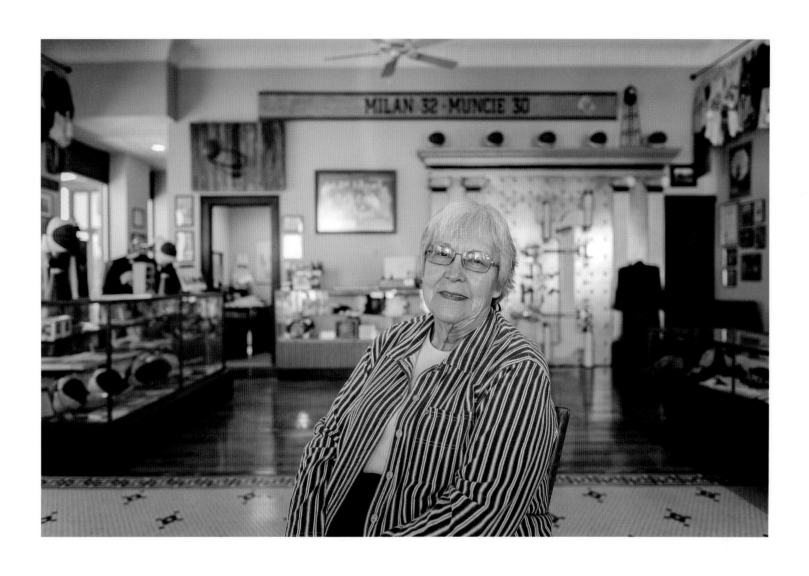

Roselyn McKittrick, founder of the Milan
'54 Museum. Milan. 2013

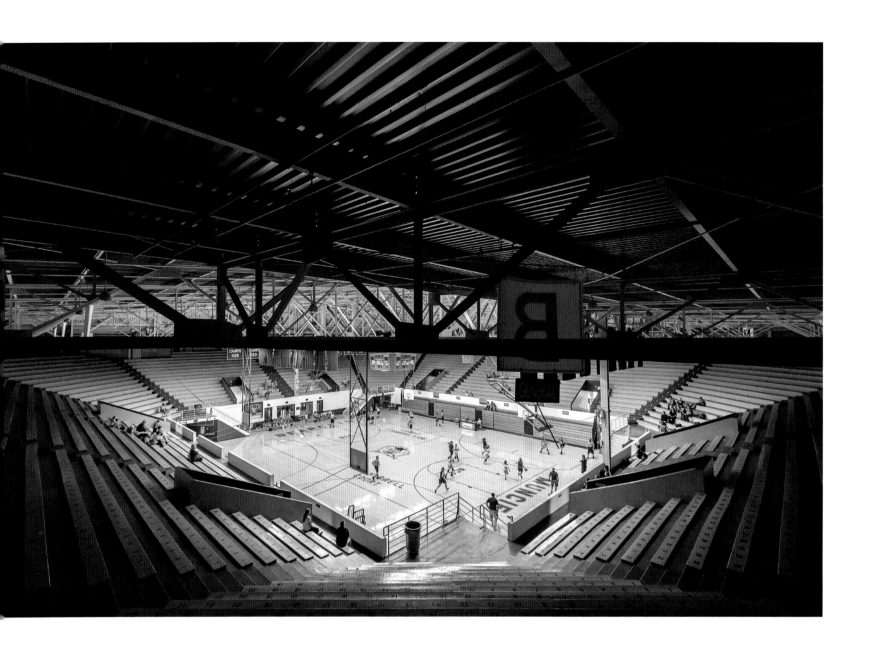

Muncie Fieldhouse, home to eight
state championship banners. 2015

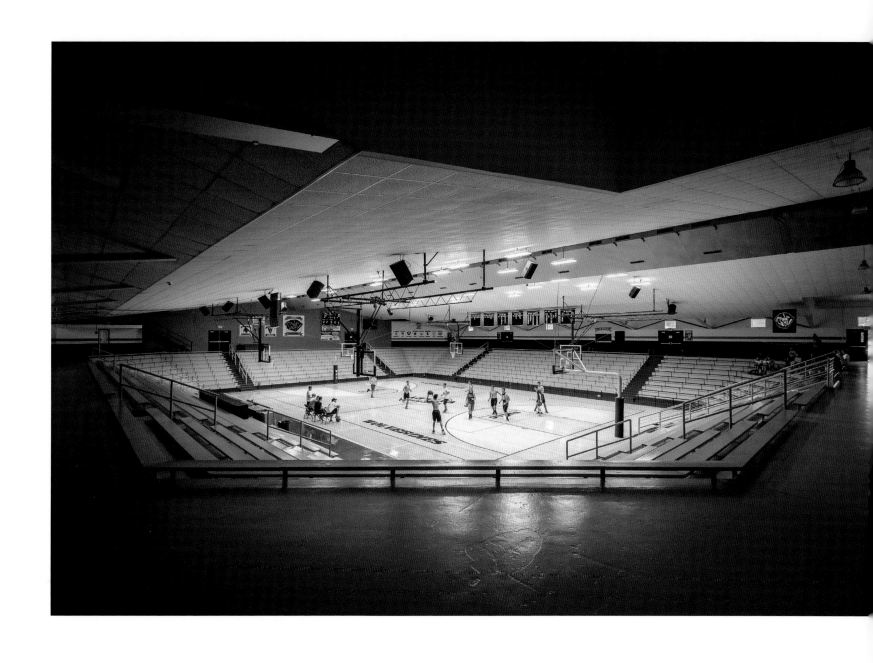

White River Valley summer
practice, Switz City gym. 2017

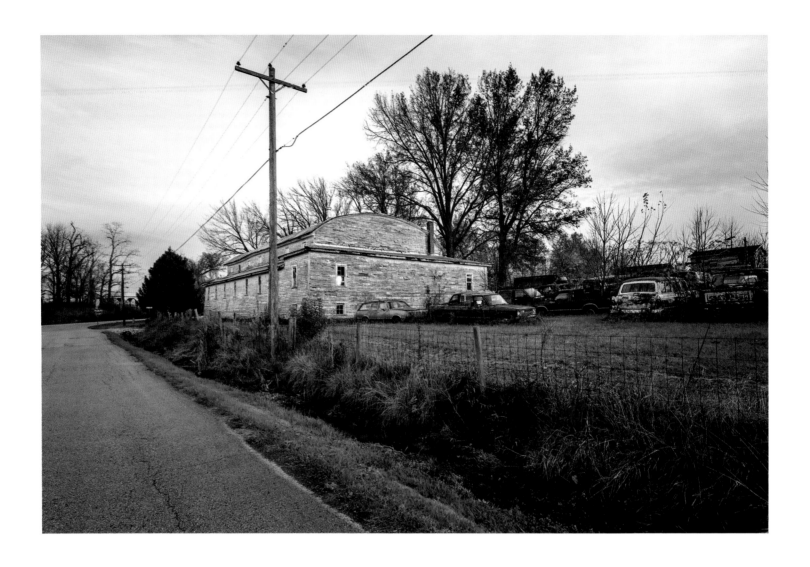

Just off Indiana Route 39 the Little York gym slips quietly into memory. Built in 1936 by the WPA, the lair of the Wildcats is now home to a combine and rusting relics of the 1950s. Even though bleachers and a backboard remain, the sound of cheering fans and the hiss of old coal stoves have long since given way to silence. 2015

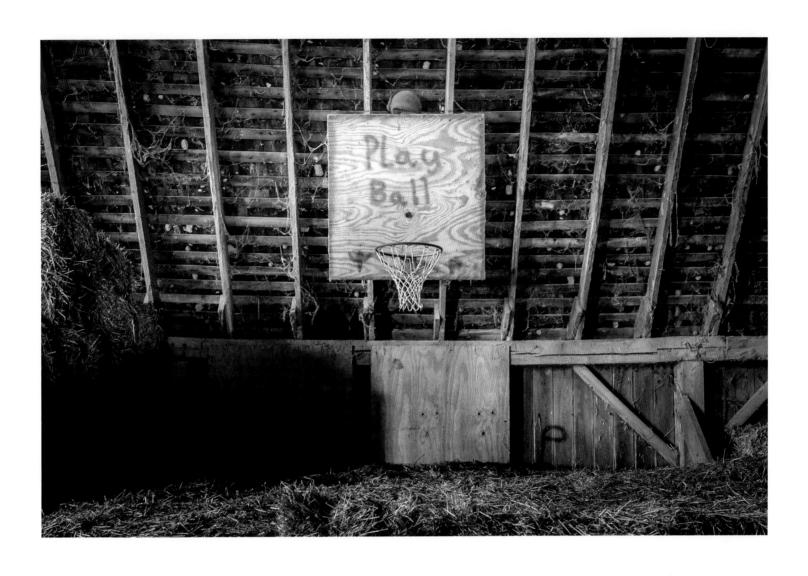

Dandy Breeze dairy barn, Sheridan. 2018

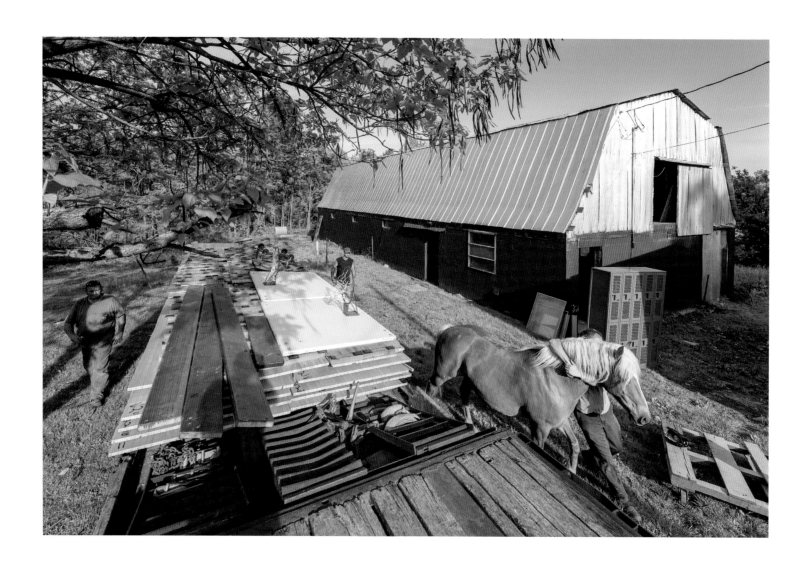

Remnants of the old Lawrenceburg gym
arrive at Comer's barn, Osgood. 2014

"Have you been to Crocker's barn?" asked Nick Rohlfing.

"Where?"

"Crocker's barn—it's where we played ball on the weekends. Guys from Holton, Versailles, and Osgood—all over. Old Orville Crocker built a court in the loft of his barn so that his boys could play ball. But on Sundays we'd catch rides down there just to play. You need to see it."

And so the search was on. A couple of phone calls led us to Tanya Horn, Orville Crocker's granddaughter, and she told us that yes, Crocker's Christmas Tree Farm was home to the barn—or was before it fell victim to Hurricane Ike. "You're welcome to come, but there's not much left." What was left, down the long gravel drive that had been the pathway for many young ballplayers through the years, was a stack of broken poplar flooring with a faded out-of-bounds line and a backboard that had been spared by the wayward winds of 2008. But, there was something else. "I heard that someone, a banker maybe, was building a court in his dairy barn outside of Osgood. You might check that out."

On April 16, 2014, we got the OK to photograph in the old Lawrenceburg gymnasium as it was being torn down. Structural damage had led to the demise of the Tigers' home court, and by the time we arrived the center section of maple flooring had been removed and sold off for fundraising. What we did find were old game programs, long lost beneath the court, and a love letter from 1968—the author scolding her boyfriend for admiring another during chemistry class. But more important, we found another full court's worth of maple hidden under the home bleachers, wooden bleachers capped in plastic, hardwood backboards complete with rims, and a storage room full of lockers. "What's going to happen to all of this?" we asked the maintenance man who was acting as our guide. "Well, when the trackhoe rolls in here on Monday I guess it'll all be a pile of junk."

In late March, following Tanya Horn's advice, we found the dilapidated dairy barn that Napoleon banker Mark Comer was converting into a basketball court for his young grandsons. At the time, it was nothing more than a shell with a stack of 4×8 plywood sheets stored on the second floor. I promised to return when games began in the fall, hopeful that the floor would be down and a basket hung, but the April trip to Lawrenceburg changed all of that.

I called Mark on Good Friday (April 18) to let him know that much of what was left of Lawrenceburg's gymnasium was up for grabs, and, having done our good deed, we assumed the story would end there. But on Saturday Mark toured the gym and consulted contractors on the feasibility of removing and transporting 1,500 square feet of tongue-and-groove maple flooring. By breakfast on Easter Sunday he had secured a tractor trailer and let us know that the remains of the Tigers' gym would soon be in transit to Osgood.

By late May another phone call from Mark had me on my way to Osgood, arriving just as the truck pulled into the rutted dirt drive, loaded with flooring, bleachers, backboards, and lockers. All afternoon and into the early evening friends, neighbors, cousins, grandkids, and co-workers unloaded, hauled, and lifted the remains of Lawrenceburg into the loft of the old dairy barn. Dogs chased chickens, men wrangled runaway horses, kids shot at imaginary hoops—all to the delight of mothers and daughters supplying food and drink. Despite cha-

os all around, Mark made sure that the 4 × 8 sections of numbered maple were stacked so future grid work would be minimal.

Six months later I received a text message from Mark. "Remember when I said I am not sure whether I am thanking or blaming you? I am now in the process of leveling the floor. Considering the fact that there are 13 runs two feet apart with 30 sets of shims that have approx. 3 pieces of wood. That is 390 sets of trims and 1170 shim pieces. All this work is 1 inch above the floor. Each run takes approx. 5 hours. So right now I don't like

you very much. It looks like it will work and eventually I look forward to putting up the side walls in March and then maybe you will be 'OK.' Ha ha."

Spring of 2015 brought full-scale construction of the barn to an end, and on my last visit the backboard was hung (painted IU colors, cream and crimson) and a game of knockout between adults and kids ensued. Amidst all the dunking, ball hogging, and elbow flying, Mark beamed, "You know, I played ball for Jac-Cen-Del, and we never defeated Lawrenceburg on their home court. And now I own it."

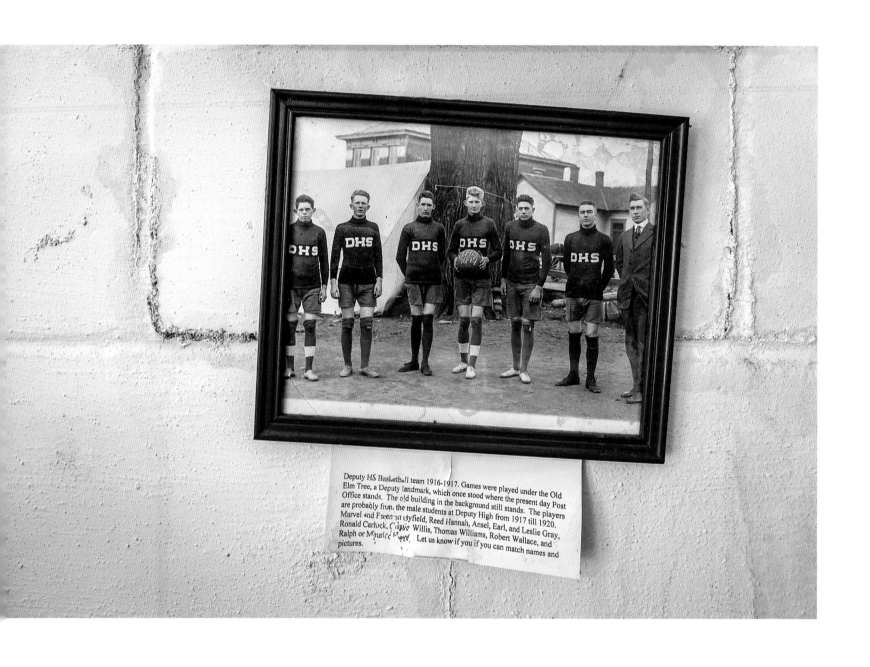

1916–17 Deputy Panthers, Gaffney's Grocery, Deputy. 2014

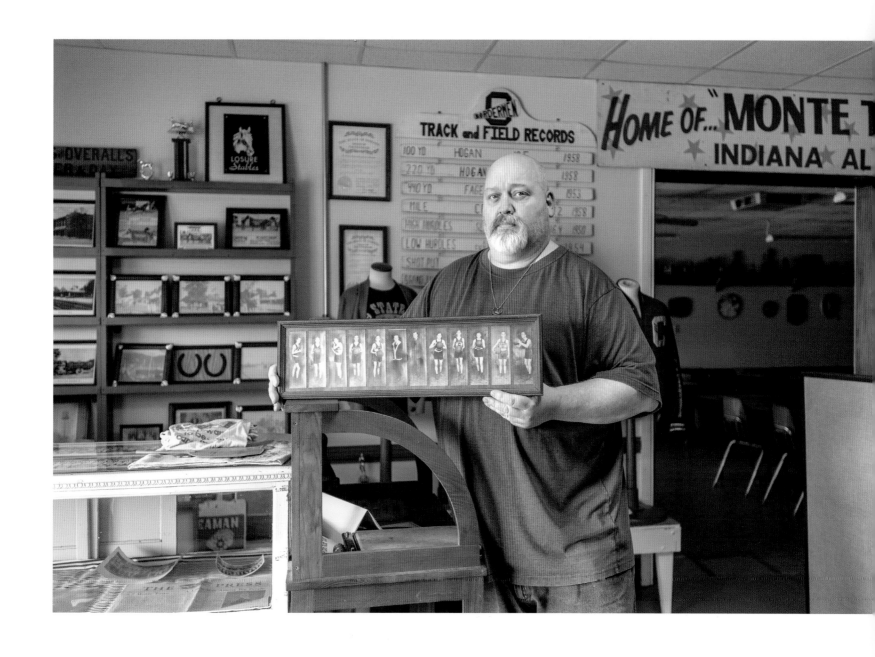

Converse and Oak Hill High Schools sports memorabilia. 2018

Dale Moeller was a member of the 1954 Aurora Red Devils basketball team, one of only two teams to defeat the Milan Indians during the '54 regular season. The Red Devils won twenty games and captured their fourth consecutive sectional title during that campaign, eventually ending with a number nine state ranking. After defeating Connersville 67–51 in the opening round of the Rushville regional, the Devils and Indians took the court for a second time, and, as the story goes, with several Aurora players suffering flu-like symptoms. Milan prevailed in the final, 46–38, and moved one step closer to their 1954 State Championship. In the ensuing years Dale and his teammates were often invited to reunions held in nearby Milan and reminded by their old rivals that they were the only team that the '54 State Champs truly feared.

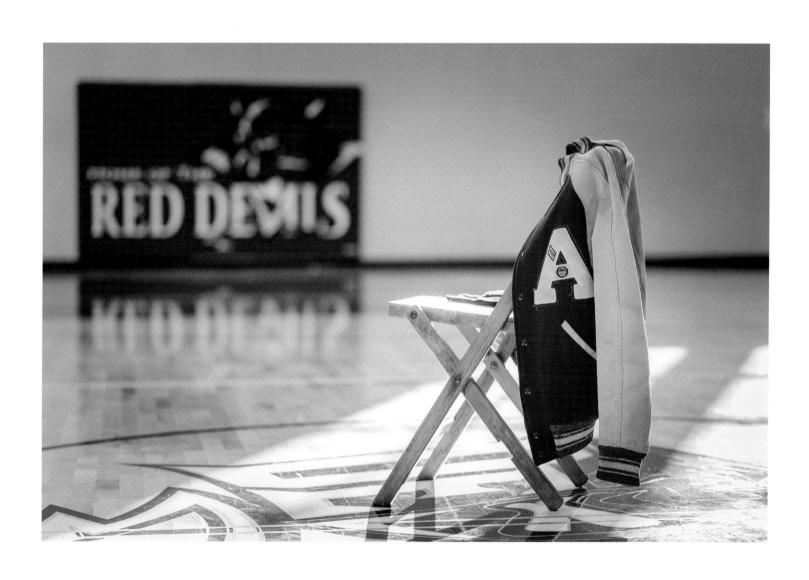

Dale Moeller's Aurora Red Devils jacket, Aurora. 2013

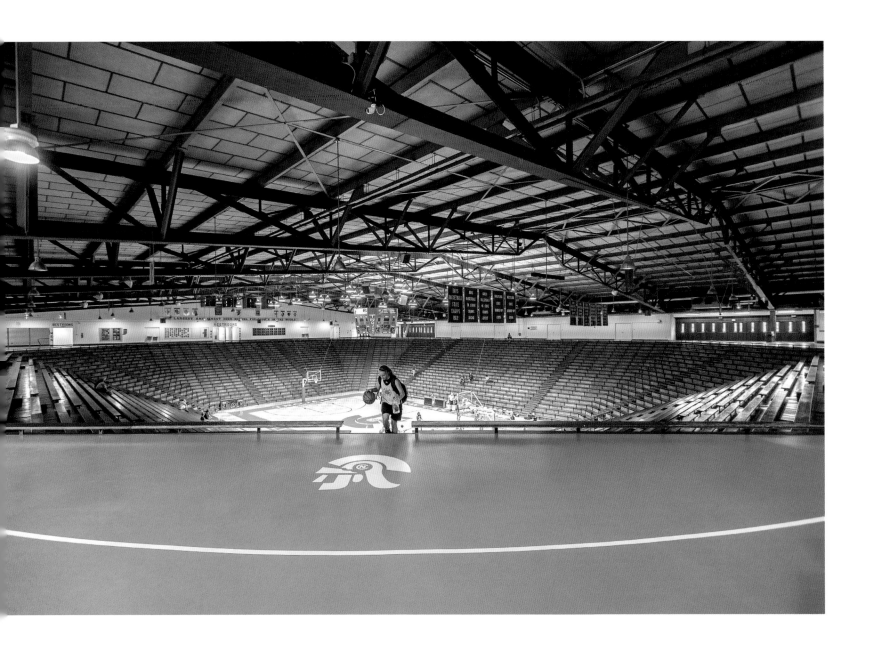

"The Largest and Finest High School
Fieldhouse in the World," New Castle. 2015

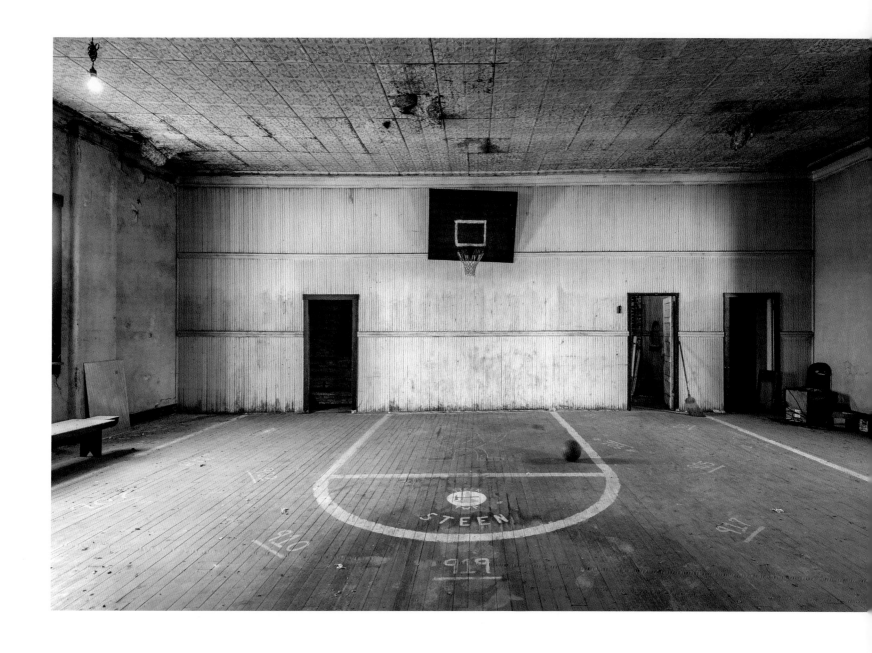

Wheatland court, above the old Hedrick's Drugstore. After their 1958 sectional victory over Freelandville (55–48), and on the eve of a matchup with the Vincennes Alices, a young Wheatland Jeeps player wrote a letter to his parents: "Get us up by 8:30 or 9:00. We will eat breakfast at Sinclair Station at 10:30 (eggs, poached, and tea). Beat the Alices." The next day Vincennes defeated Wheatland 70–55. Wheatland. 2017

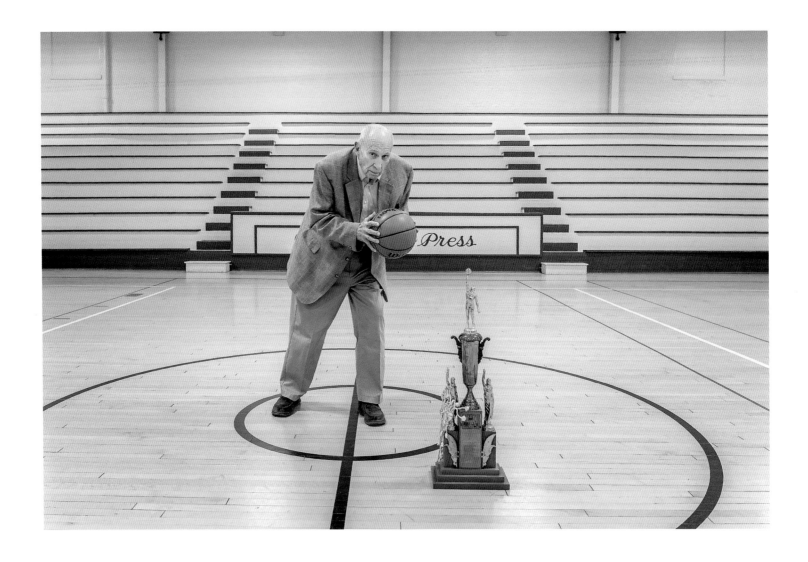

Spence Schnaitter was a member of the 1949 state runner-up Madison Cubs, who lost an agonizingly close game to Jasper 62–61. A year later he was the captain and MVP of the 1950 state championship team—and then an Indiana High School All-Star, a four-year baseball letter winner who pitched three no-hitters, a graduate of Yale, an Indiana state legislator, and a member of the Indiana Basketball Hall of Fame. We reunited Spence with his championship trophy in the old Brown Gymnasium, where he played under the guidance of Coach J. Ray Eddy. "This is how Mr. Eddy taught us to pass the ball," he told us, striking the pose. We then learned it had been sixty-three years since he'd last touched the trophy and victor's net that helped shape his future. "I want to show you one other thing," he said, passing me an old *Indianapolis Star* photo. "That's me, after I got off the bus outside the gym the morning after the game, with my high school sweetheart and my championship ring." That sweetheart, Laura Ann Mills, would become Spence's wife for fifty-seven years. She is gone now, but the ring and all of the memories remain.

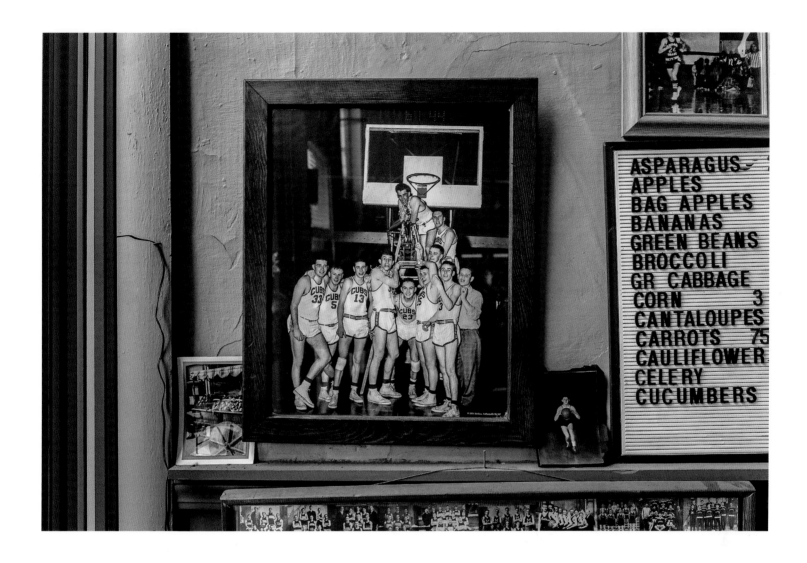

Left: Spence Schnaitter and the 1950 state championship trophy, Brown Gymnasium, Madison. 2013

Right: 1950 state champ Madison Cubs, Dattilo's Fruit Market, Madison. 2013

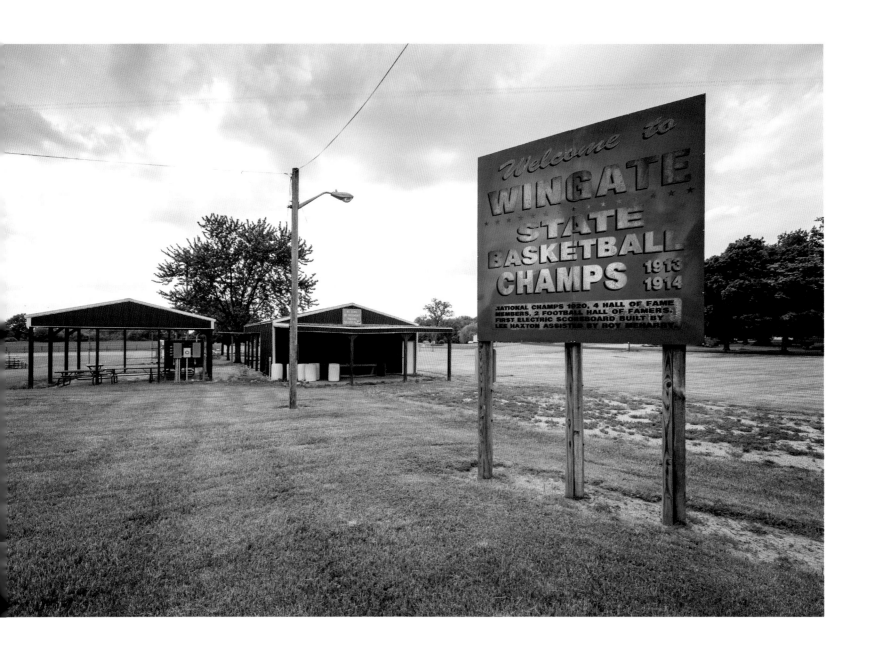

Wingate, hometown of the 1913 and 1914 state champs. 2018

Newspaper celebrating 1965 sectional title, Chrisney. 2018

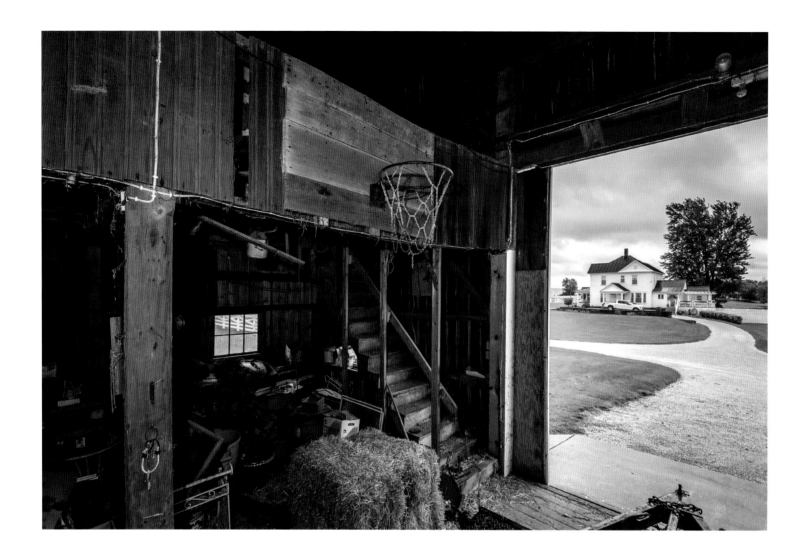

Before he was Cal Trask in *East of Eden*, Jim Stark in *Rebel Without a Cause*, or Jett Rink in *Giant*, James Dean was simply Jimmy, a complex young man from Fairmount, who went from bit-part actor to international icon. And then, in a violent car crash in his beloved Porsche 550 Spyder, "Little Bastard," he died. His life and Hollywood career ended at age twenty-four.

Six years earlier, as an eighteen-year-old senior guard on the Fairmount Quakers, Jimmy led his team to upset wins over Van Buren and Mississinewa in the 1949 sectionals, totaling 40 points in the two victories. Although the Quakers fell to the Marion Giants 40–34 in the semifinals, one can guess that Dean considered the end of his high school basketball career a success. Fairmount, however, was too small to hold on to Jimmy Dean, so he made his way to California, eventually landing at the famed Actors Studio and, by twenty-two, securing the lead role in Elia Kazan's *East of Eden*. His path to the top lay before him.

Dean's last trip home to Indiana and the Winslow farm was prompted by a *Life* magazine photo story, shot by another rising star, photographer Dennis Stock. The farm pictured in that iconic story is still there—and still owned by Dean's cousin Marcus. And the basket where a young James Dean practiced his hook shot still hangs in the old barn, perhaps awaiting another star.

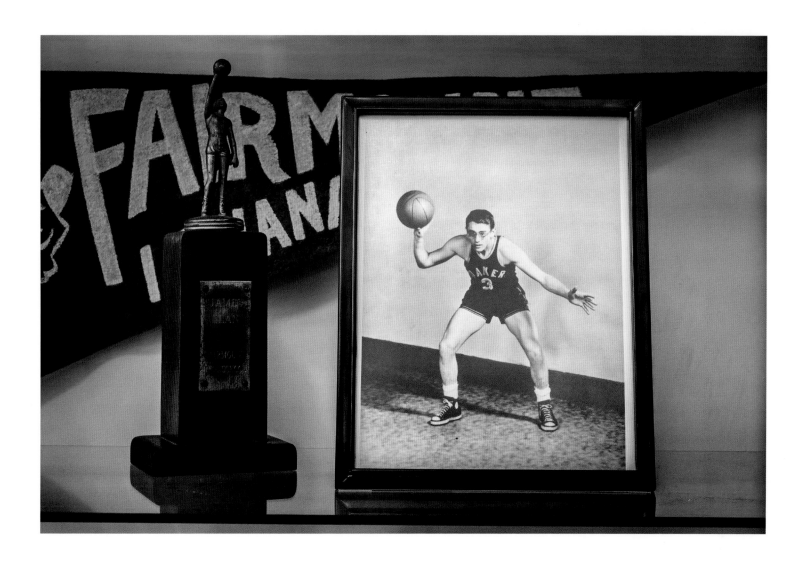

Left: Winslow barn and farmhouse, Fairmount. 2016

Right: James Dean memorabilia, Fairmount. 2016

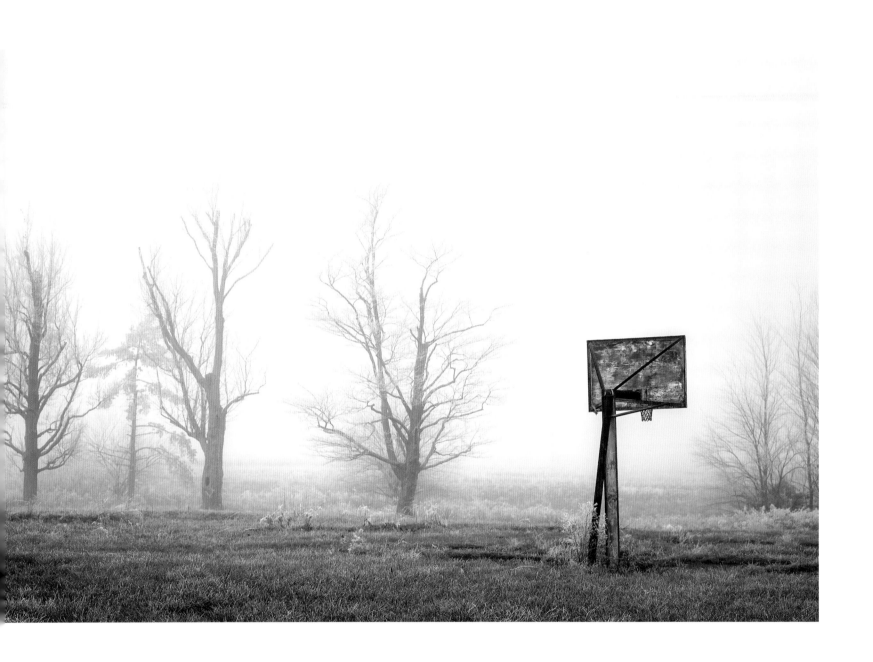

After a 2012 tornado struck Ripley County all that was
left of the old Holton School and Warhorse gym was
a broken blacktop court and a lone basket. 2015

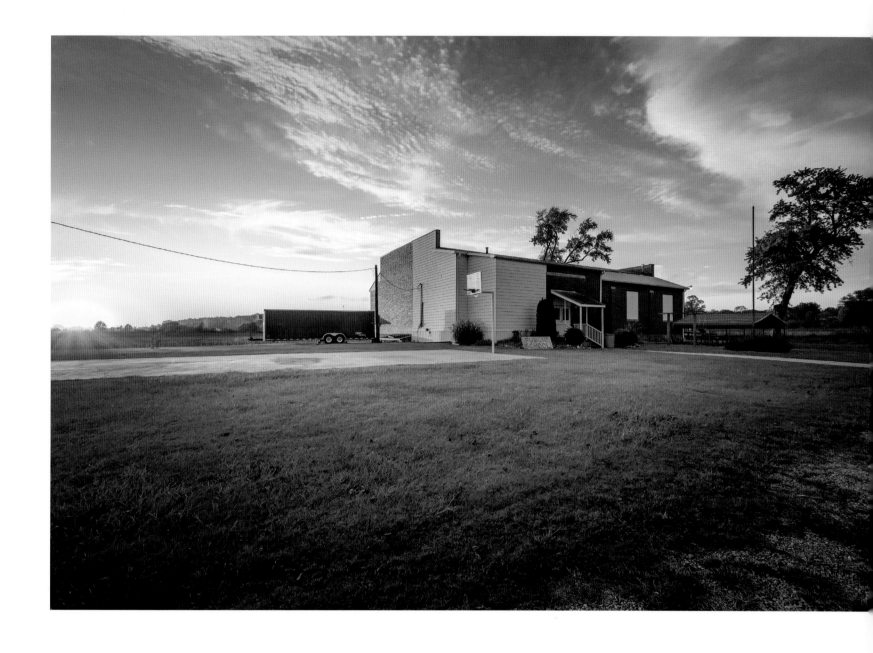

Griffin, former home of the Tornadoes, on a warm October evening. By the time a 1925 tornado hit Griffin it was a mile wide, destroying one hundred fifty homes and eighty-five farms and killing twenty-six. The EF-5 twister was considered one of the ten worst natural disasters of the twentieth century and ran continuously for almost four hours with wind speeds nearing 200 mph. 2017

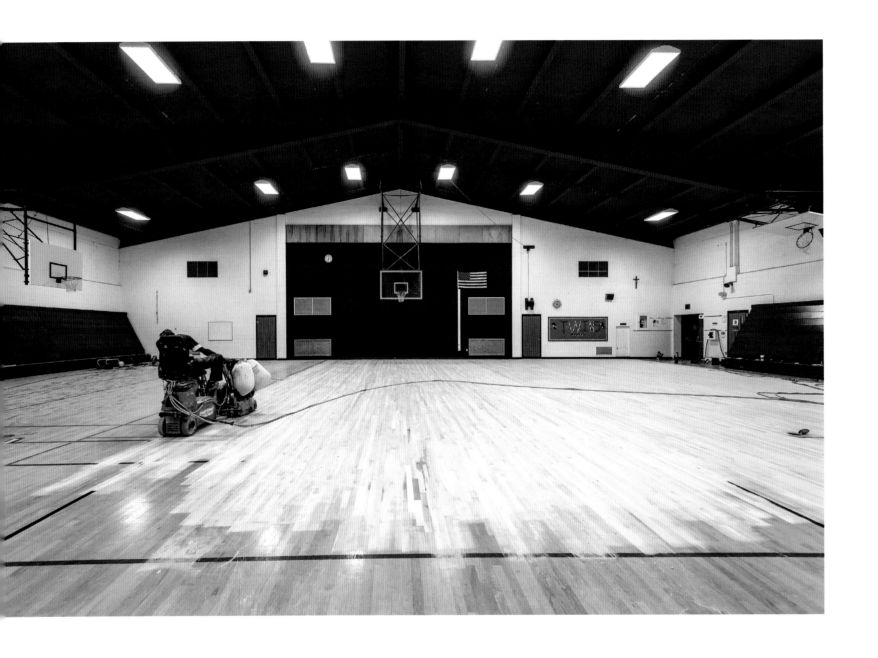

Restoring the home court of the Monroeville Cubs. 2017

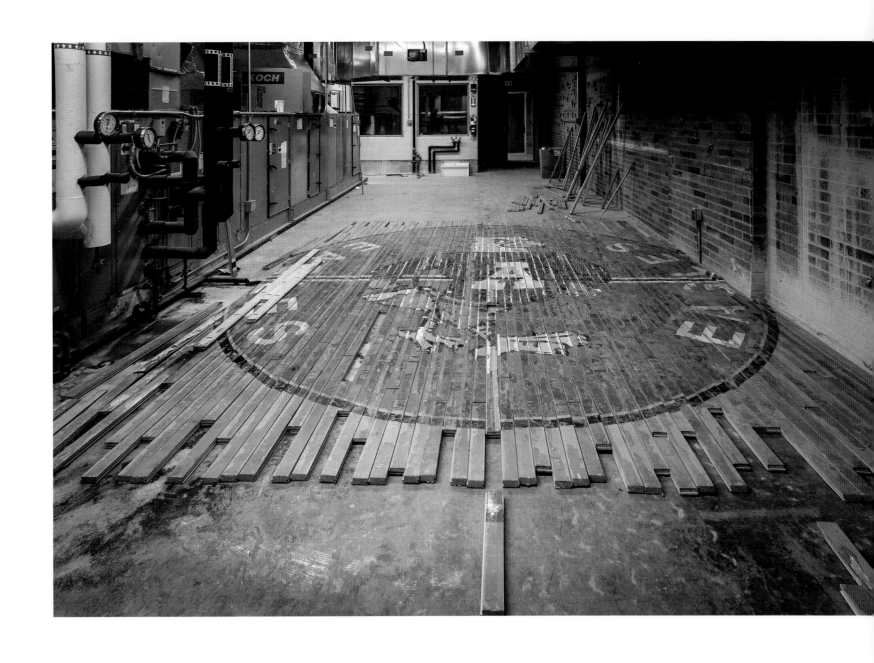

Salvaged center circle at South Bend Adams. 2018

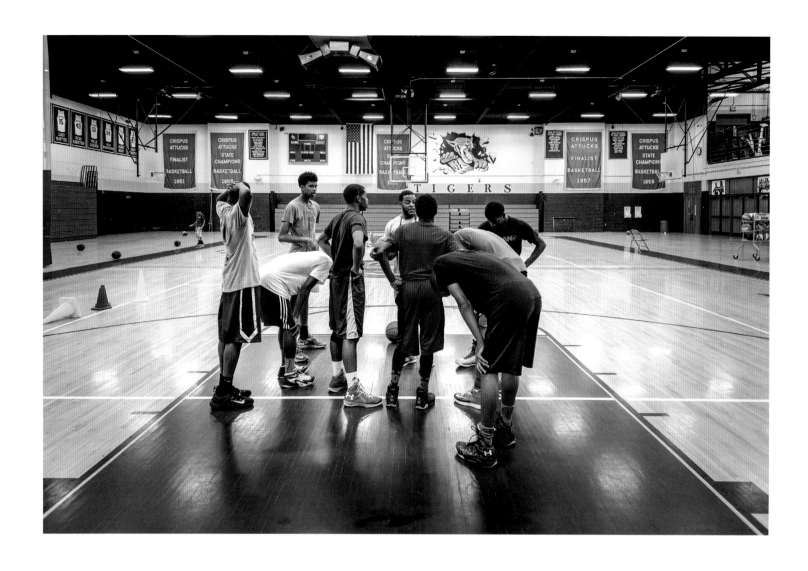

Summer practice, Indianapolis Attucks. 2015

Tuesday night summer ball, Williamsburg. 2015

On Saturday February 22, 2014, the Jac-Cen-Del Lady Eagles were about to play Indianapolis Tindley in the first round of the 1A regionals at Southwestern (Shelbyville) High School. Minutes before tip-off, I descended the stairs to the Lady Eagles' locker room and witnessed something very special—morning light streaming in on senior Brooklyn Ronsheim leading her teammates in their pregame call-and-response cheer. No coaches, no managers, no cheerleaders—just their voices echoing off the empty walls. Fifteen digital frames and it was over. Up the stairs they went, about to have the day of their lives.

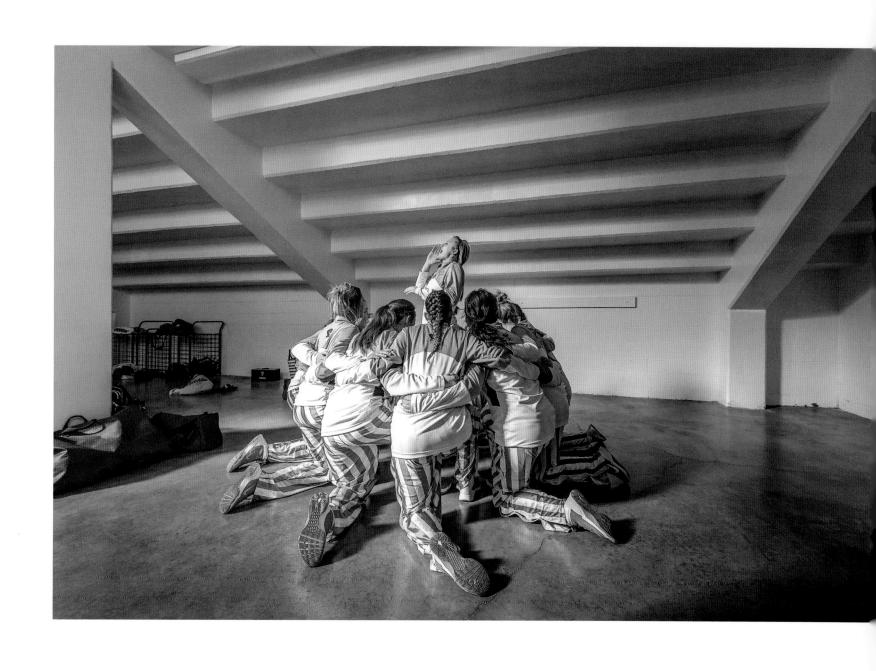

Jac-Cen-Del Lady Eagles, Southwestern
(Shelbyville) 1A regional. 2014

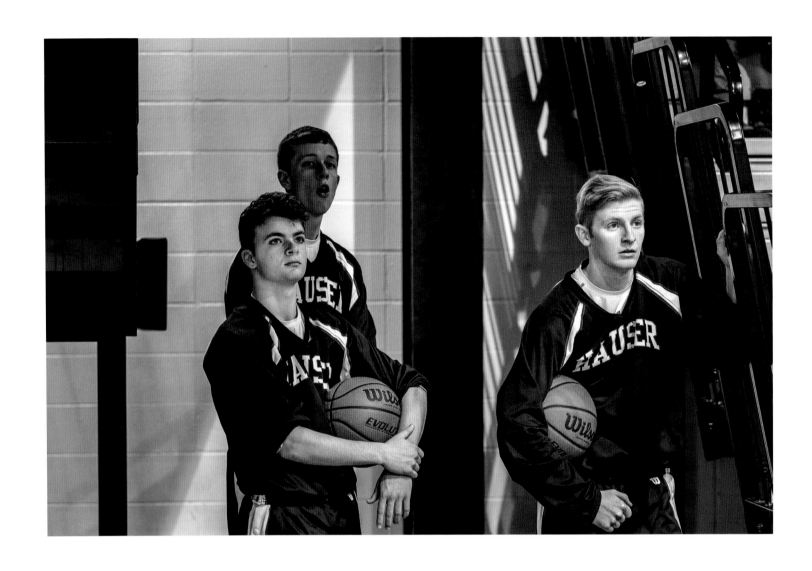

Hauser Jet varsity players watch their JV teammates. 2018

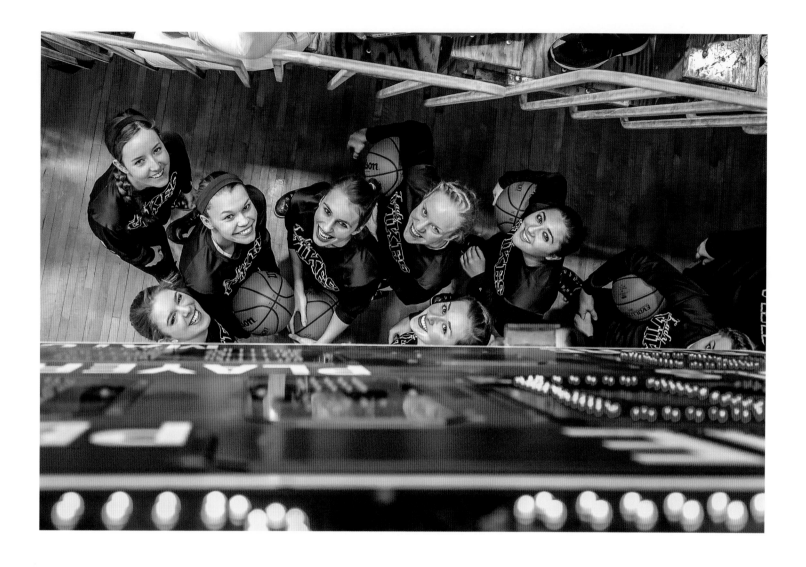

The Barr-Reeve Lady Vikes were 27–0 when they took
the floor for the 1A semi-state at Jeffersonville. A senior-
laden team, they fell behind Jac-Cen-Del by as many
as 22 points in the first half. But with 2:19 left in the
final quarter, they overtook the Lady Eagles, punching
their ticket to the state championship game. 2015

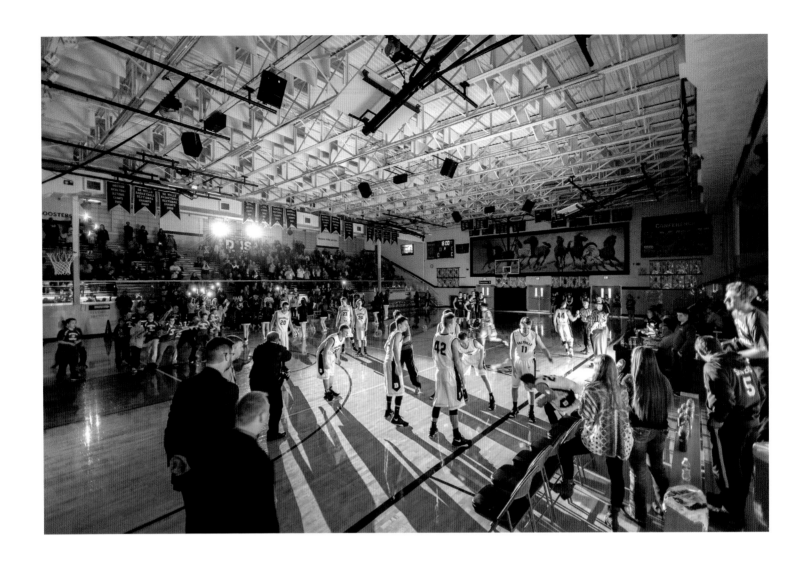

Team introductions,
Daleville Broncos gym. 2016

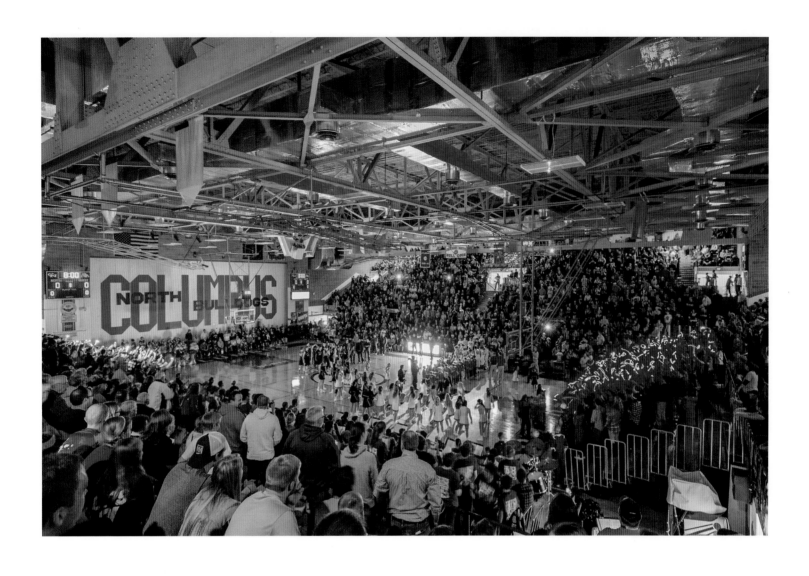

"Chuck Taylor Night," Columbus North
versus Columbus East. 2014

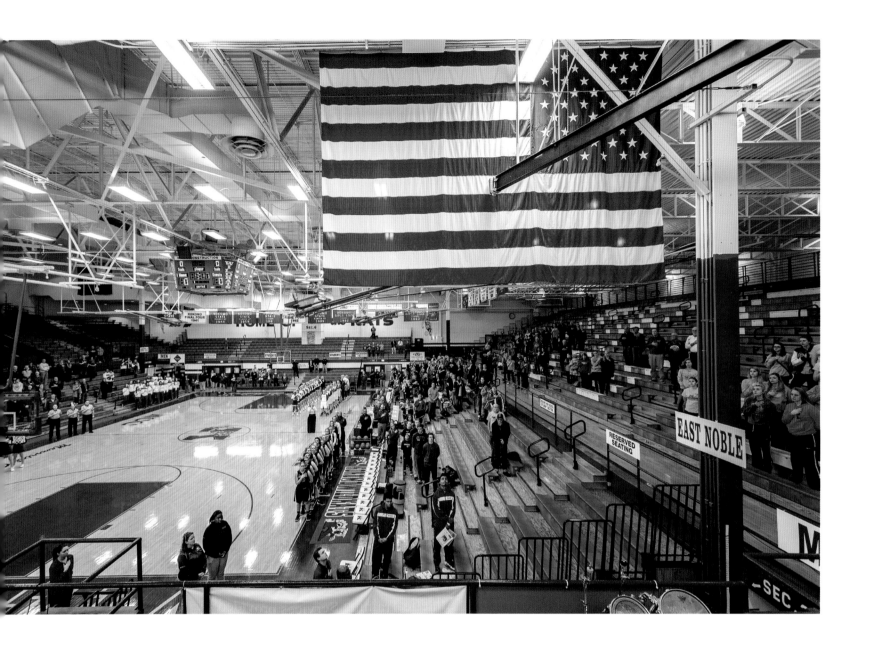

Morning game, 4A
regional, Kokomo. 2016

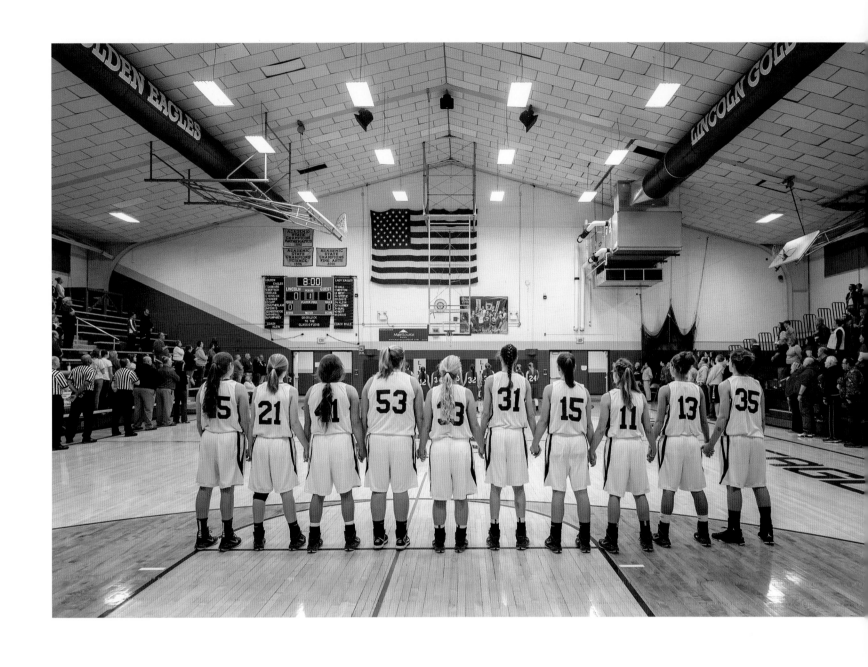

Hagerstown Tigers, Cambridge
City Lincoln 2A sectional final. 2015

Second annual Basketball Day
Indiana, Fort Wayne Luers. 2018

The Greensburg Pirates and Rushville Lions tip off in
the old Rushville Memorial Gymnasium, built in 1926.
The Pirates would prevail 73–43 and later in March
would go on to win their second consecutive 3A state
championship, posting a record of 28–1. 2014

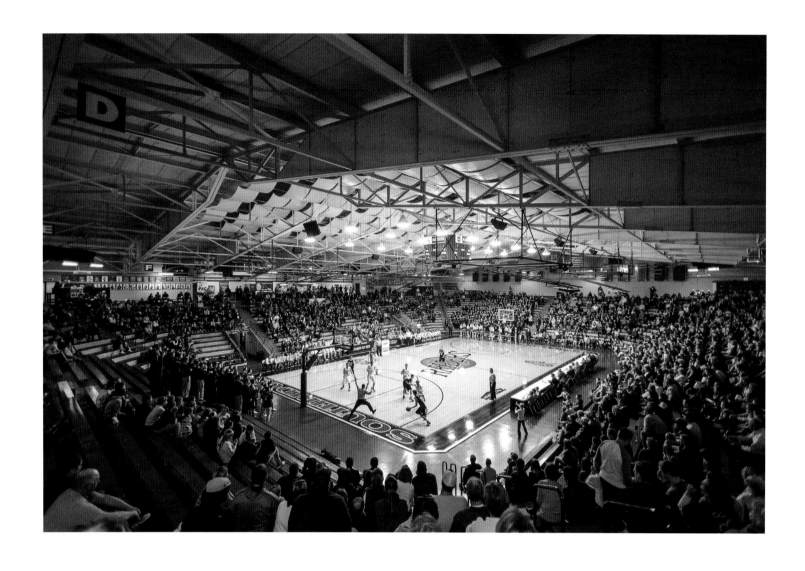

2A sectional final, Huntingburg
Memorial Gymnasium. 2015

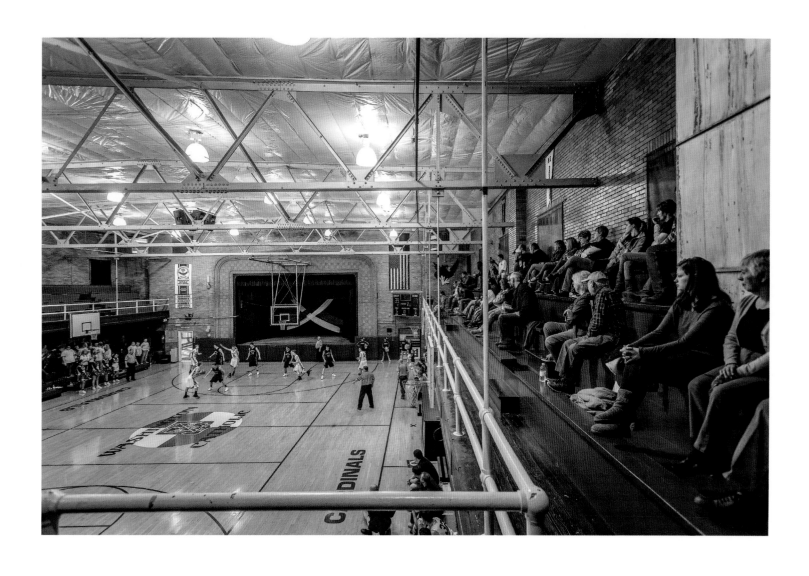

"The Birdcage," built in 1926,
Washington Catholic High School. 2015

Varsity Rocket players before
practice, Union (Modoc). 2015

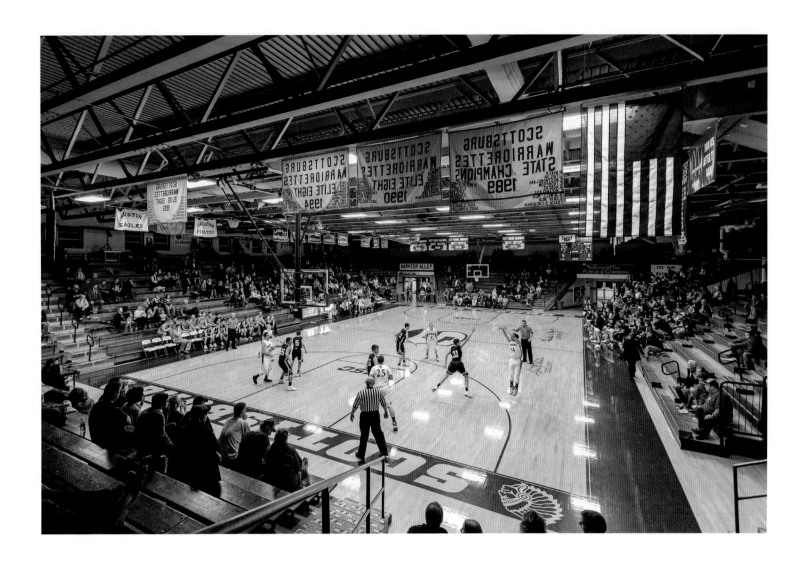

"The Pressure Cooker," home court of the
Scottsburg Warriors and Warriorettes. 2015

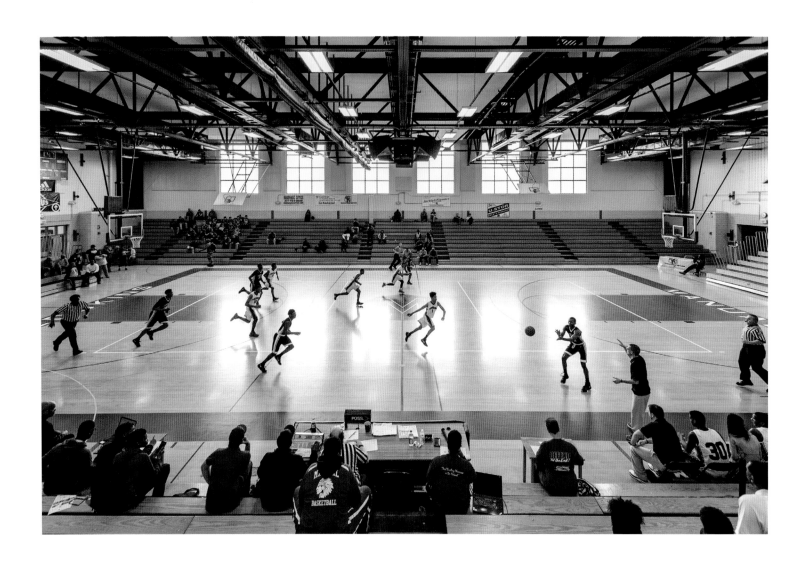

"Most Exciting Showcase in the Midwest,"
Indianapolis's Emmerich Manual gym. 2015

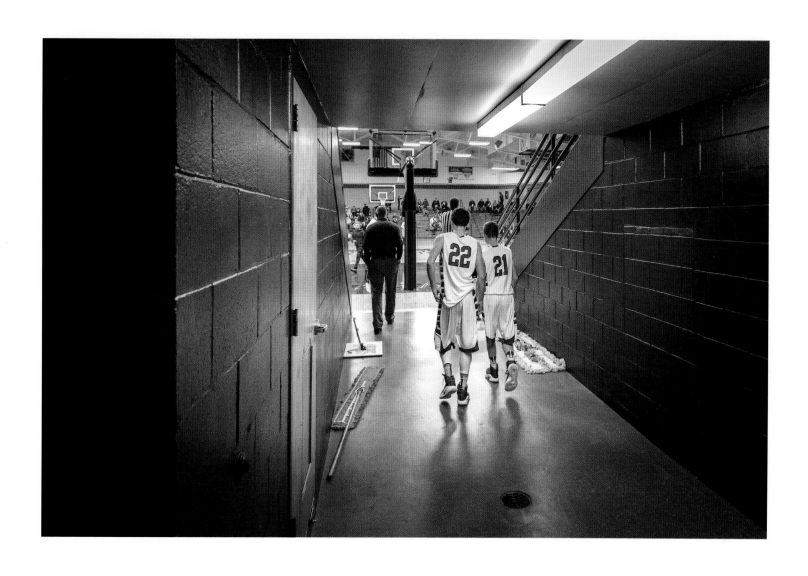

Edinburgh Lancer varsity players leave the
locker room for warm-ups, Edinburgh. 2017

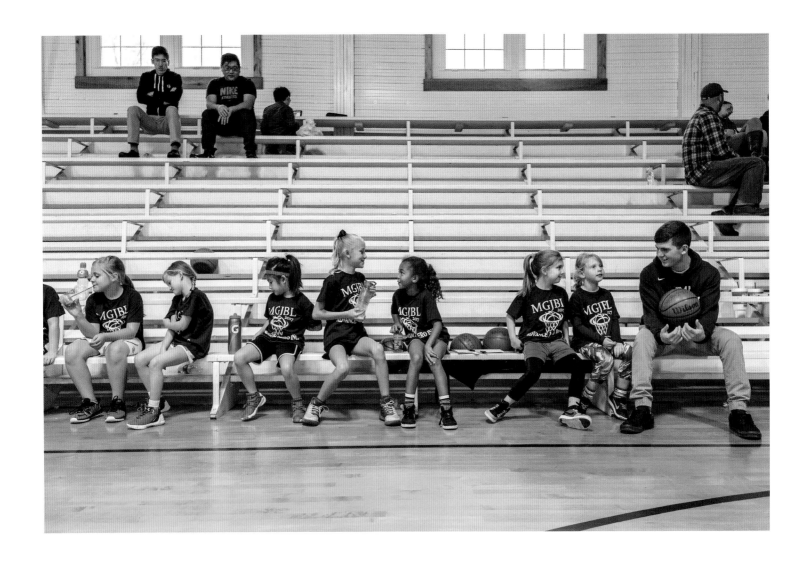

Saturday morning girls' basketball
league, Newby Gym, Mooresville. 2017

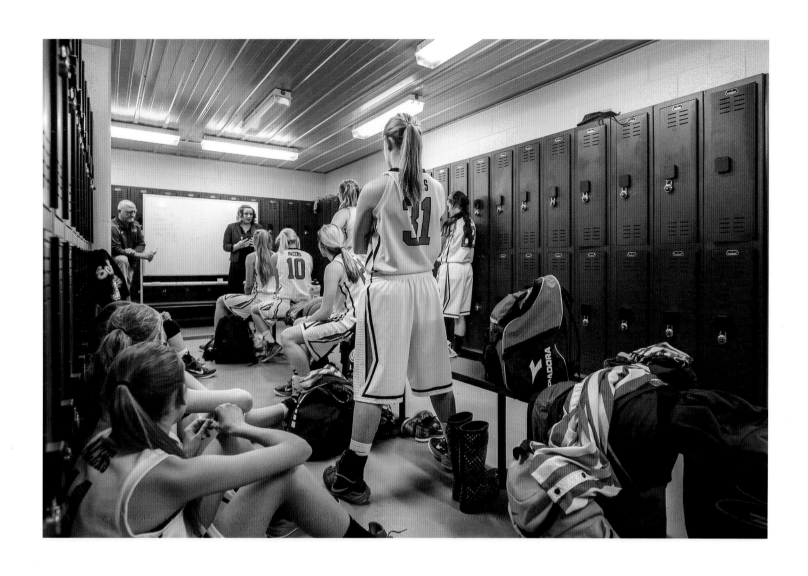

Switzerland County Lady Pacers before 2A Paoli regional
game against North Posey. The Pacers would win 49–35
but eventually lose to Providence in the final, 49–42. 2015

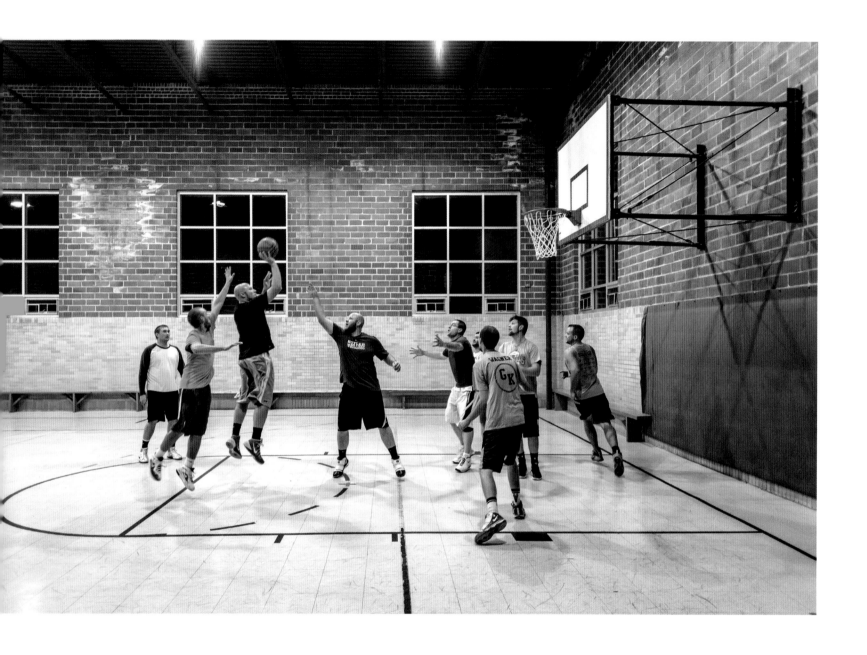

Monday night men's league, Immaculate
Conception gym, Millhousen. 2017

Pick-up game outside of the old
Mitchell Bluejacket gym. 2017

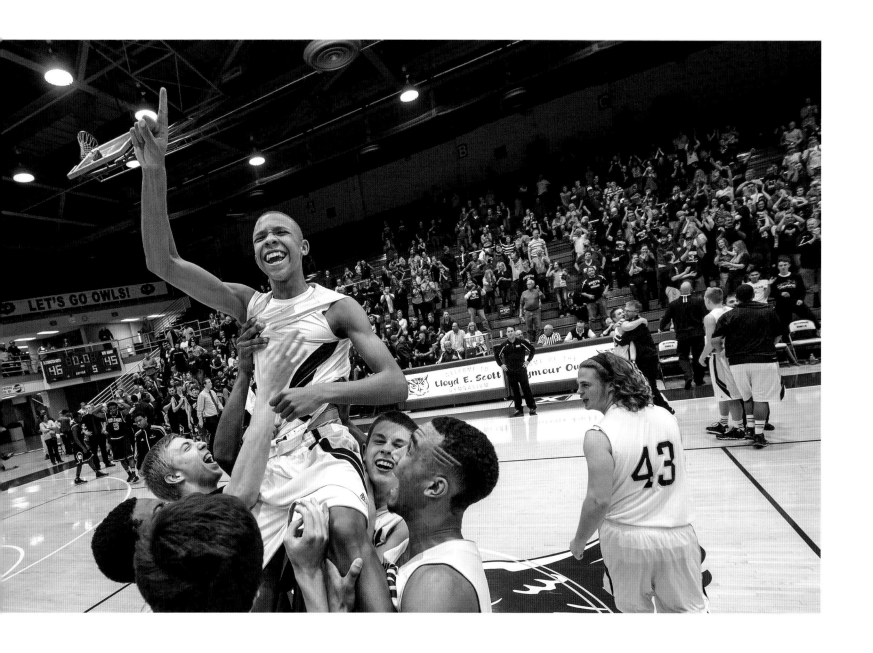

Bloomington North defeats New Albany in
overtime to win the 4A Seymour regional. 2014

Marion player fouls out in the 3A
regional final loss to New Castle. 2018

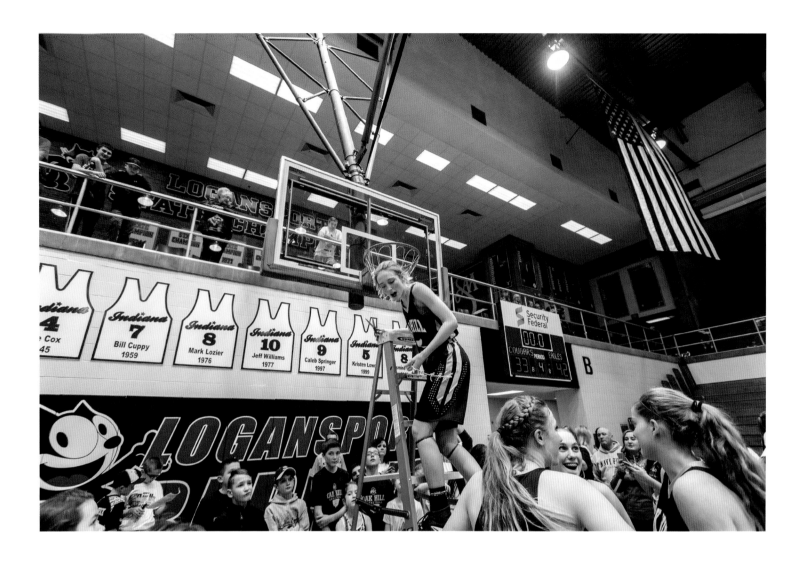

Oak Hill Golden Eagles, 2A semi-state
champions, Logansport. 2017

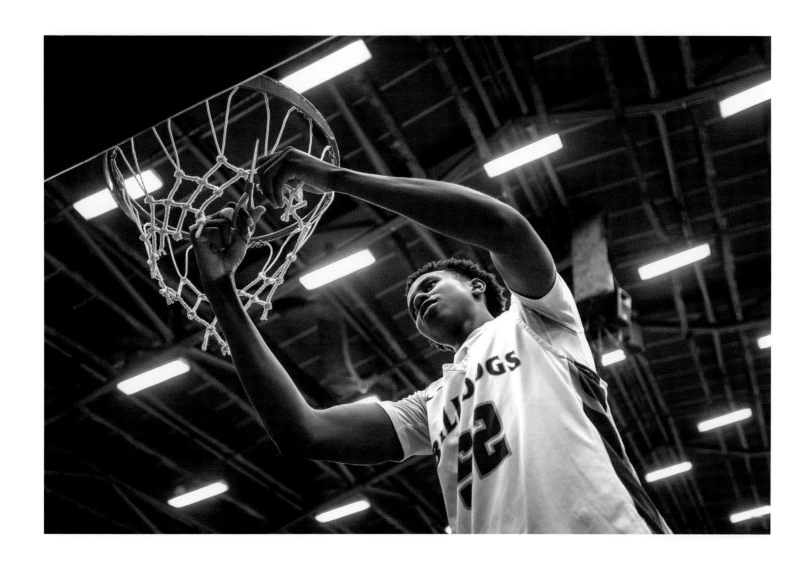

Evansville Bosse cuts down the nets,
3A sectional final, Boonville. 2018

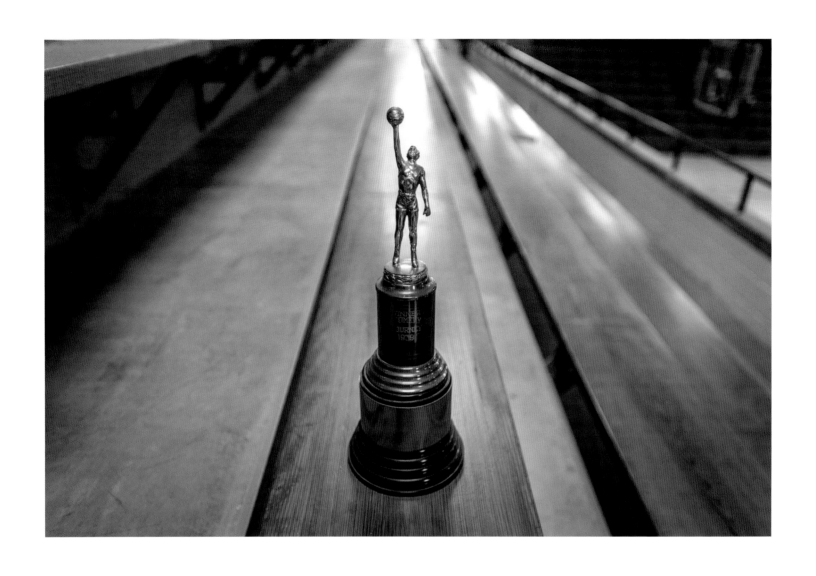

1939 Montgomery County championship
trophy, New Market. 2018

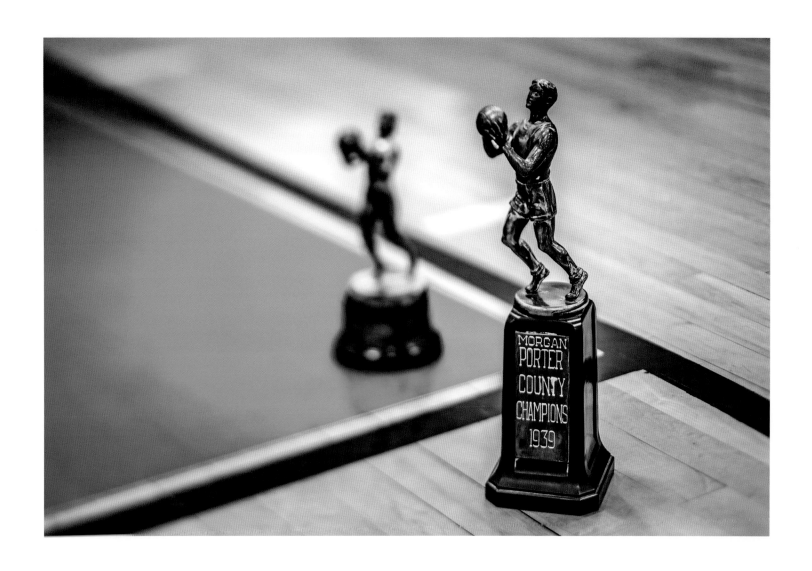

1939 Porter County championship
trophy, Morgan Township. 2016

When most Hoosiers awoke on the morning of February 26, 1956, it seemed like an ordinary Sunday in late winter or early spring. The temperature in the southern part of the state started out in the high 20s, but would hit 54 by day's end, and although Dwight Eisenhower was president, the Platters were the hot topic of conversation with their number one hit "The Great Pretender." But Sunday February 26 wasn't just a normal day for Keith Huber of St. Paul—it was a day of endless possibilities. You see, Huber and his teammates Don Gordon, Jerry Owens, Jim Harris, and Ray Bostic had defeated Greensburg the night before, 44–42, for the sectional championship—the second one in school history for the Blasters (1941 was the first). So on this Sunday an unwritten page of their basketball history lay ahead, with the possibility of a regional, semi-state, or even state crown to come. If Milan had done it two years before, why not St. Paul? But, by Saturday evening March 3, Huber and the Blasters had fallen to a very good Scottsburg squad (68–54) and, like most in the state, would sit back and watch Crispus Attucks march to a second state title.

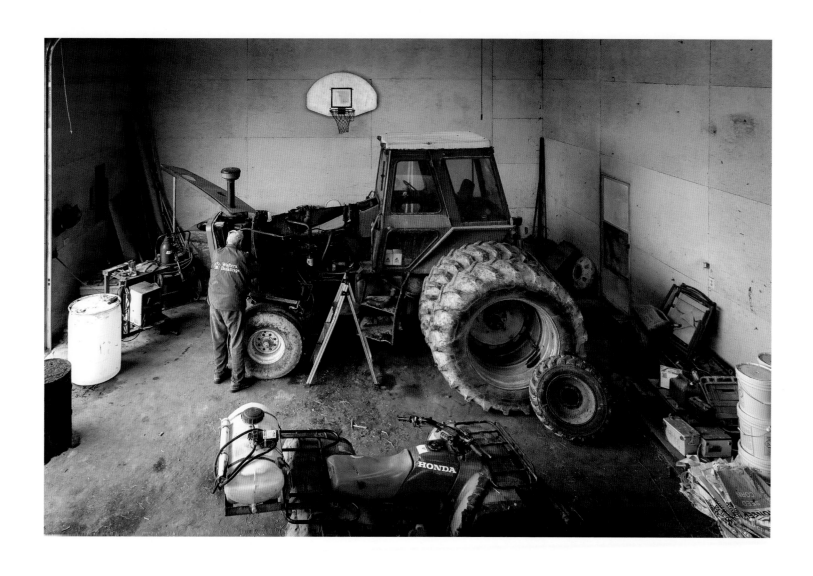

Left: On the road to St. Paul. 2017

Right: Keith Huber works on one of his
tractors outside St. Paul. 2017

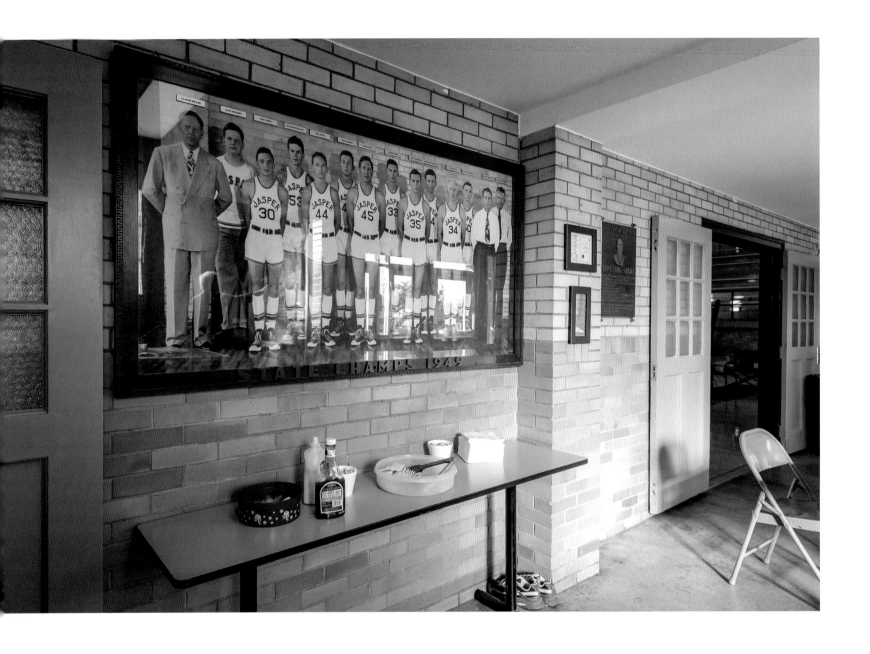

Jasper Wildcats, 1949 state champs,
Cabby O'Neill Gymnasium. 2015

78

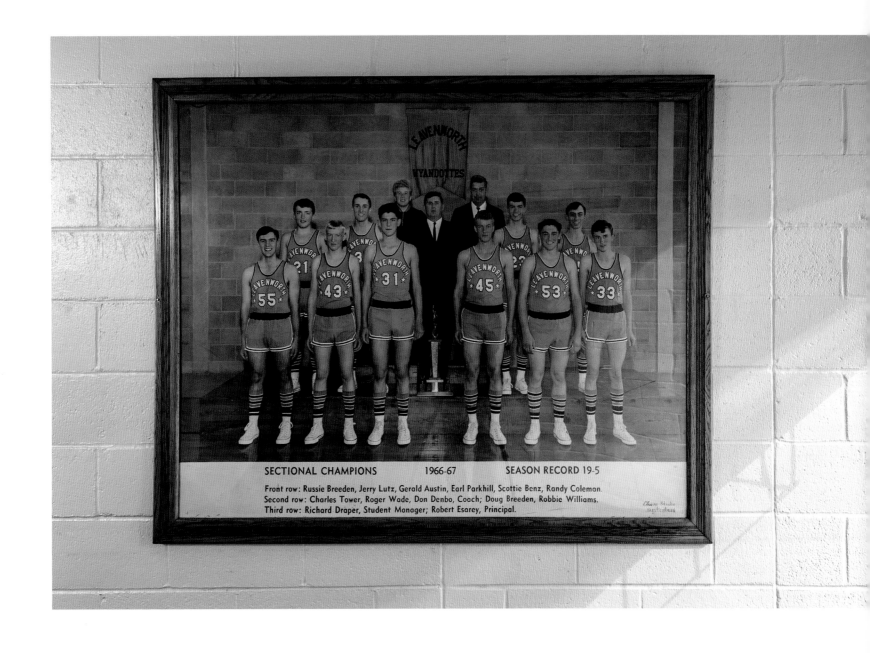

Leavenworth Wyandottes, 1967 sectional
champs, Leavenworth. 2017

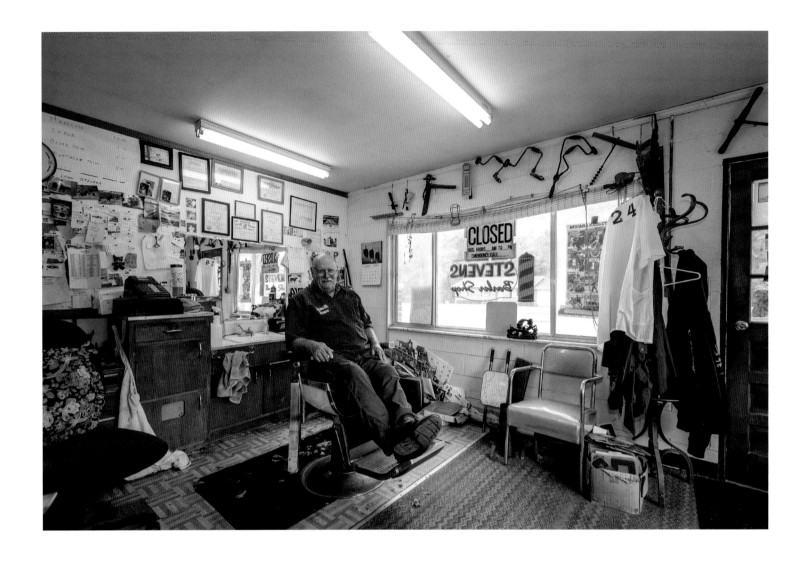

Lynn Stevens remembers his last-second shot that propelled Unionville to the 1966 sectional title and is happy to tell you the final score—Unionville 69, Bloomington 68. Angelo Pizzo remembered that shot too, along with the packed house in Martinsville and the "sound and fury" of the game. Pizzo remembered the newspapers that turned up every year at tournament time also, the ones telling the tale of tiny Milan's 1954 championship run. Inspired by those events Pizzo would go on to create the story that became the film *Hoosiers*—a story capturing the times, places, and connections between small towns and basketball in the 1950s, a story that many believe became the finest sports film ever made.

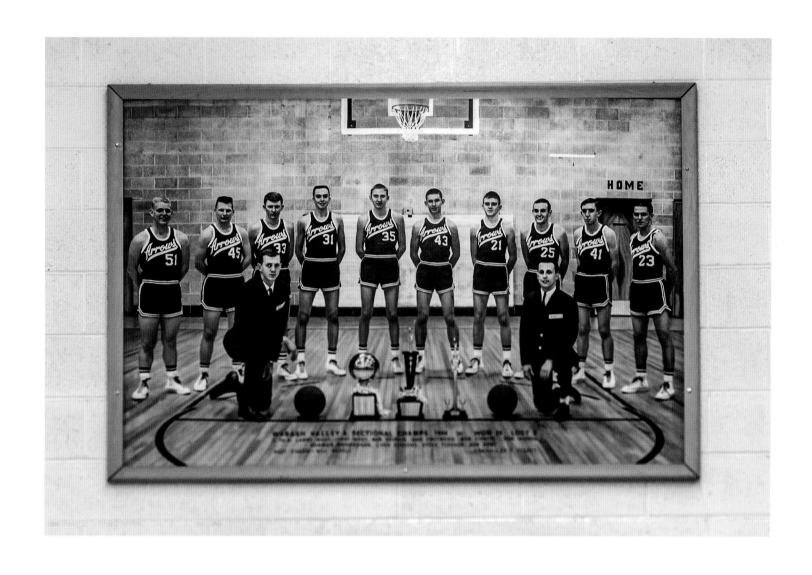

Left: Lynn Stevens (number twenty-five), hero
of the 1966 sectional champs, Unionville. 2016

Right: 1966 Unionville Arrows. 2016

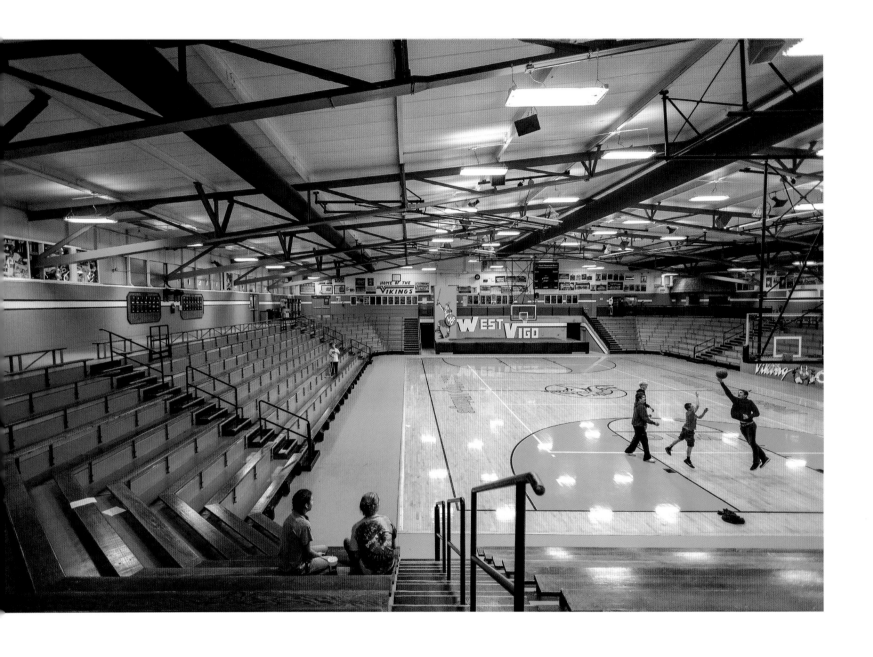

After the game, West Vigo
gym, Terre Haute. 2017

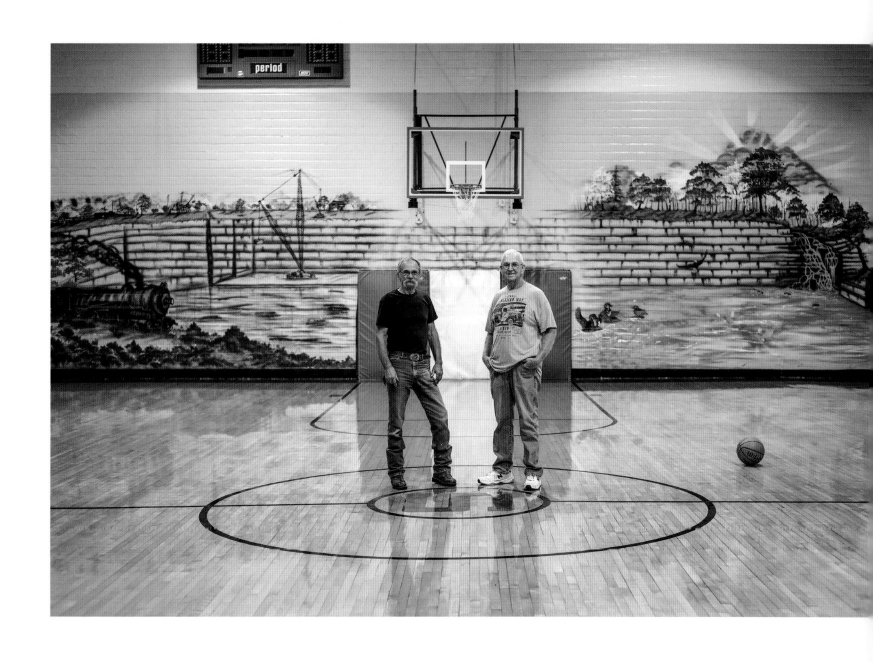

Larry Hayes and Larry Pursell, caretakers of the
Stinesville gym, home of the Quarry Lads. 2016

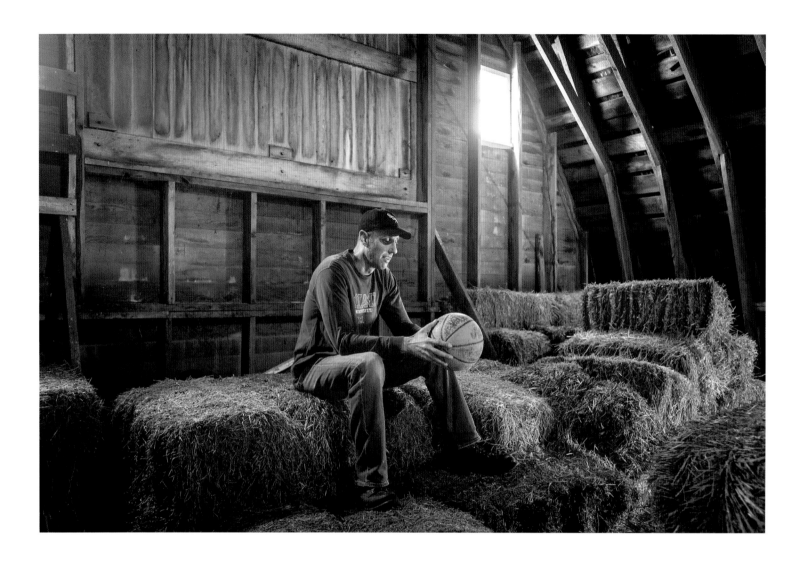

Matt Werner grew up on a farm near Union Mills playing
basketball. He even named the upper deck of the family
barn Werner Arena. Always a student of the game,
Matt was now a historian, penning two books on local
area teams and writing for a local newspaper. 2016

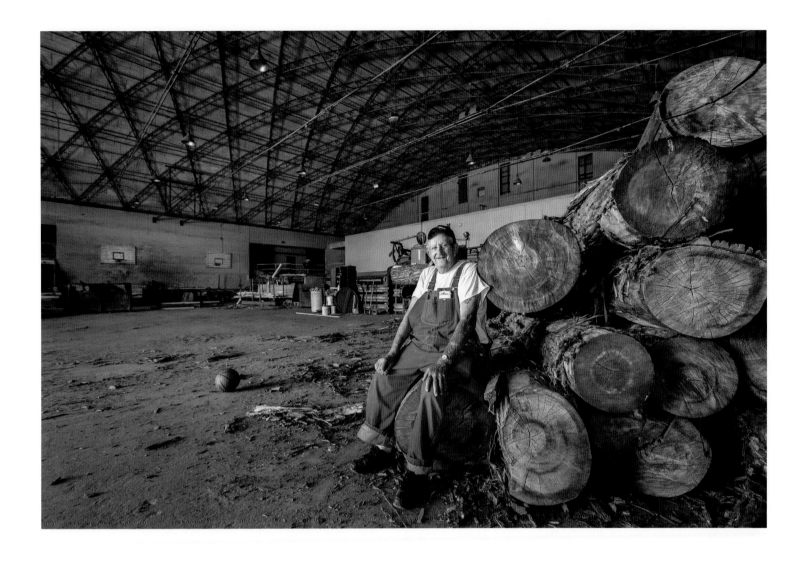

As a player for Monroe City in 1953, Gary Shouse never liked playing in the old Decker gym. Even though his team, the Blue Jeans, would win the sectional crown that year, his disdain for the gym lasted until he bought the school (and the gyms) and turned the location into a sawmill, letting profits overcome hard feelings. 2017

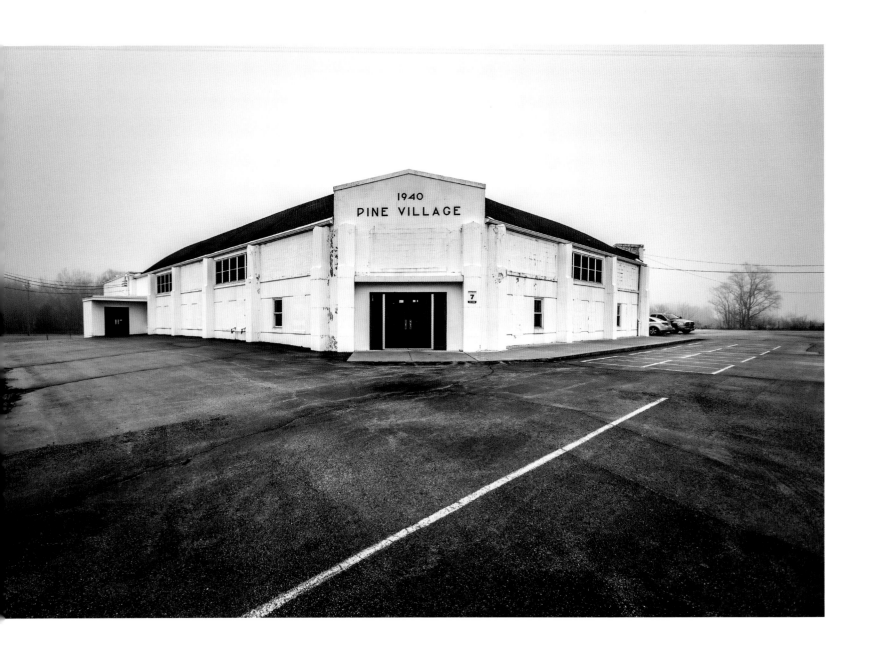

Pine Village gym, home of the Pine Knots. 2017

Roadside court. 2017

Lawrence County's abandoned
Tunnelton gym. 2017

Lawrenceburg's Tiger Arena rises from the ashes of
the old George "Bud" Bateman Gymnasium. 2015

On the road to Bedford. 2016

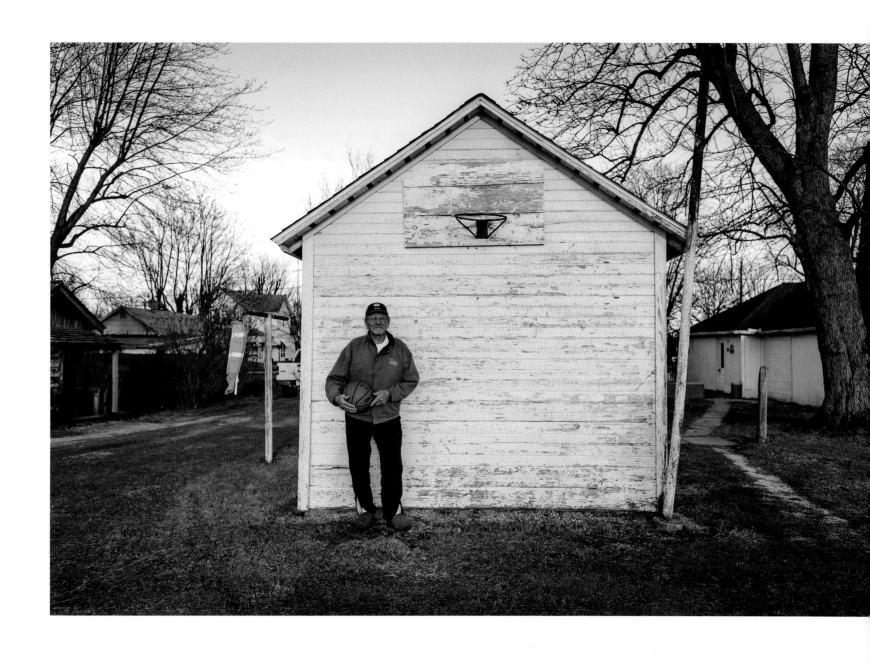

Jim Dickey, 1951 sectional champ, Roll. 2018

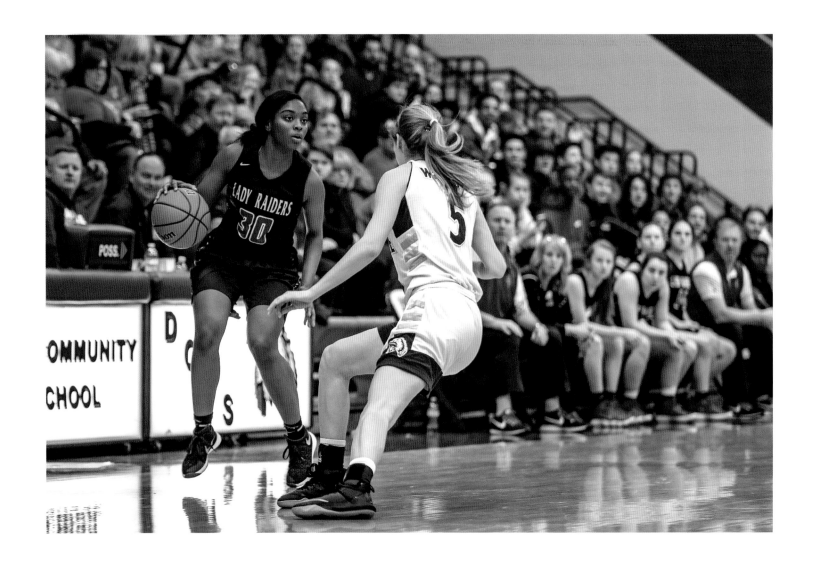

The Lady Raiders of Indianapolis Ritter take on
the Warriors of Danville in a 3A regional matchup.
Danville prevailed 52–37 and later in the day defeated
Owen Valley to win the regional crown. 2018

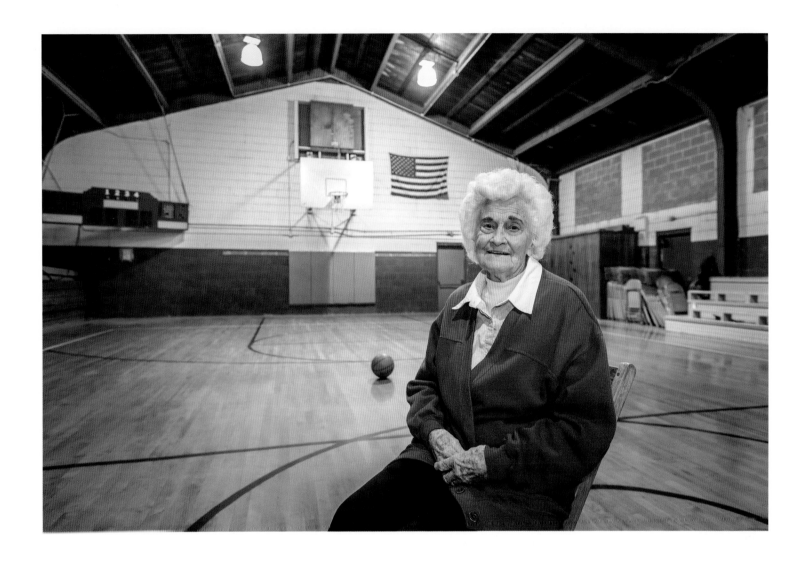

We photographed Loretah Blake in the old Paris
Crossing gym on a cold January day. She proudly told
us that she was ninety-eight and a half years old, and,
as much as she liked living in Paris Crossing, she didn't
play ball there but three miles down the road in Deputy
during the early, dark days of the Depression. 2014

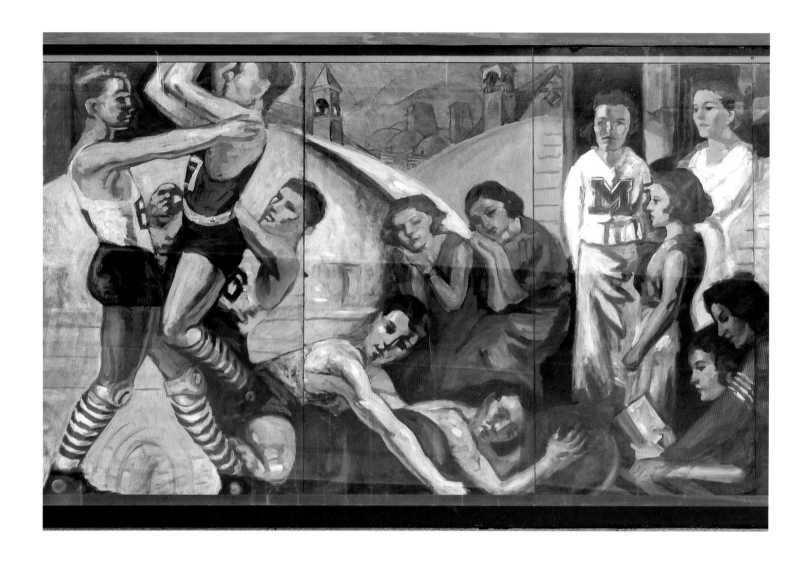

Mural on the wall of the Mecca gym,
former home of the Arabs. 2017

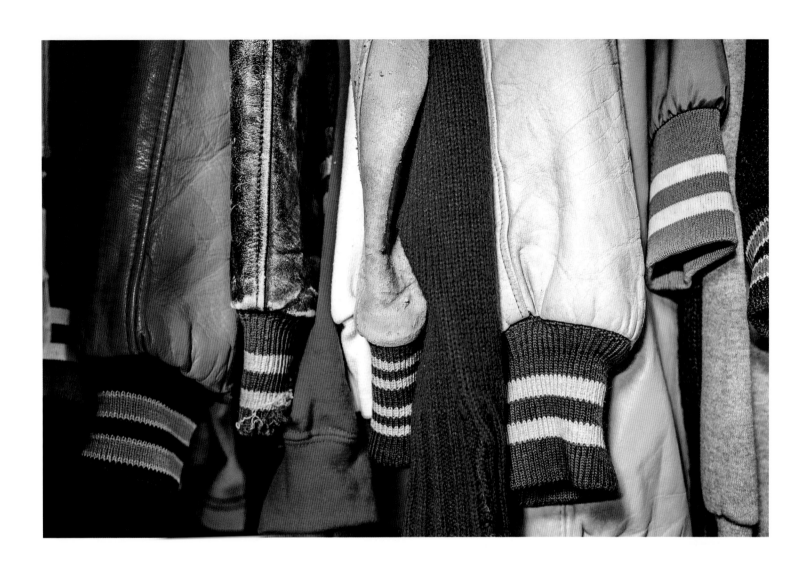

Vintage letter jackets,
Crawfordsville. 2017

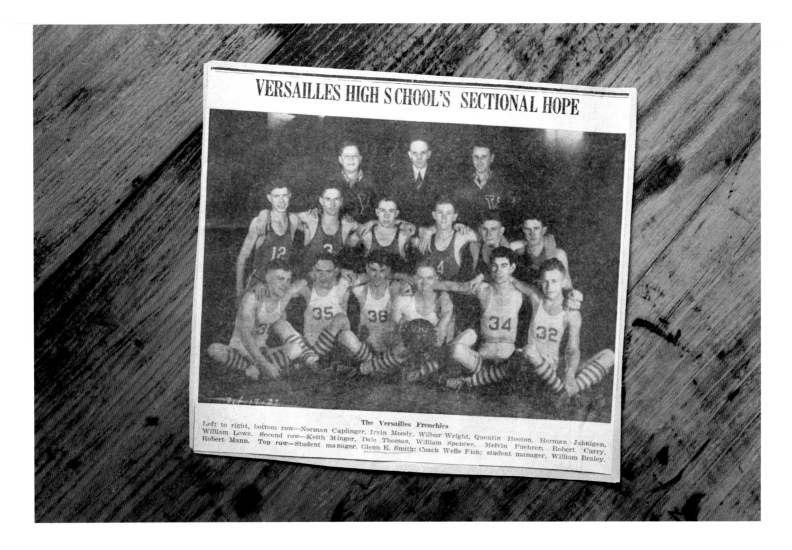

VERSAILLES HIGH SCHOOL'S SECTIONAL HOPE

The Versailles Frenchies

Left to right, bottom row—Norman Caplinger, Irvin Moody, Wilbur Wright, Quentin Hooton, Herman Jahnigen, William Lowe. Second row—Keith Minger, Dale Thomas, William Spencer, Melvin Fuehrer, Robert Curry, Robert Mann. Top row—Student manager, Glenn E. Smith; Coach Wells Fish; student manager, William Braley.

hree years into this project I received an over-sized envelope from a distant cousin. Inside, along with letters and old photos, was a newspaper clipping from the *Versailles Republican* titled "Versailles High School's Sectional Hope." And now, for the first time, I had names to go along with the faces in my dad's old team photo. There was Quentin Hooten and Bill Spencer, manager Bill Braley and head coach Wells Fish—names that I had heard in long-ago stories, but since my dad's death in 1997 (long before the start of this project), I had no way to attach them to the one team image I held. And there too was Herman Jahnigan (number 34).

I'm not sure that in the winter of 1937 Herman or any of the Versailles Frenchies were thinking much further ahead than the upcoming sectional tourney. Although they played well, defeating Vernon (40–13) and Scipio (49–20), their season ended in a 49–25 loss to eventual sectional champ North Vernon. The Panthers of North Vernon would march on, winning the regional before losing in the second round of the semi-state to eventual state champ Anderson. Moving toward graduation and away from the Great Depression, Herman and the boys probably imagined a very different future from the one that was about to unfold, for this team from a small country town would be swept up in the greatest maelstrom ever seen—the Second World War.

My dad graduated in 1938, attended Indiana University (graduating with a degree in business), and

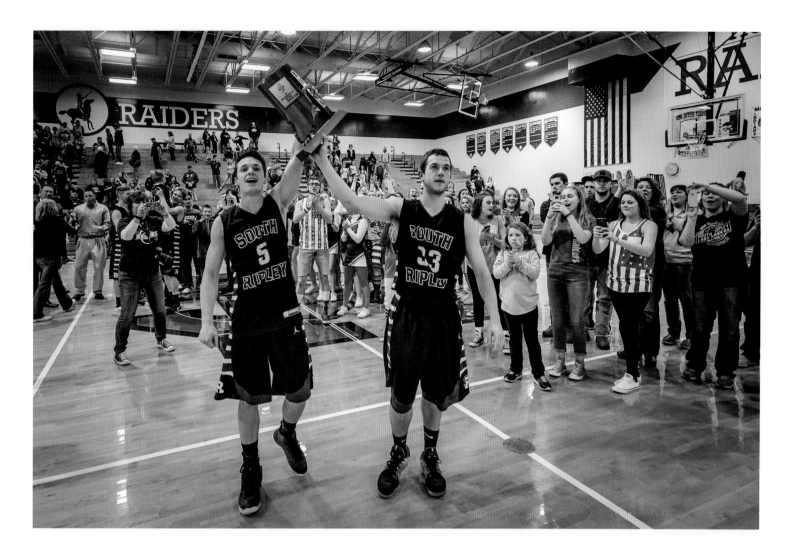

joined the air corps as a captain in Army Intelligence. Herman followed a different route as a member of the 508th Parachute Infantry of the 82nd Airborne Division, parachuting into France on June 6, 1944, in the first wave of the D-Day invasion. He was wounded, but fought on through Western Europe and eventually ended up at the Battle of the Bulge, where America suffered seventy-five thousand casualties. By the time the war was over Herman became Ripley County's most decorated veteran.

The Versailles Frenchies went on to lead different lives, but the common bond of growing up during the Depression, being team members on a Hoosier high school basketball team, and fighting in a world war shaped them forever. And in 2017, eighty years after

the Frenchies took to the floor for the 1937 sectionals, the South Ripley (Versailles) Raiders defeated the Milan Indians on the Raiders' home court for the 2A title. A fitting end for the story of an old photograph and for my dad and Herman, who lie less than one hundred yards apart just up the road.

Left: Newspaper clipping from the *Versailles Republican*. 2016

Right: The South Ripley Raiders celebrate their 2A sectional championship, Versailles. 2017

MICHAEL E. KEATING PHOTOGRAPHS

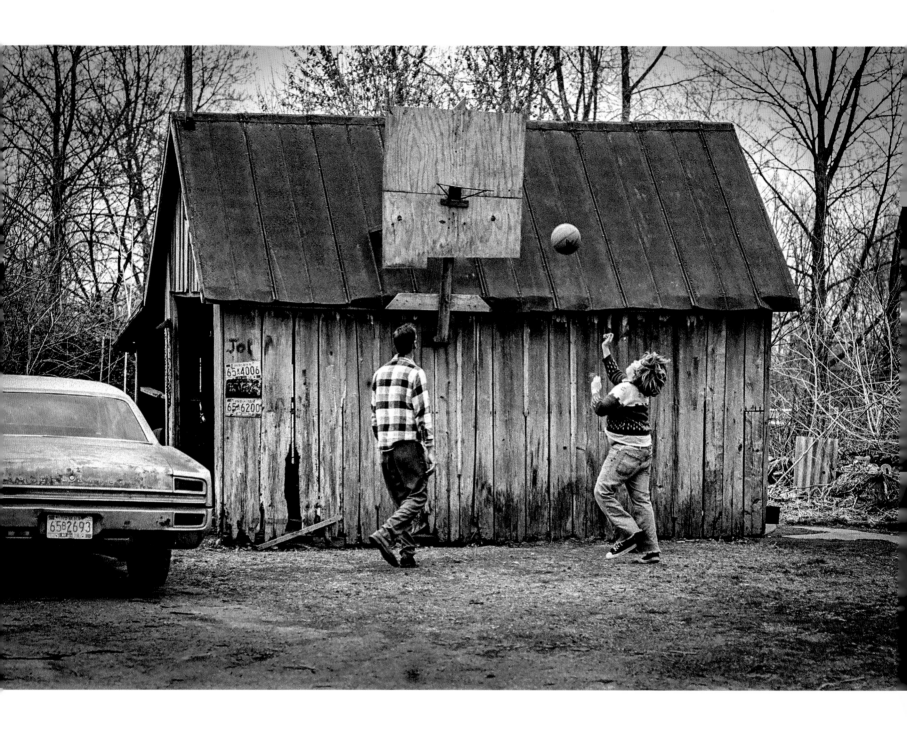

Paul Strader and his son John take turns shooting at a
backboard and rim attached to a small barn in Solitude. 1976

I began this journey, without knowing it, more than forty years ago, while on assignment for the *Washington Post*. Tasked with photographing the southwest corner of Indiana during America's Bicentennial, my focus was on the small, unincorporated town of Solitude, platted in 1815. Solitude sits on the north bank of Big Creek, just off State Road 69 in Posey County, and at one time was a railroad stop and grain depot. But by 1976 all signs of commerce were long gone. Occupied by little more than a few houses, mobile homes, and reconstructed log cabins, Solitude suited the *Post's* calculated headline that framed it as "A Town in Name Alone."

The published piece would include my photograph of Paul Strader and his son John trading shots at a plywood backboard and rusted rim hanging from the side of an unpainted wooden barn. This scene would be brought to mind years later by David Halberstam when he wrote of "fathers nailing backboards and rims to buildings" in his 1985 *Esquire* magazine essay about basketball in the Hoosier state. Little did I know the lasting impact that single photo would have on my photographic life.

Following a forty-year newspaper and freelance photography career I welcomed the opportunity to document Indiana's game—a project more rooted in passion than profit—and before long my thoughts turned to Cannelton, my hometown. Located on the north shore of the Ohio River, with a population hovering around 1,500, Cannelton was the seat of Perry County before losing that honor to its northern neighbor Tell City and was known mostly for the Cannelton Cotton Mill (a National Historic Landmark) and the Cannelton Locks and Dam.

What I remember most about my hometown is the Community Building. A center for the town's many activities, the Community Building housed the high school gymnasium upstairs and the volunteer fire department, two-officer police department, and public library downstairs. I played grade school basketball there, helped set tables and chairs for my church's Turkey Bingo, played keyboards in a garage band at sock hops, starred in school plays, and, most importantly, received my high school diploma on that parquet floor. Because the Community Building was also home to our volunteer fire department, it was known that ball games could possibly be paused when firefighters responded to a blaze, leaving the station below with sirens blaring.

In 1960 the gymnasium became a temporary morgue when a Northwest Orient Lockheed Electra, en route from Chicago to Miami, Florida, crashed nearby, killing all sixty-three on board. The original gymnasium flooring

was damaged during that time and later replaced with a new parquet floor that Joe Hafele, a Cannelton basketball legend and former teacher, described as "being like the one the Boston Celtics have." Unfortunately, that new parquet floor, like much of the surrounding community, has also fallen into disrepair. The Bulldogs from Cannelton High School now play in a newer gymnasium located across the alley behind the school building.

That scene, a once proud gymnasium gone to dust, would be witnessed over and over as we travelled around our state: Tunnelton, Alamo, Butlerville, Anderson, Alfordsville, Lew Wallace, and Gary Emerson—the list goes on. At the same time, gyms in New Harmony, Pleasantville, Fort Branch, and other Indiana communities have been lovingly restored and preserved. Others, like Versailles, Gas City, and Paoli, have been repurposed into senior housing. These links between Indiana high school basketball, the places where it is played, and the communities where it lives would become the basis for our travels—the vehicle to our understanding. Quoting again from *Esquire* essayist Halberstam, "A community's identity came as much as anything else from its high school basketball team. It was what the state needed, for there was so little else to do in these small towns. In the days when all this took place, when the idea of basketball was bred into the culture, there was neither radio nor television; it became in those bleak years the best way of fending off the otherwise almost unbearable loneliness of the long and hard winters. In a dark and lonely winter, the gym was a warm, noisy, and well-lit place."

As a former newspaper photojournalist, I have always been focused on personal narratives in my work, and this journey afforded me the opportunity to go down that road again. Illustrating this, two moments come to mind.

In the 1950s, a young Indianapolis teen named Oscar Robertson wanted so badly to play the game that he wrapped rags into basketball-sized spheres to practice his shot on Indianapolis playgrounds. He rode a wave of talent to become a two-time state champion at Crispus Attucks, a University of Cincinnati three-time All-American, an Olympic gold medalist, and a professional basketball legend. I was lucky enough to be on the Banker's Life Fieldhouse floor in 2017 when alumnus Robertson placed state championship medals around the necks of Indianapolis Crispus Attucks players, a celebration that was more than fifty years in the making.

In a quieter moment, while walking with Hall of Famer Jerry Memering around Vincennes Adams Coliseum, where he played under Hall of Fame coach Orlando "Gunner" Wyman and scored more than 1,650 points, I was told that, "winning the sectional in all four years of my high school basketball career was the highlight of my playing days." Memering would go on to play for Bobby Knight at Indiana University and was a member of the 1973 NCAA Final Four Hoosier team.

These players and these gyms have been a part of my collective memory since my days as a young man in Cannelton, and turning down the road to Solitude was just the first sign of what was to come.

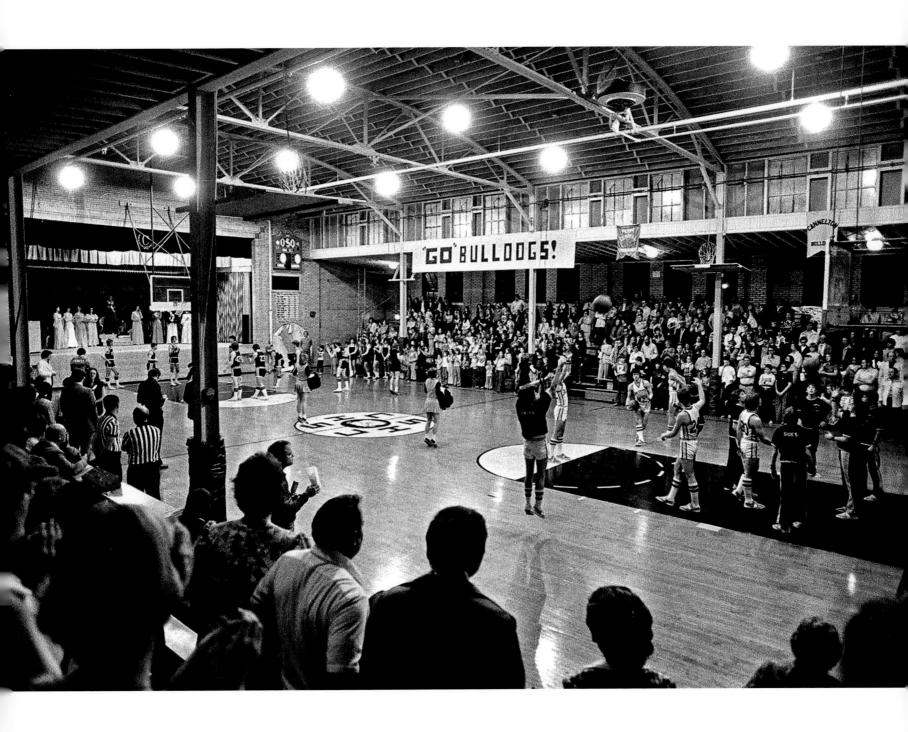

The second floor of the Cannelton Community Building,
packed with Bulldogs fans for a homecoming game
against a Whitesville, Kentucky, high school. 1977

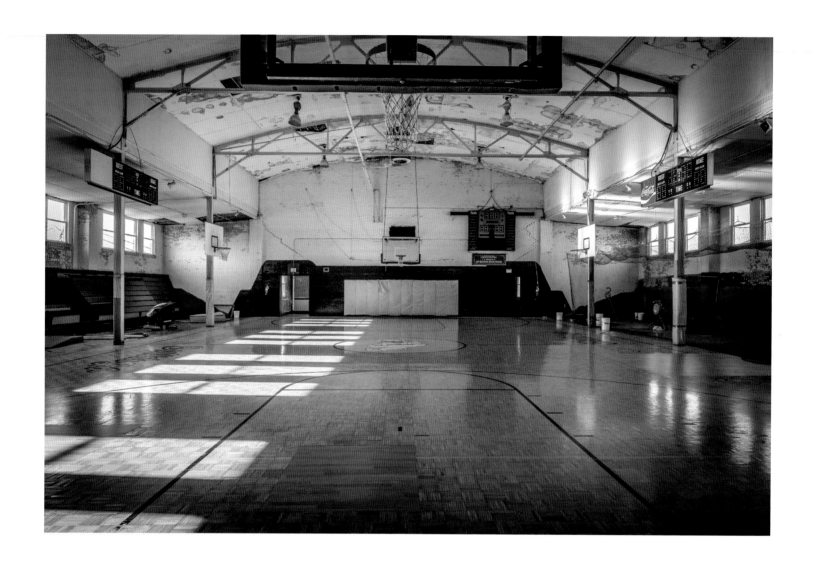

The Cannelton Community Building's gymnasium was
home court for Cannelton's Bulldogs until 1998. 2013

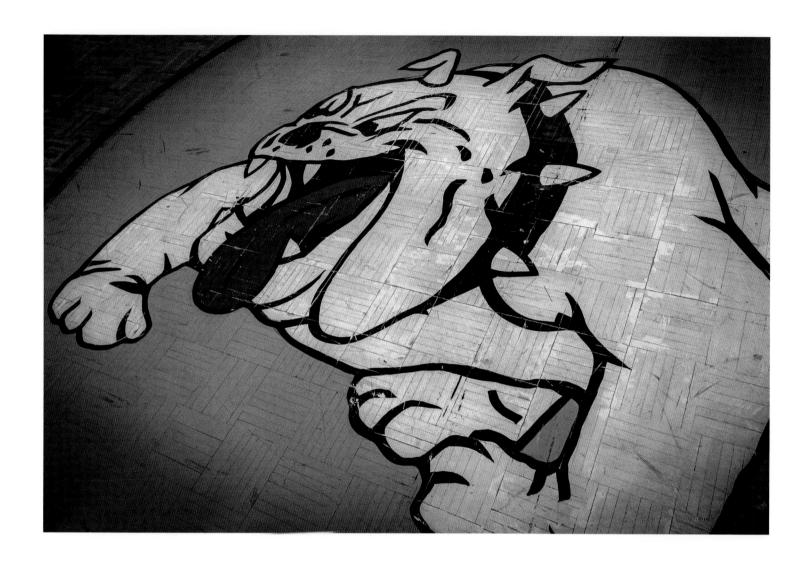

A leaking roof and the passage of time have taken
their toll on the Bulldog's center court logo. 2013

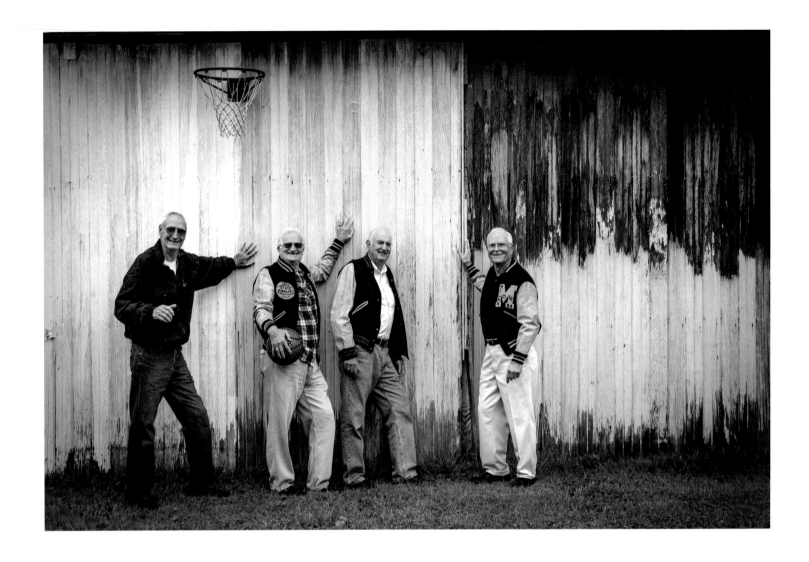

The Pierceville Alley Cats gathered for a portrait near the site where they honed their basketball skills as kids. *From left:* Glenn Butte, Bobby Plump, Gene White, and Roger Schroder were starters on the 1954 Milan High School state championship basketball team. The four, often joined by older and younger local kids, played basketball on a dirt court at the rear of Schroder's family store. A "Welcome to the Home of the Pierceville Alley Cats" sign once hung above the outdoor goal on this site. Their bond as teammates remains strong today. 2016

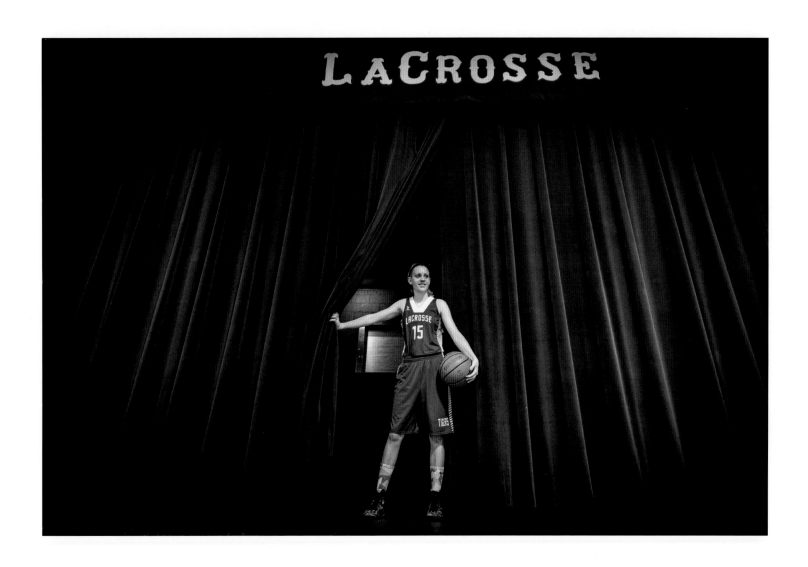

Justene Charlesworth set the LaCrosse High School
girls scoring record with 1,403 points and holds the
school record for most 3-pointers in a game, season,
and career. Considered a pure shooter, she posed
for this portrait on the gymnasium stage. 2016

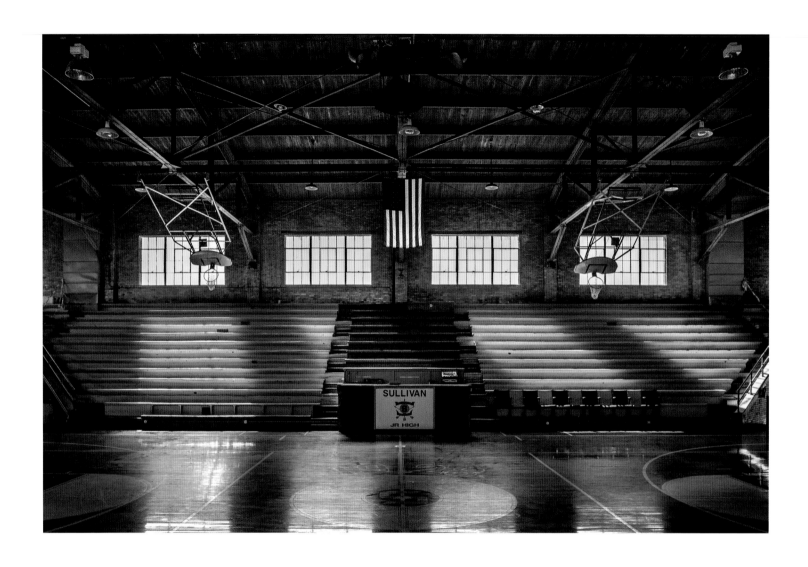

The home of the Golden Arrows, the Sullivan High School
gymnasium was built in 1928 and is now privately owned.
The gymnasium featured wooden chair seating in the first
row around the court, considered innovative at the time.
The last varsity boys' game was played there in 1991. 2018

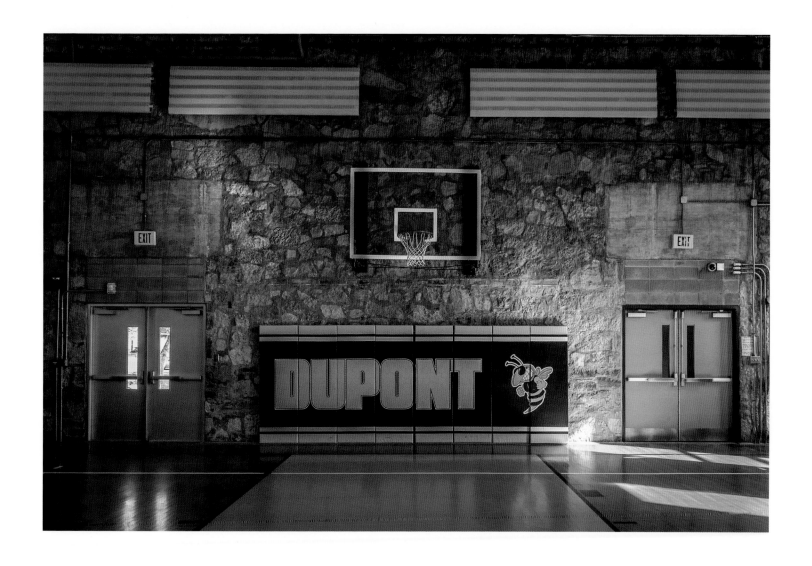

"Education—The Light of Progress" is printed above the stage curtain in Dupont's gymnasium, built in 1938. The gymnasium was first home to the Red Devils and later the Hornets. Dupont consolidated into Madison in the 1960s and then served as an elementary school until it closed in 2012. 2013

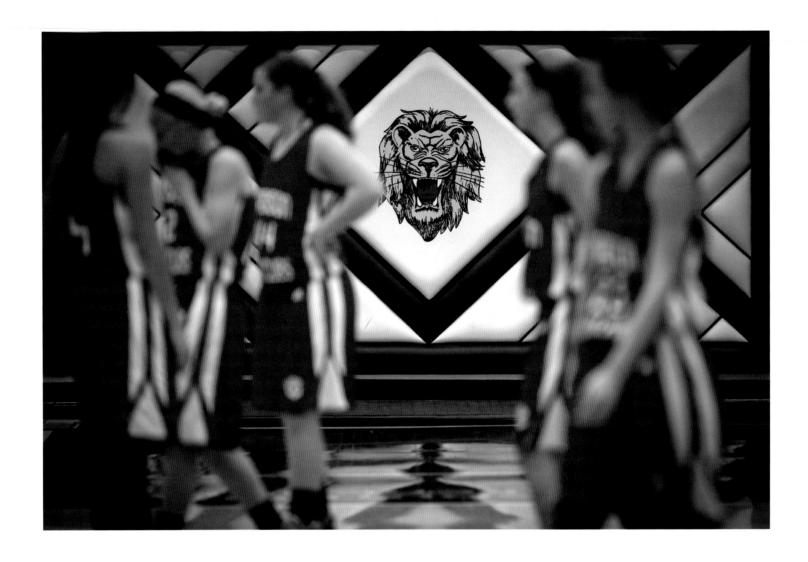

Customized gymnasium wall pads, like this one featuring the Salem Lions logo, have become the norm while adding protection for players. 2016

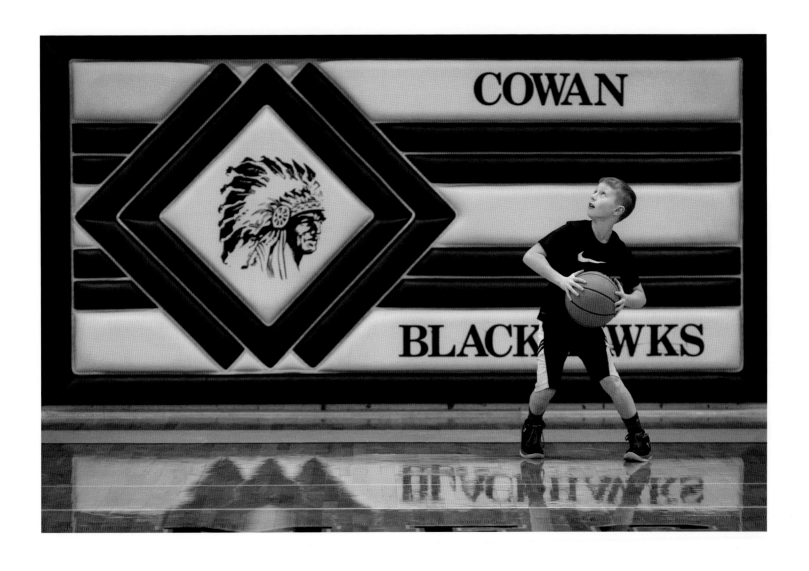

Following a game, Jesse Rumfelt, nine, a fourth-grade elementary student, gets in a few shots on the Cowan High School court. 2016

In 2013 Dugger residents packed the North Central gymnasium in Farmersburg to hear the verdict that the Northeast Sullivan School Board had voted to close the Union (Dugger) Junior/Senior High School. Consolidation was once again the answer to save a community's dying school. Begun in the 1950s, school consolidation became the norm throughout the Hoosier state as schools struggled with shrinking populations and budgets. In 1954, the year tiny Milan won a boys basketball state championship, there were more than seven hundred schools participating. By 2018, that number had shrunk to four hundred.

Dugger, like so many Indiana towns, appears as little more than a dot on most state maps. The downtown supports a diner, a bar, some light industry, a few knickknack shops, and more than a handful of empty storefronts. One downtown building houses a small industrial precision equipment shop. The people in this town are close knit, and many, like resident Johnathan Frink, feel deeply about their small school where, "teachers treat my kids like their own."

The 2014 homecoming game brought me to Dugger and the Bulldogs' court in what promised to be their last homecoming for some time. The night proved to be a

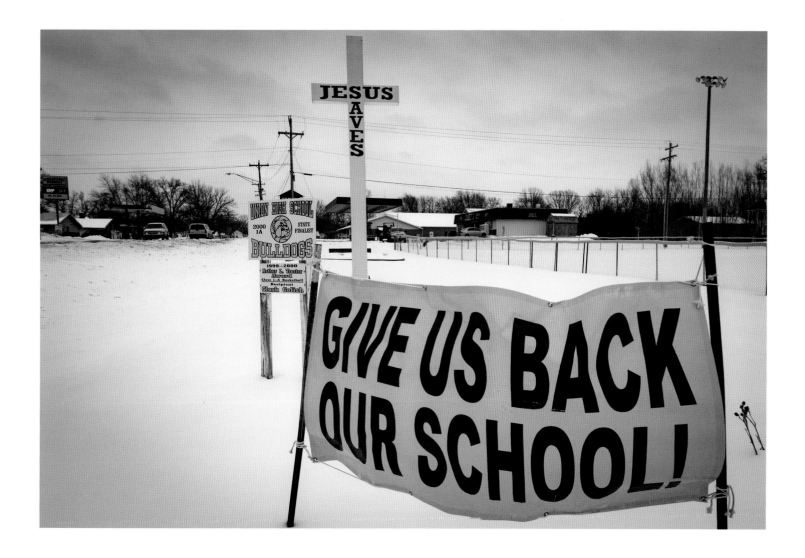

bright spot in an otherwise miserable season as the Bulldogs defeated Riverton Parke 55–41 to notch their third win of the season (they would end the 2013–14 campaign at 4–16). Frink's daughter Brooklyn and son Jesse carried the homecoming queen's crown and souvenir basketball at halftime.

The Union (Dugger) boys' basketball teams have won thirteen sectionals, two regionals, and the 1A semi-state championship in 2000, and the girls' basketball teams have won one sectional title. In 2014 the Indiana Charter School Board declined Dugger Union Community School's initial application, so the school operated as an

Indiana Cyber Charter School and did not participate in the Indiana High School Athletic Association sanctioned sports. Dugger Union has since regained membership in the IHSAA.

Left: As the crowd gathered for what might be the final homecoming game, Union (Dugger) cheerleaders stood at attention for the playing of the national anthem, Dugger, 2013

Right: Dugger residents rallied support in the community in an effort to avoid a consolidation that would close their community schools. 2013

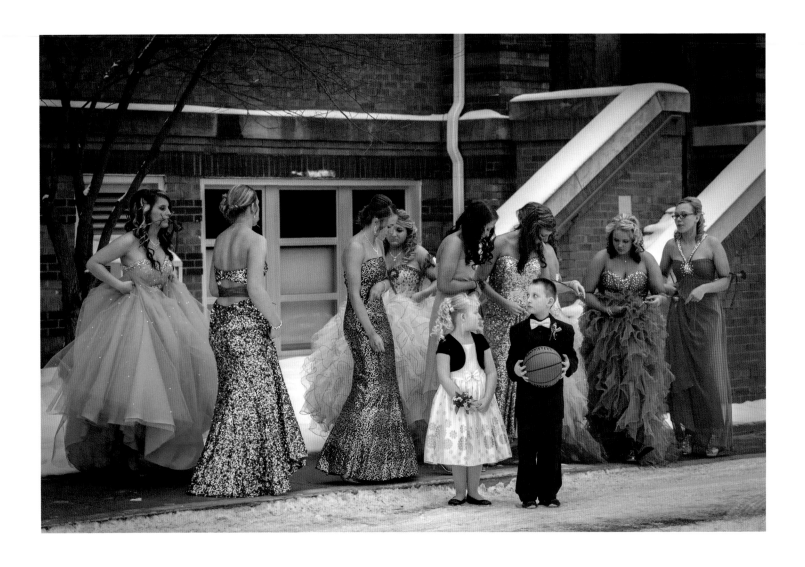

Union (Dugger) High School's 2013 Homecoming Court
gathered for a group photograph dressed in vivid colors.
Brooklyn and Jesse Frink, Little Miss and Mr. Basketball,
watched as the group took their positions. 2013

Dugger shares a kinship with many rural Indiana towns
that have struggled to maintain their community schools
and remain vibrant in uncertain economic times. 2013

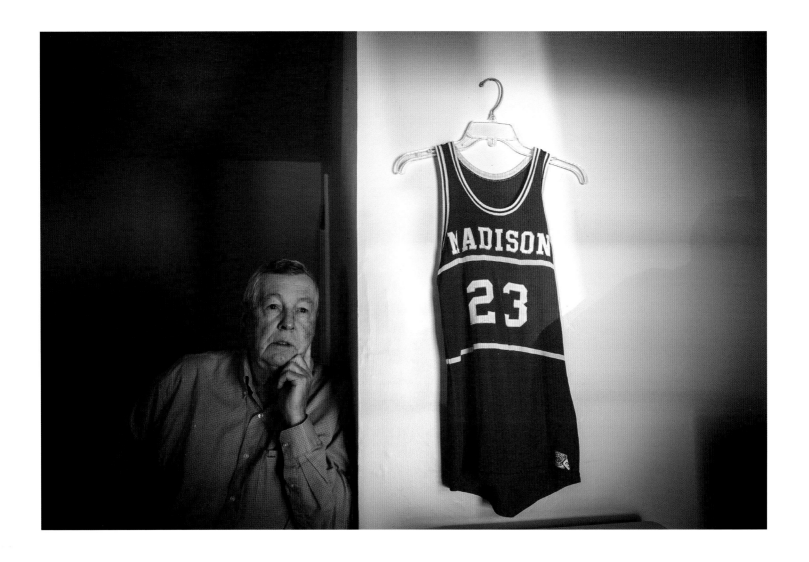

Harold "Pee Wee" Lakeman from Madison possesses
encyclopedic knowledge of Indiana high school basketball—
he's like a living "Google search" when it comes to Madison
Cubs history. His high school jersey from a trip to the Final
Four and his photograph collection are treasures. 2013

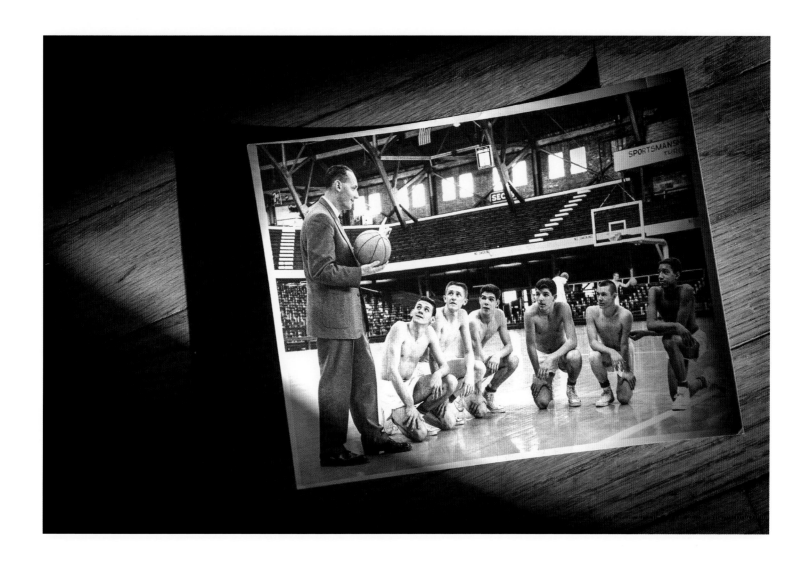

A photograph from Lakeman's collection shows Madison
Cubs head coach Julius "Bud" Ritter, an Indiana Basketball
Hall of Fame member, talking with his team in Hinkle
Fieldhouse. Lakeman is second from the right. 2013

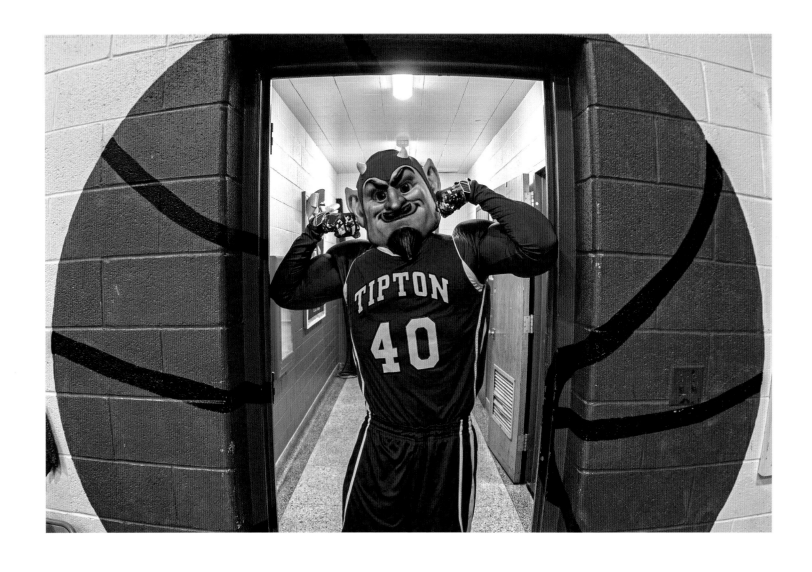

A Blue Devil mascot stands in a doorway painted in a basketball motif inside the gymnasium at Tipton High School. Nicknamed the Inferno and featuring two levels of seating, the gymnasium can hold three thousand Blue Devil fans, who can really heat up the place on a cold winter evening. 2020

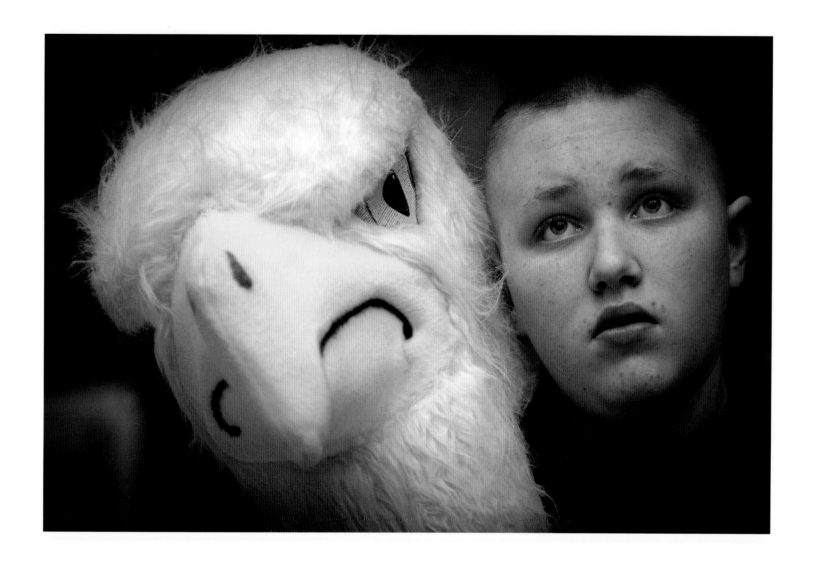

A Jac-Cen-Del student rests his Eagles mascot head on his shoulder as he watches the closing seconds of a girls' semi-state tournament game. The Eagles lost to Vincennes Rivet, the eventual state champion. 2011

Now called the Star Financial Coliseum, this venue was the
home of the Marion Giants until 1970. A banner touting the
Giants' accomplishments hangs next to the US flag. The
YMCA of Grant County in Marion operates the facility. 2017

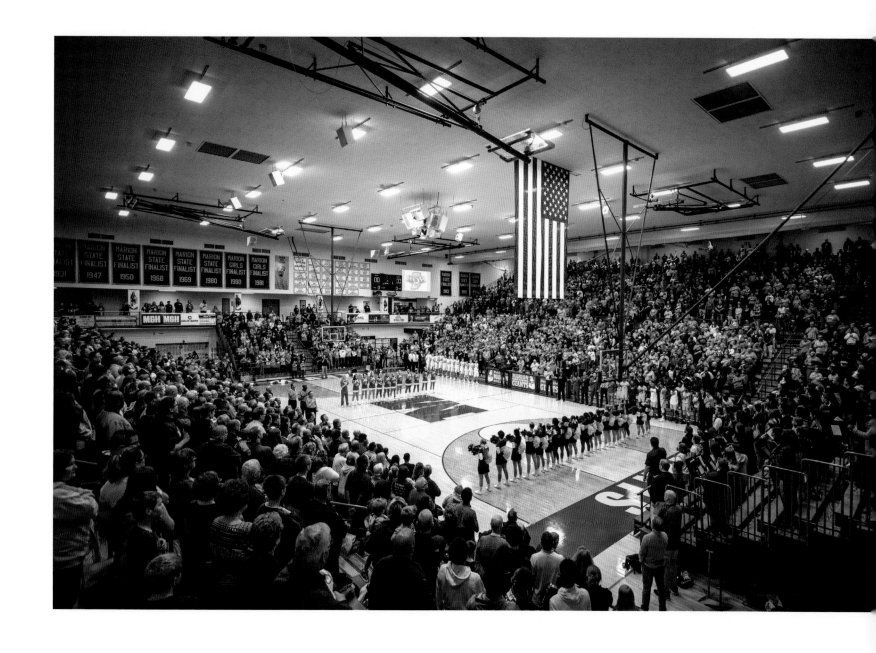

The Marion Giants' home court since 1970 is among the state's largest gymnasiums, with a seating capacity over 7,500. A sellout crowd stands for the national anthem prior to a New Castle–Marion basketball game, 2018

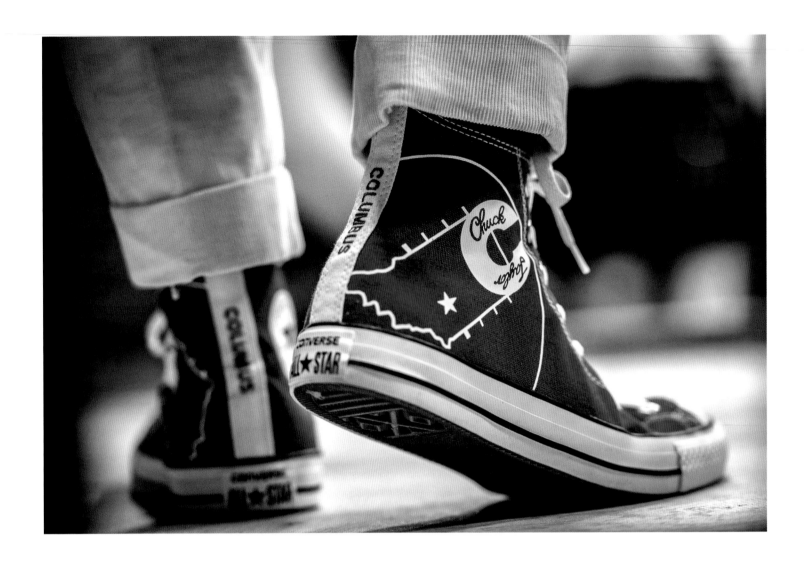

These special edition Chuck Taylor All Stars, the iconic
basketball shoe known simply as "Chucks," were designed
to honor the Columbus North versus Columbus East rivalry.
Columbus North fans were treated to blue Chucks and
Columbus East received orange shoes. Chuck Taylor,
a Columbus native, was a basketball player and successful
salesman for Converse, now a subsidiary of Nike. 2013

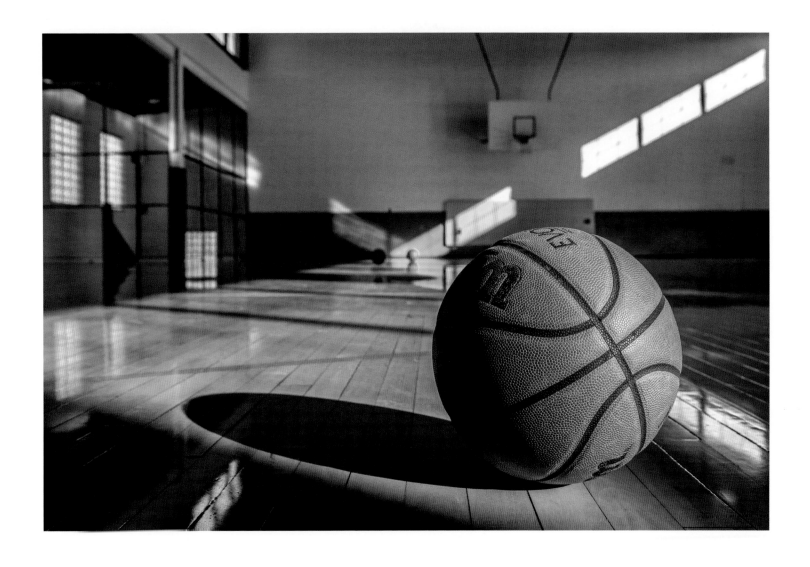

Late afternoon light shines in through the windows of the Madison Armory. The gymnasium is now used as a sports practice facility for Shawe Memorial Junior/Senior High School. The building's second floor gymnasium was used by area high schools in the wake of the 1937 Ohio River flood when nearby basketball facilities were filled with floodwater. 2013

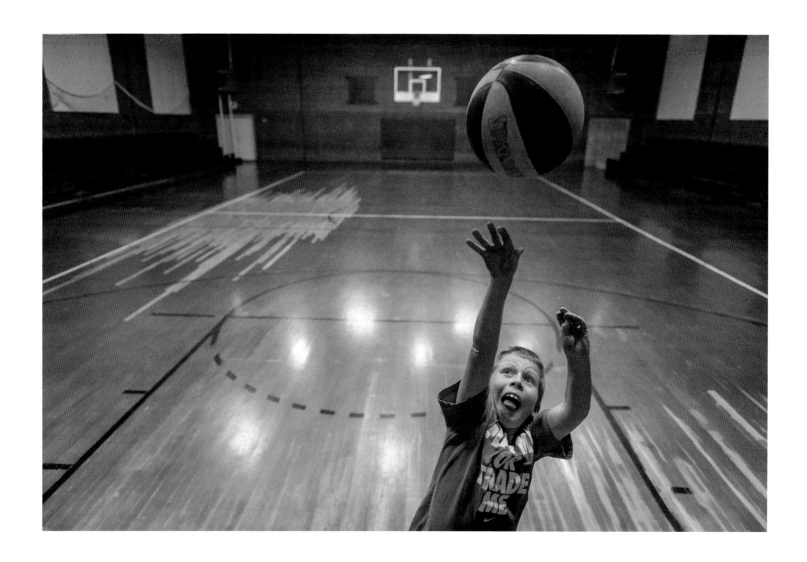

Brady Lamb shoots the ball in the old Vernon High School gymnasium in Vernon. Lamb's grandfather, Jerry Lamb, played high school basketball on the same floor for the Vernon Blue Devils in 1963. The facility is now a community center. 2013

A Vernon High School athletic letter
and Blue Devils logo photographed on
the gymnasium's hardwood floor. 2013

The façade of the Linton-Stockton High
School gymnasium, built in 1938. 2018

The façade of South Bend's Washington High School
gymnasium. The school opened in a new facility in 1960. 2018

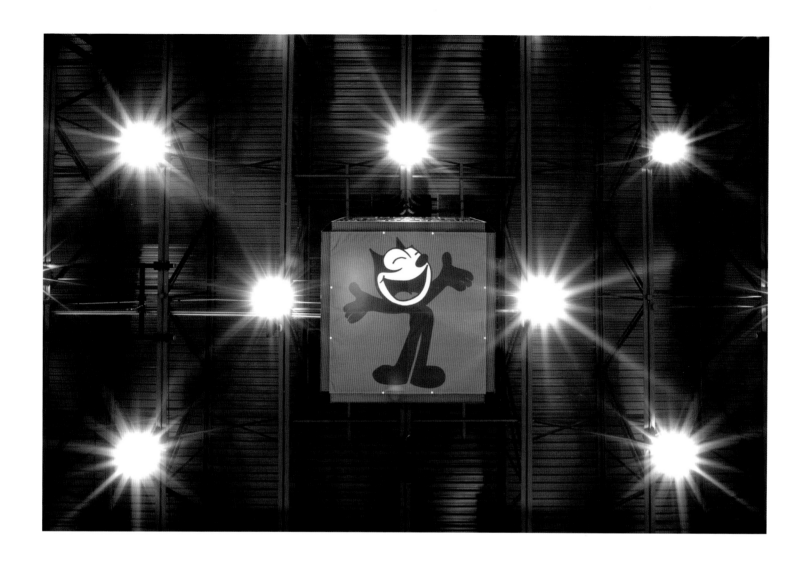

Logansport's Felix the Cat is the oldest recognized high school mascot in Indiana. The school's website explains: "The date was March 31, 1926, and members of the Logansport High School basketball team, on their way to a postseason banquet, spotted a small stuffed cat made of oilcloth in a store window. This replica of Felix the Cat was in Logansport's school colors, red and black, and immediately won the admiration of the team. Coach Cliff Wells purchased it right then and there." 2016

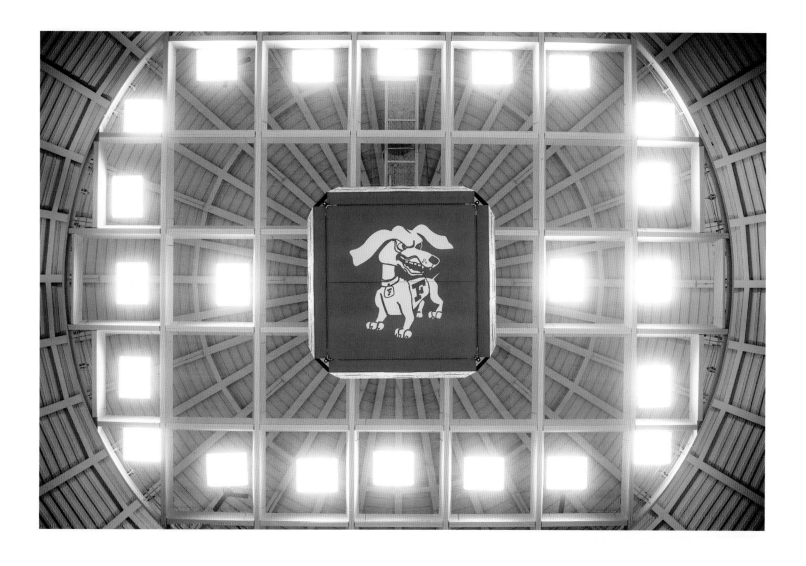

The Hot Dog mascot from Frankfort High School was designed by Joe Sneathen and has been used by the school since the 1960s. *ESPN the Magazine* called it the cleverest nickname in sport. Indiana, it seems, does have some unique mascot names, including the Jimtown Jimmies, Cory Apple Boys, Tell City Marksmen, and Speedway Sparkplugs. 2016

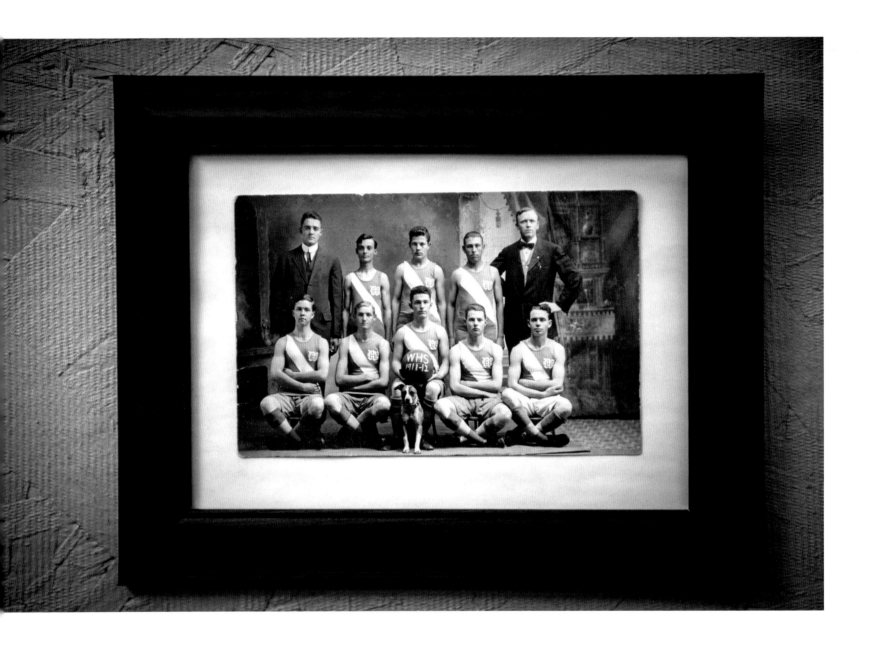

This team scored 162 points in a game! During a time when
teams had a center jump after each basket Warren High
School's Lightning 5 routed rival Converse 162–4. The game
details were authenticated by Indiana Basketball Hall of Fame
researchers. That 1911–12 team posted a record of 20–4. 2016

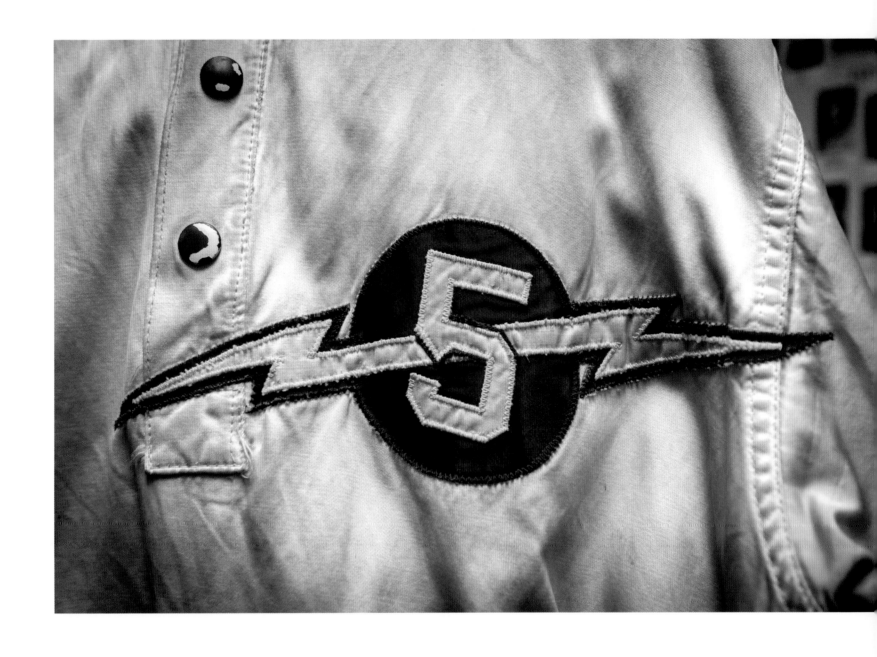

This Lightning 5 warm-up jacket is featured
in a collection of memorabilia at the Knight
Bergman Center in Warren. 2016

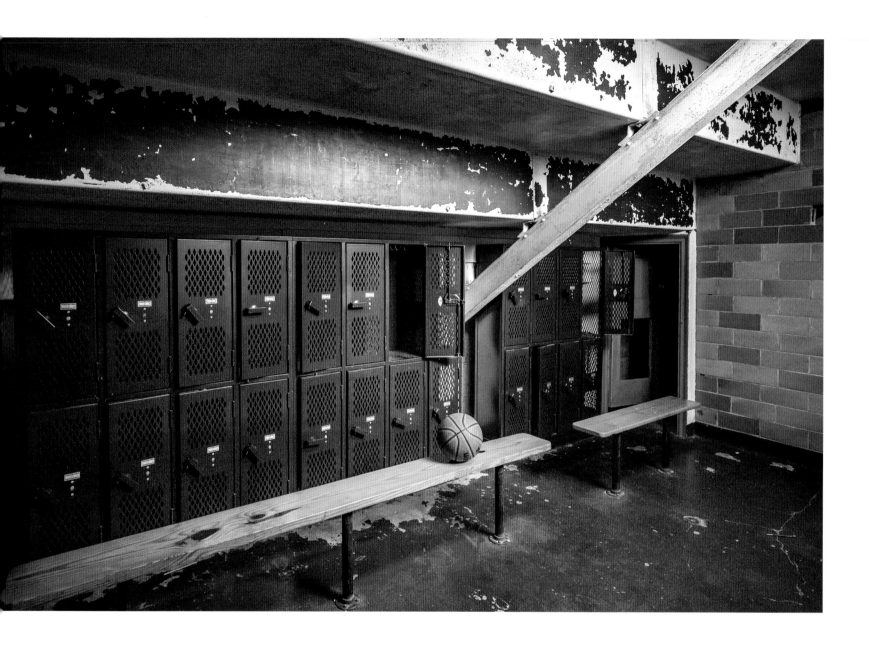

The Spiceland High School locker room was a true find as we pursued
stories about Indiana's high school gymnasiums. Simple instructions
from Richard Radcliffe, an Indiana historian, to "take a left off SR 9 at
the Phillips 66 Station in Spiceland," led us to the gym that was built
in the post–Depression era by the Works Progress Administration.
The gym was at one time home to the Quakers, then the Yellow
Jackets, and later the Stingers. Indiana lore purports that a sports
scribe in New Castle tired of writing the words "Yellow Jackets" in his
reports on Spiceland athletics and simply began calling the team the
Stingers. The school eventually adopted the nickname. 2016

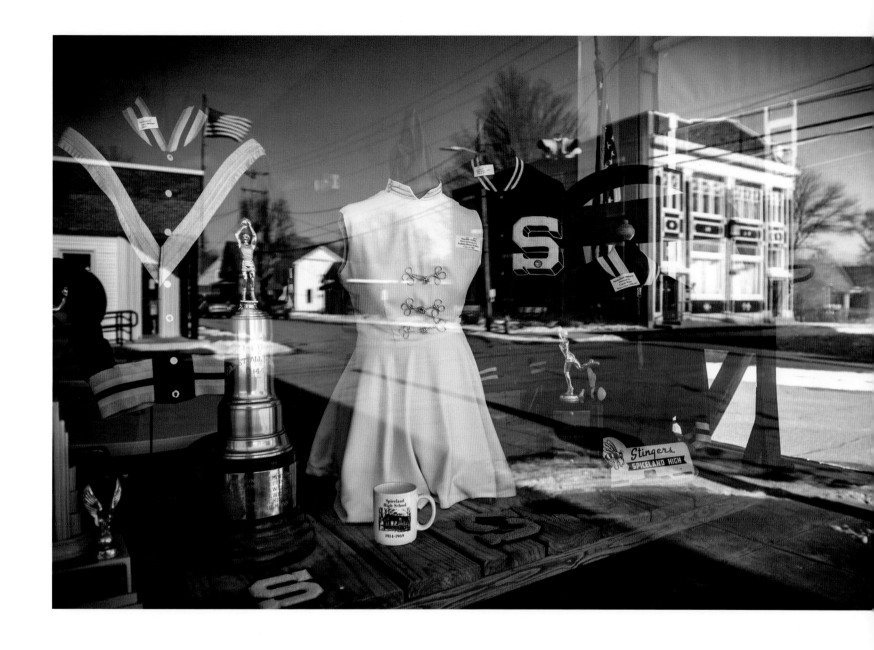

A glass storefront displaying a collection of
Spiceland High School memorabilia reflects
the Spiceland business district. 2016

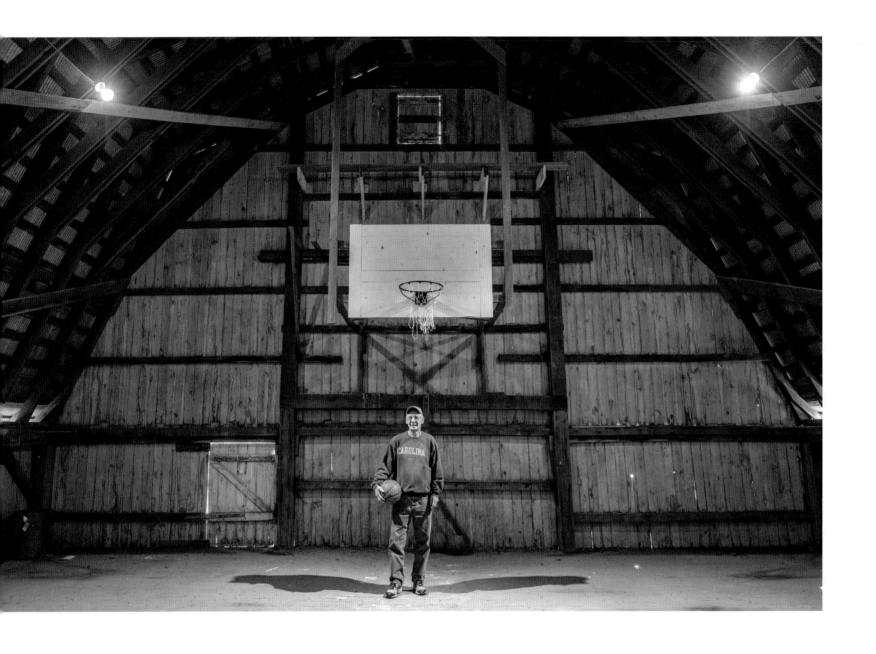

Welcome to Mr. Walker's barn in Gentryville. Steve Walker's
father, Dick Walker, built the barn's second-level basketball
court in the 1950s. Steve Walker said, "The barn is where
we learned not to whine and simply play the game." 2018

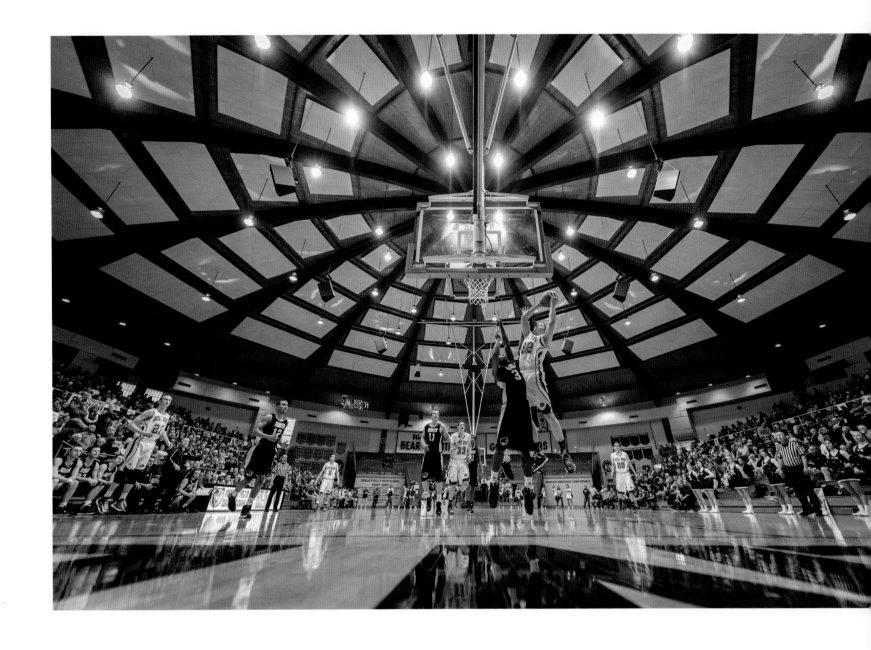

Shelbyville's gymnasium is named for William Garrett,
who led Shelbyville to the state championship in 1947, was
named Indiana Mr. Basketball, and became the first African
American to play on Indiana University's basketball team.
The William L. Garrett Memorial Gymnasium features an
intricate patterned wood dome and seats 5,800. 2014

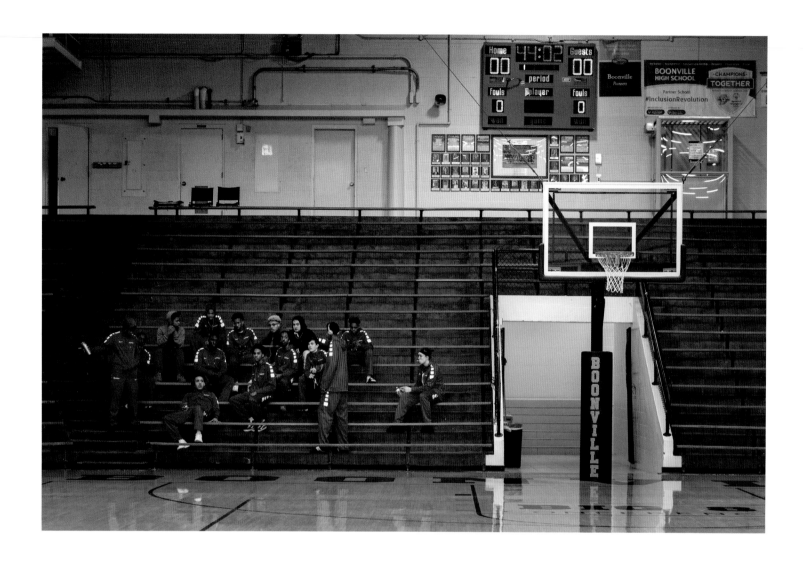

Evansville Bosse Bulldog players wait in the stands
at Boonville High School prior to the sectional
championship game in which Bosse beat Reitz Memorial
High School and moved on to the regionals. 2018

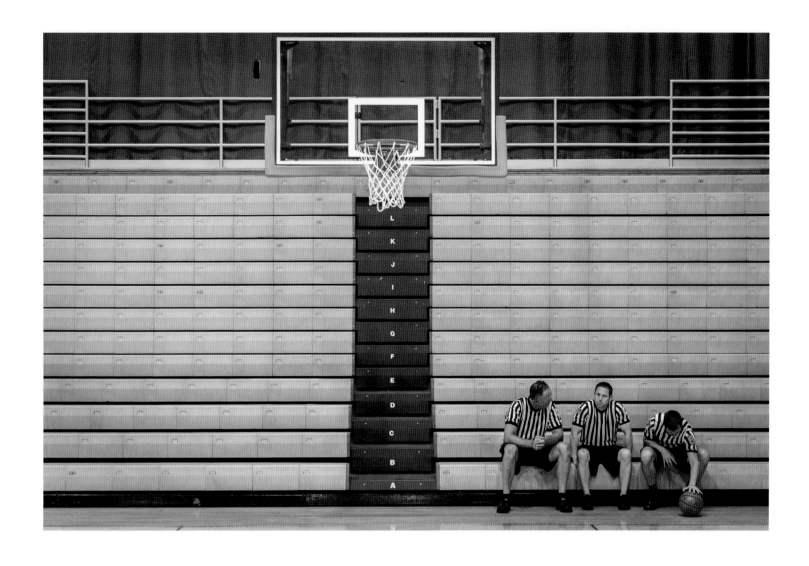

Referees wait for scrimmages to begin at Indianapolis Ben
Davis High School's summer basketball camp. 2015

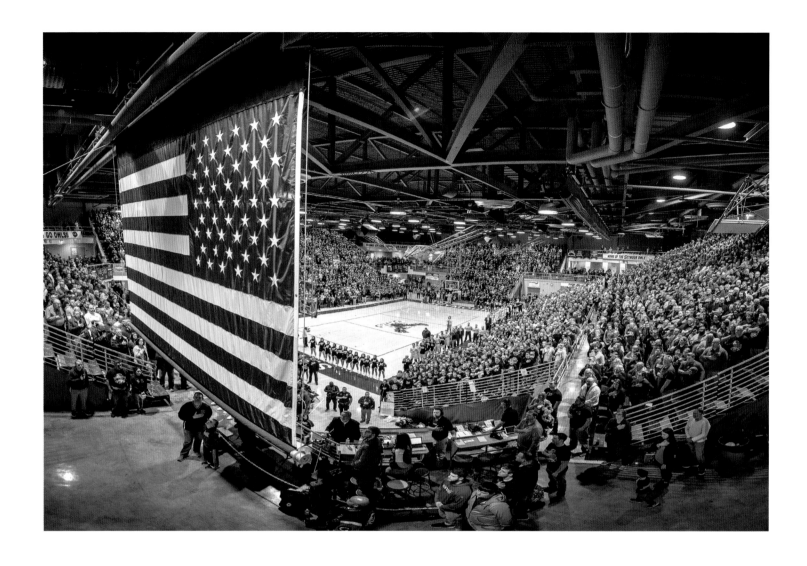

A sellout crowd of over eight thousand packed Seymour's
Lloyd E. Scott Gymnasium to watch the semi-state
championship games. Morristown dispatched Barr-
Reeve in the opener, and Warren Central, en route
to a 4A state championship, sent Indiana University
recruit Romeo Langford and his New Albany team
home with a last-second shot to win 64–62. 2018

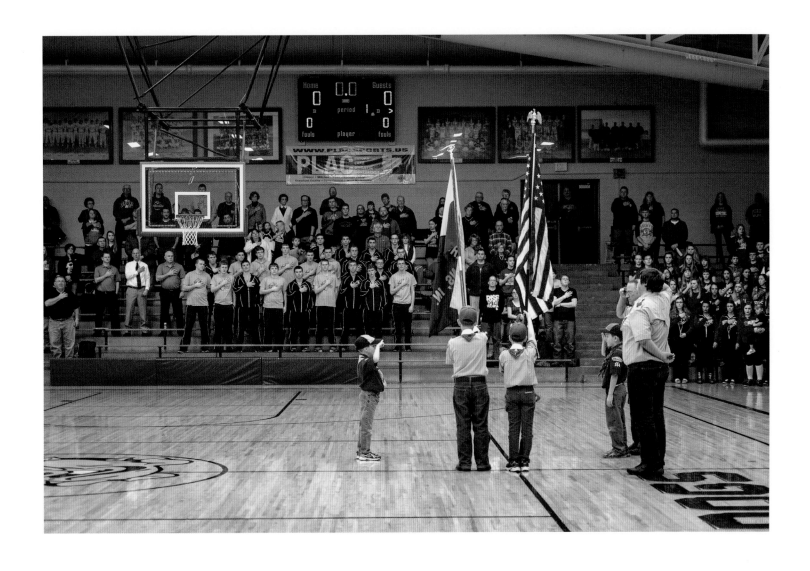

Loyal scouts present the colors before a 1A
sectional game at Orleans. 2014

The 2017 4A sectional title game between the Connersville Spartans and the New Castle Trojans had all of the makings of a great Indiana high school basketball tournament story. Longtime rivals, the matchup saw what could be their last tournament head-to-head meeting as New Castle was moving down in class for the 2018 season.

Historically, the two towns are linked because of their industrial heritage. Auburn, Cord, and Duesenberg all built cars in Connersville, and during World War II the iconic Willys Jeep rolled off Connersville manufacturing lines. Before selling out to Chrysler, the Maxwell Automobile Factory in New Castle was one of the largest in the country. Less than twenty-five miles apart, the small boomtowns with deep civic pride are natural rivals.

The competitive spirit has touched many aspects of each community, but none more so than their gymnasiums. Both fieldhouses are sunken gyms designed by Evansville architect Ralph E. Legeman. Connersville's Spartan Bowl seats nearly six thousand. Not to be outdone, New Castle spared no expense in building "The Largest and Finest High School Fieldhouse in the World" (or so they claim on one of the interior walls), seating more than nine thousand. Both schools have won scores

of sectional titles, and, more importantly, they both have won two state championships.

March 4, 2017, saw nearly eight thousand fans decked out in green (New Castle) and red (Connersville) pack the New Castle fieldhouse to settle this tournament rivalry for what could be the last time. Expectations ran high on both sides, perhaps remembering the close game earlier in the season when Connersville won in overtime, 52–51. But on this night, the Trojans were again out-matched, 59–44, allowing the Spartans to move on to the regional. The game may have been summed up best by Connersville senior Grant Smith's celebration at the top of the key—a clenched fist guttural scream leaving none in attendance with any doubt who had claimed the title.

On our journey across Indiana, we have seen what this sport has brought to communities, and we have seen folks support their schools in good times and bad. As it has done for more than one hundred years, Hoosier high school basketball has not only given people a place to go on Friday and Saturday nights, it has offered them a dis-traction when times are difficult. Maybe Connersville su-perintendent Scott Collins said it best, "Our town needed this team, as we've been through some rough times."

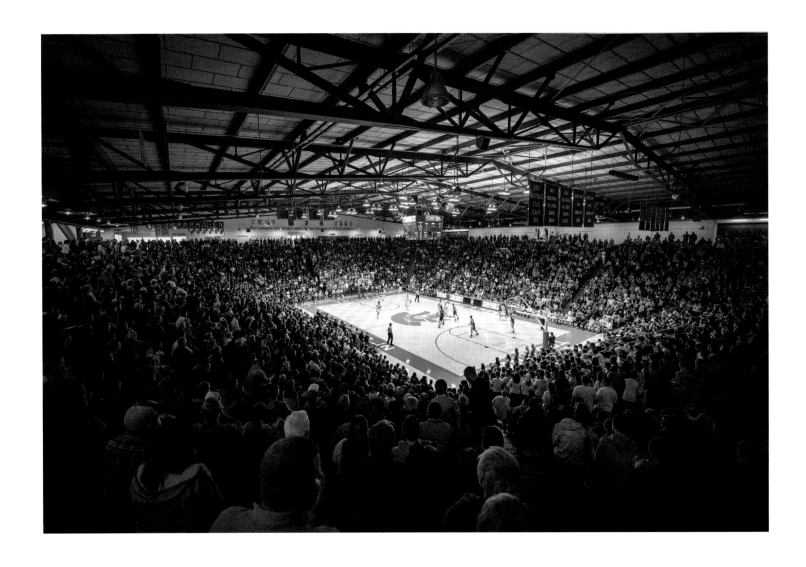

Page 140: Fans, players, coaches, and officials stand for the national anthem as Indiana's game took center stage in New Castle for the 2017 4A sectional championship. 2017

Page 141: All eyes are on the ball as fans in red and green watch the center jump between New Castle and Connersville. 2017

The Ralph Legeman designed New Castle gymnasium was packed with fans of Indiana's game as Connersville and New Castle battled for a sectional championship in 2017.

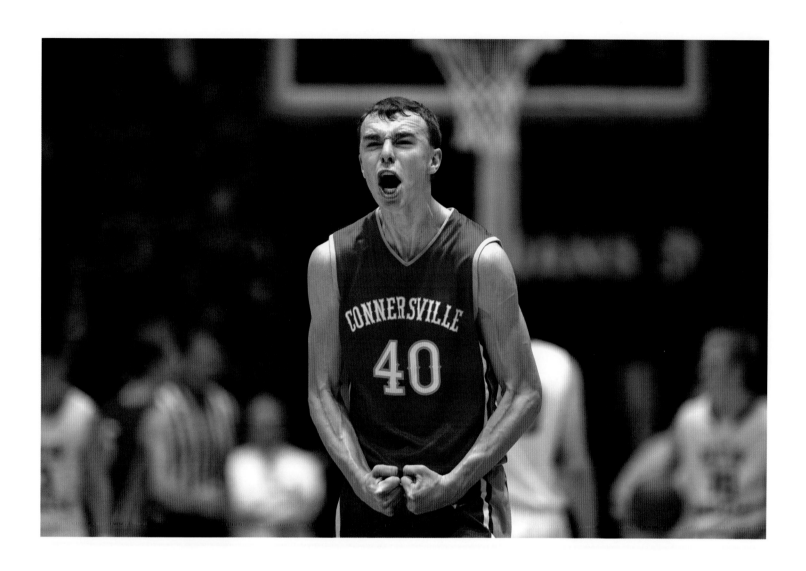

Connersville's Grant Smith celebrates the 59–44 win. 2017

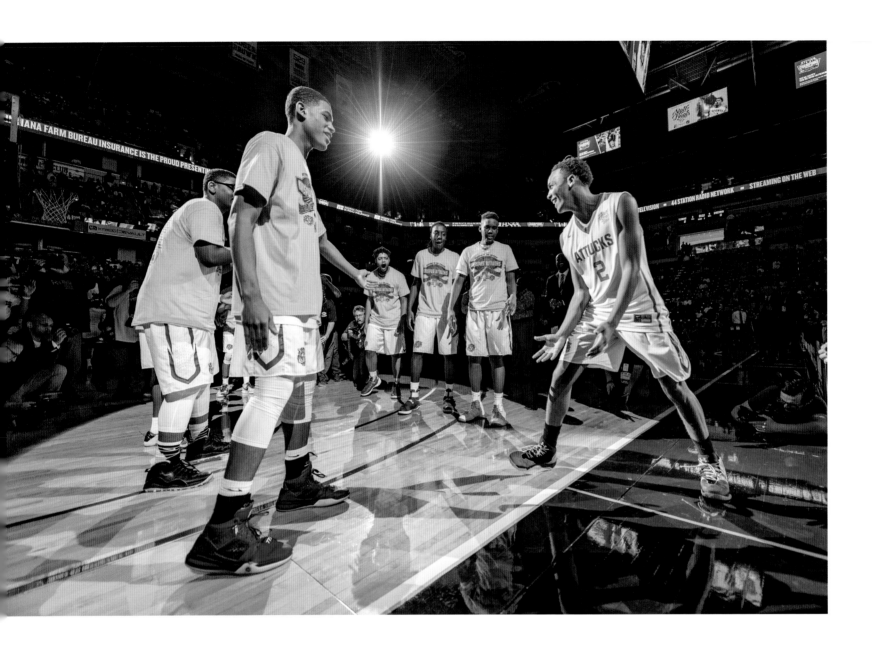

It took fifty-eight years for Indianapolis Crispus Attucks to return to a state championship game on Indiana high school basketball's biggest stage. Introductions of the teams took on the visual hype usually reserved for the professional Indiana Pacers who call Banker's Life Fieldhouse home. 2017

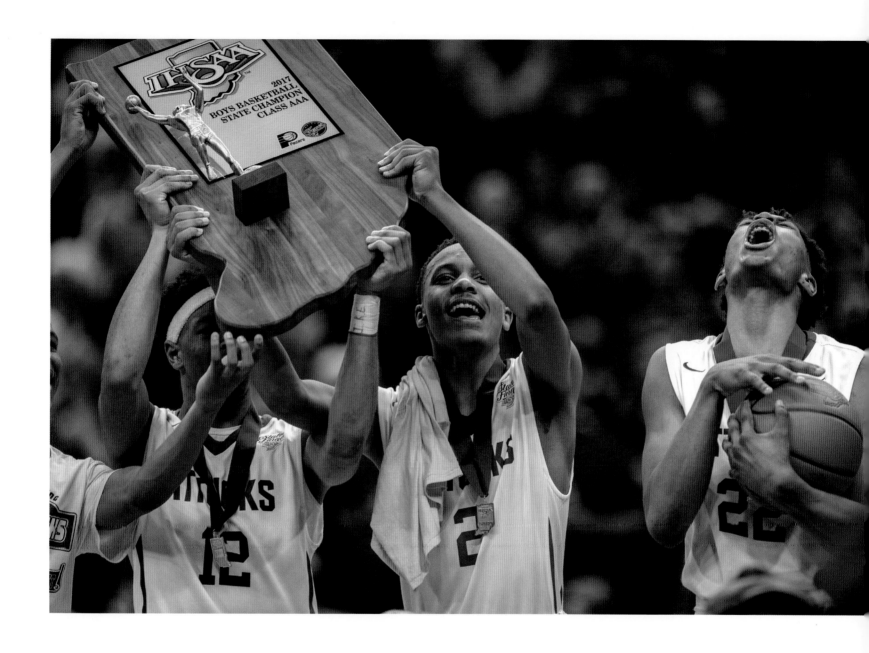

Celebrating on the podium with the State Championship trophy, players' emotions ran the gamut. The 73–71 win over Twin Lakes was capped off moments earlier when basketball legend and back-to-back Attucks state championship winner Oscar Robertson placed the championship medals over the heads of each player. 2017

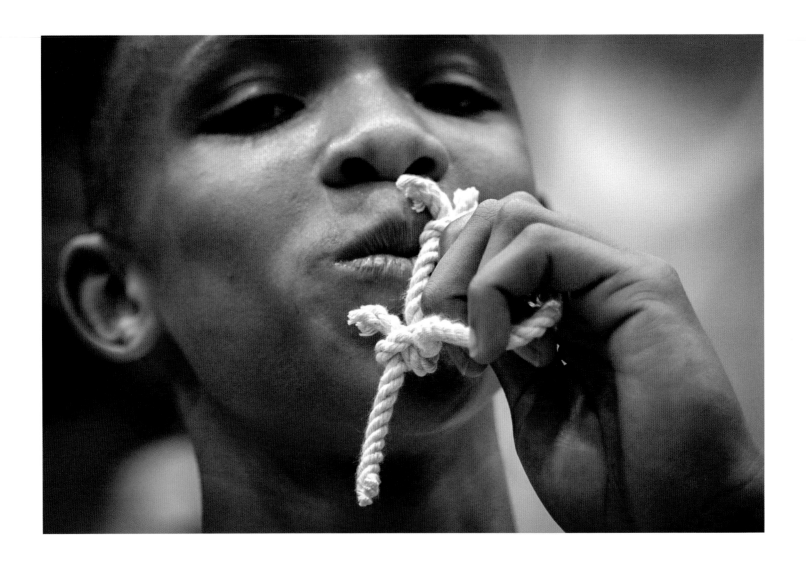

Nothing is as sweet as a snippet of
regional championship twine and a
46–45 win for Bloomington North. 2015

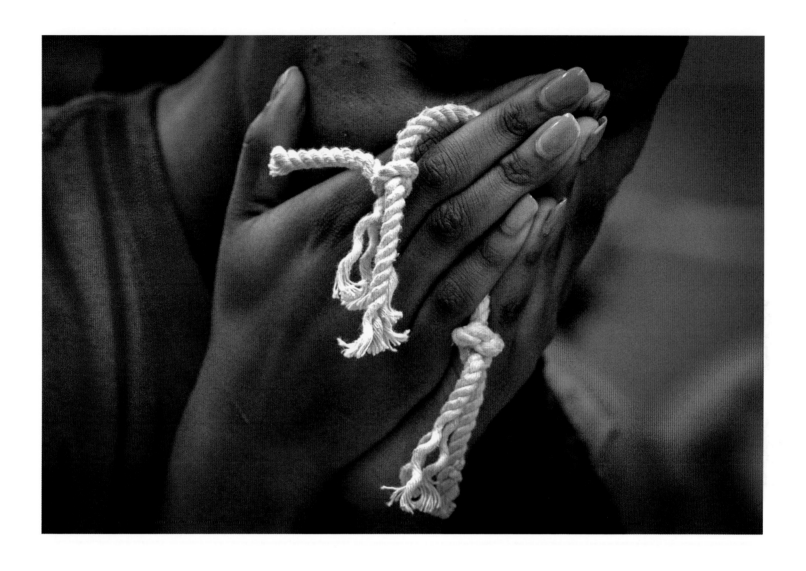

Holding a piece of the sectional championship net,
this Liberty Christian player is overcome with emotion
after a 29–25 victory over Southern Wells. 2016

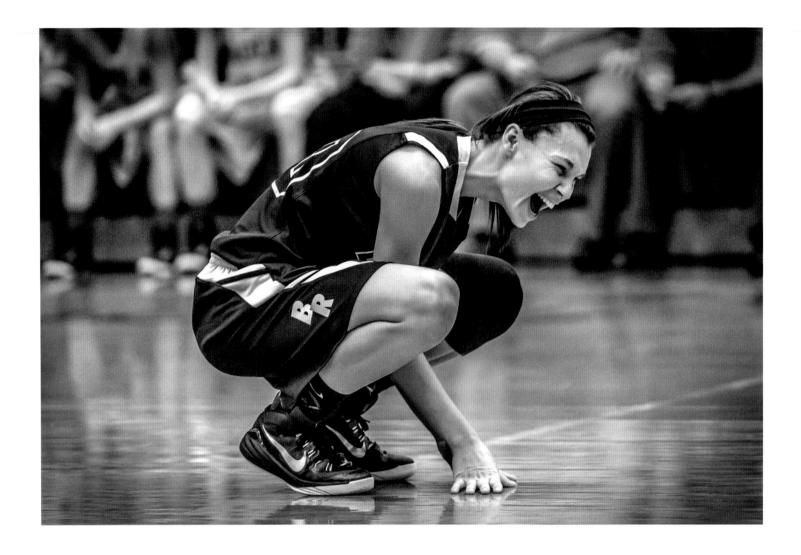

Over the course of this project and the many games attended I have witnessed exciting finishes, improbable storylines, and, much to my delight, a vast array of emotions. I have seen unexpressive game faces transformed into wide smiles, jubilation, and pride. On the other hand I have also been there when those faces became masks of utter despair.

The joy as the buzzer sounds and a Barr-Reeve player knows victory; the instant Fort Wayne Canterbury's team, coaches, and fans stand in unison, their mouths agape in disbelief, as a referee's call dramatically changes the game's outcome—with one click of the camera a scene is frozen. These are the moments within the minutes of Indiana's game.

But, as we have also seen, emotions are wrapped up in memories taking many forms. Gymnasiums, auditoriums, and fieldhouses are inanimate objects. Some are shrouded in antiquity and simple in design; others are showplaces inspiring wonder and awe. Each one is the pride of their community, and each one represents an emotional tie to the people and events that occur there. People love their gyms, exalt in their being, and ultimately mourn their loss when a structure succumbs to the passage of time or economic realities.

Left: In the moment the semi-state championship in Jeffersonville is secured, Barr-Reeve's Olivia Carroll replaces a somber game face with a wide smile. 2015

Right: Forest Park fans were stunned as their Rangers lost a lead in the second half and a chance for a sectional championship at Huntingburg's Memorial Gymnasium. 2015

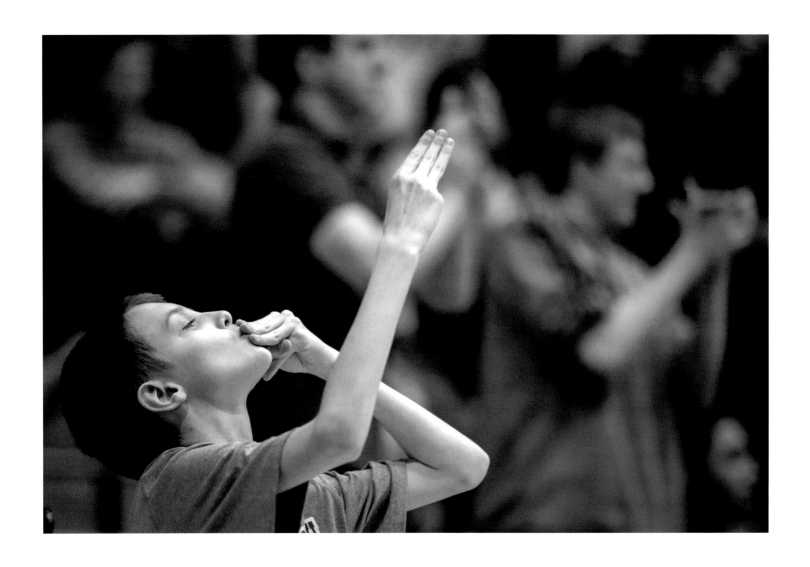

Mason Elkins, twelve, blows a kiss and signals a 3-point
goal in a sectional championship win in Shelbyville.
His sideline gestures are an addition to his regular
duties as assistant to the student managers. 2014

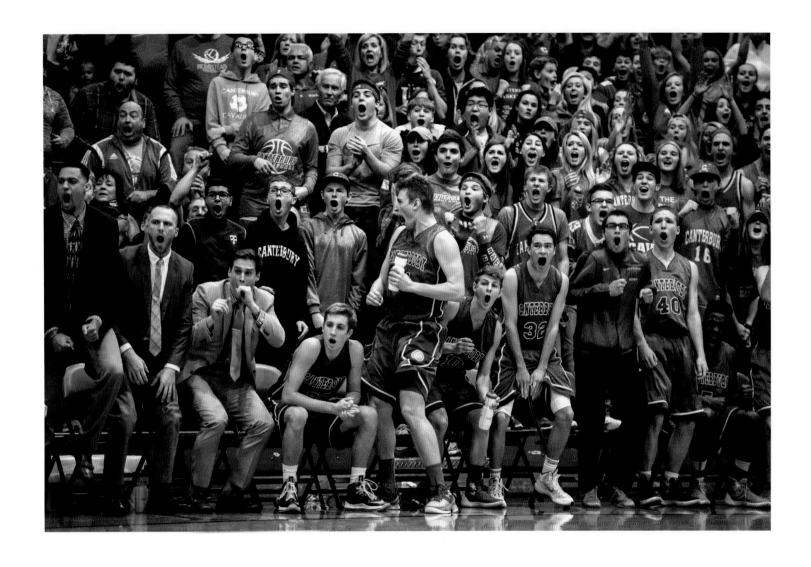

The Fort Wayne Canterbury bench and cheer block react to an official's call late in their semi-state loss to Lapel at Huntington North. 2016

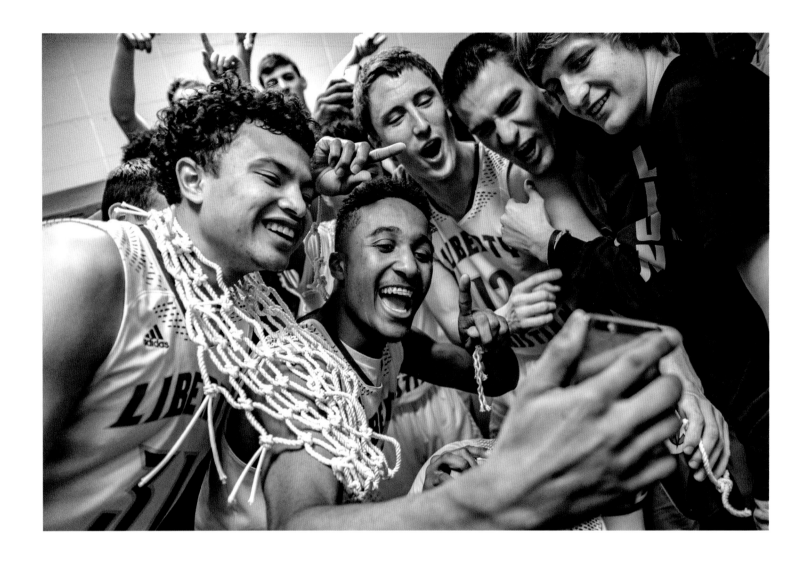

Liberty Christian players gather for a selfie in the locker room
after their 103–80 semi-state win in Huntington. 2016

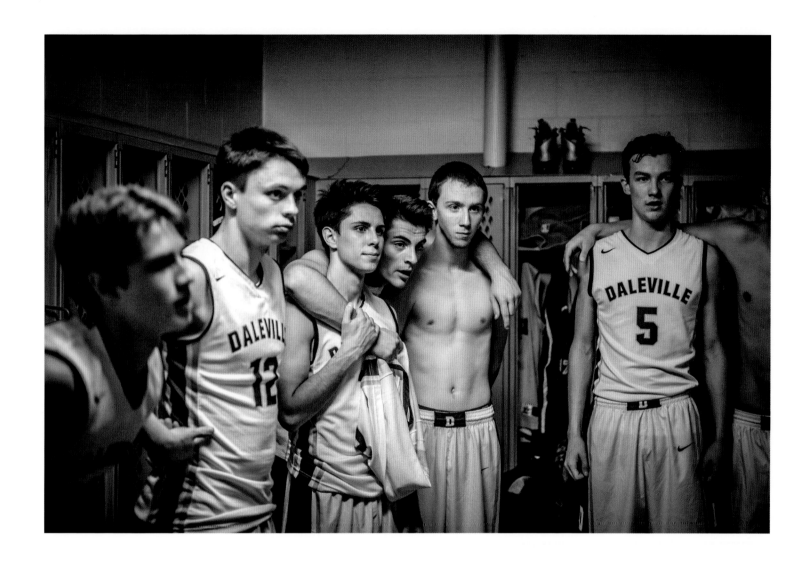

Daleville Broncos teammates listen to head coach
Dale Hanson's postgame speech following a home-
court regular season win over Tri High. 2016

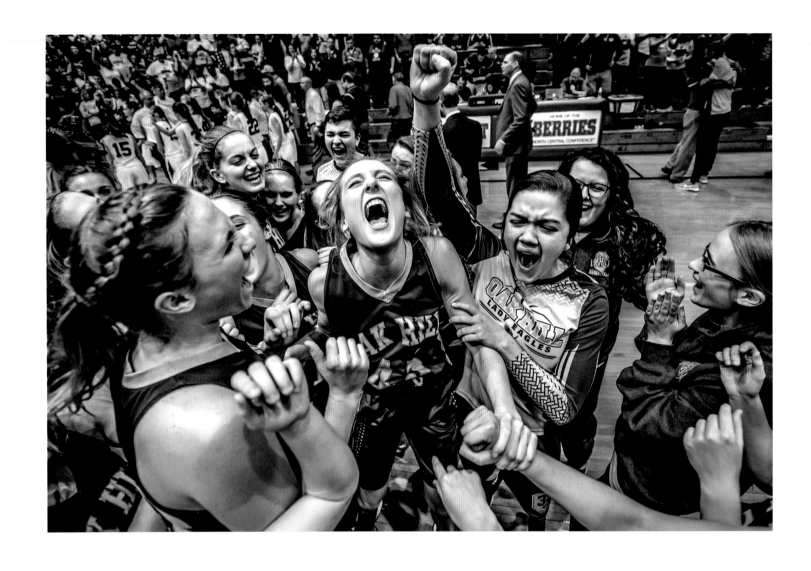

Oak Hill players celebrate their semi-state championship
win at the Berry Bowl in Logansport. 2017

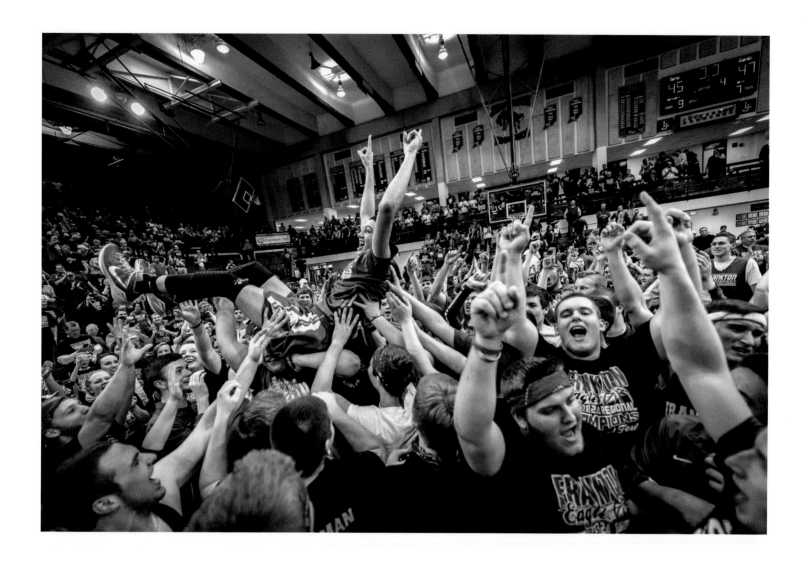

Frankton High School players and fans celebrate a semi-state
championship hosted by Lafayette Jefferson High School. The
Marion Crawley Athletic Center is home to the Bronchos. 2015

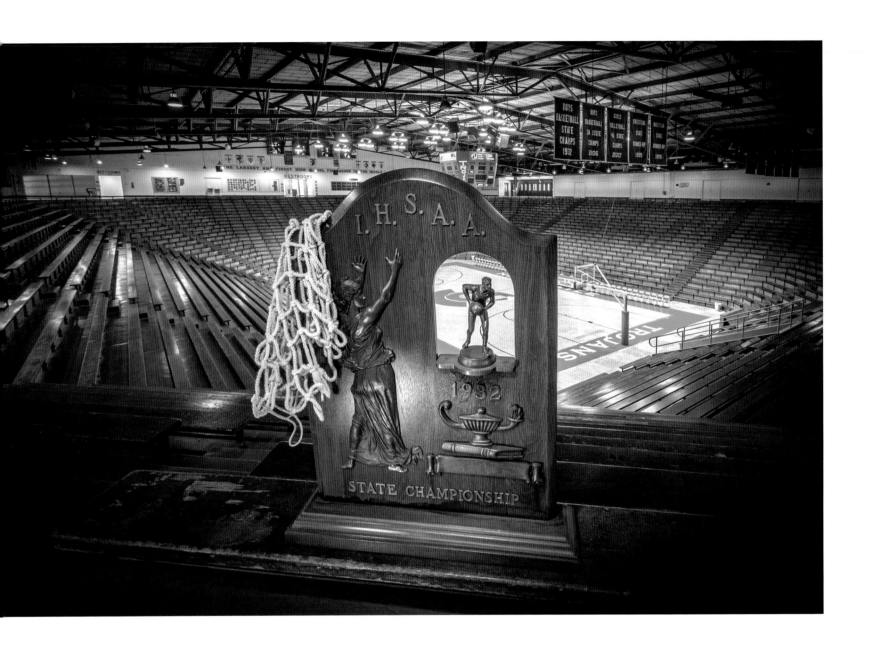

New Castle's Trojans won their first boys state
basketball championship in 1932 and they would
claim their second state title in 2006. 2015

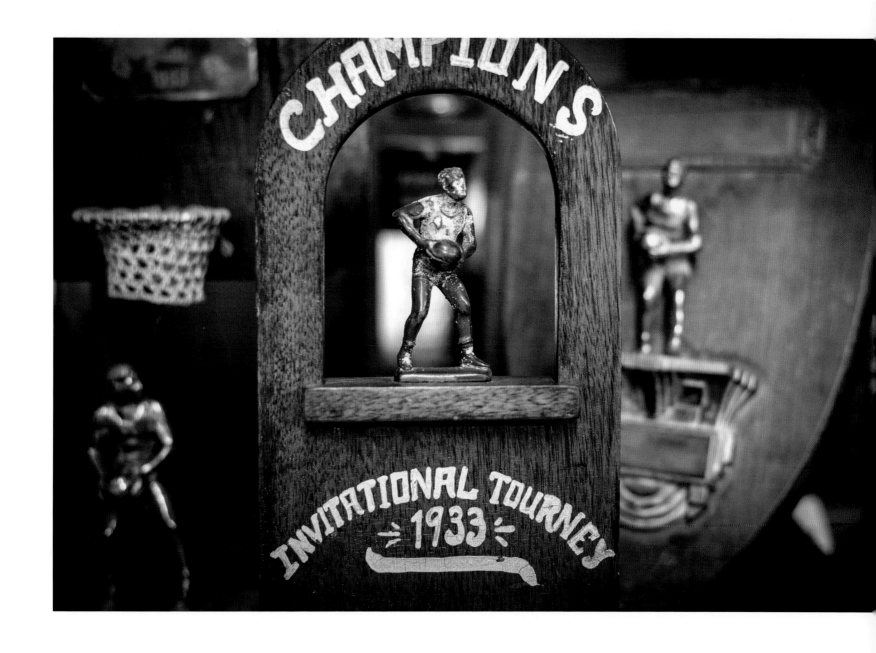

This hand-crafted 1933 trophy in a Michigantown gymnasium
collection shows the extent to which an industrious and
imaginative basketball fan will go in creating a memorable
reward for accomplishment. The creator no doubt took
design cues from the 1932 state championship trophy. 2016

Eminence Eel student fans become the gymnasium
cleaning crew following home games. The students take
on the job to earn money for their school prom. 2015

The Rushville Memorial Gymnasium was built in 1926 and is among the oldest gymnasiums used for high school basketball games. 2014

The vintage scoreboard hanging inside the restored
Pleasantville Gymnasium, built in 1956, is one of many
finishing touches Pleasantville native Lonnie Todd has
overseen with his restoration efforts. "We just want to make
the place like it used to be—a nice place for kids to come
and play ball," said Todd, "Just like we did as kids." 2017

Loogootee's John F. Kennedy Gymnasium is where
Indiana Basketball Hall of Fame member Jack Butcher
began his high school coaching career and has been
the venue for many of his 806 career wins. 2014

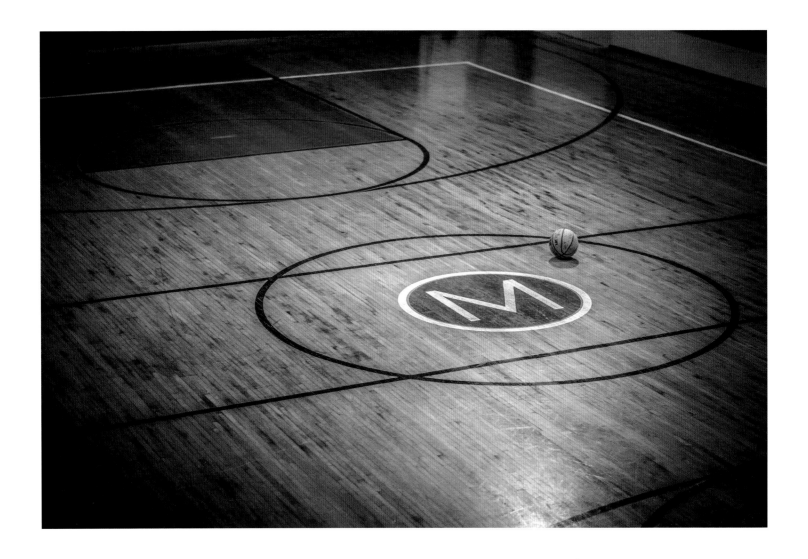

The well-preserved maple floor of the Mount Olympus gymnasium, built in 1939, seems to proudly carry the scars of battle over the years. As a basketball team their high water mark took place in 1929 when they finished the regular season 23–0 as Gibson County tourney champs. The team played regular season games in the school basement during that season. They would go on to win three more games to claim the Owensville sectional title and carry a 26–0 record into the regional against powerhouse Vincennes, where they lost. 2017

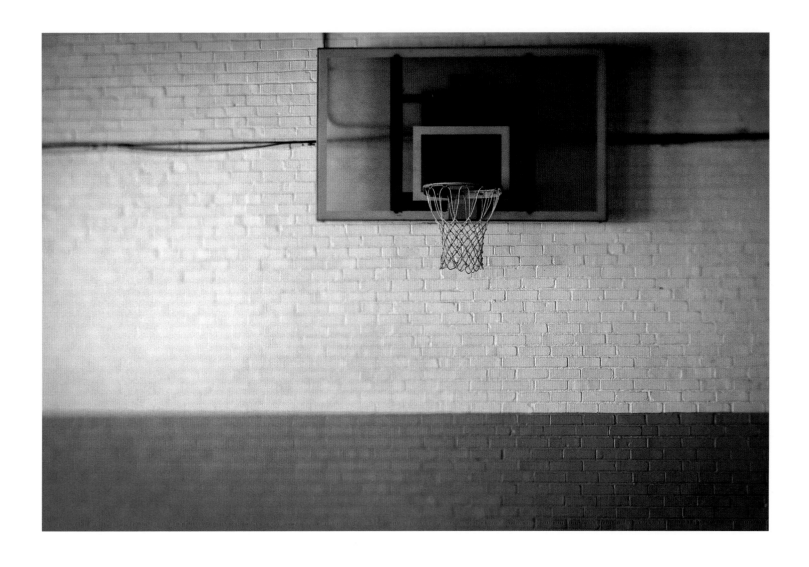

A vintage backboard and goal on the wall of the
Greensburg Armory recalls a simpler time. It is safe to
say that many Greensburg area players got their first
playing experiences there. The court is open year round
to pickup games and recreational leagues. 2014

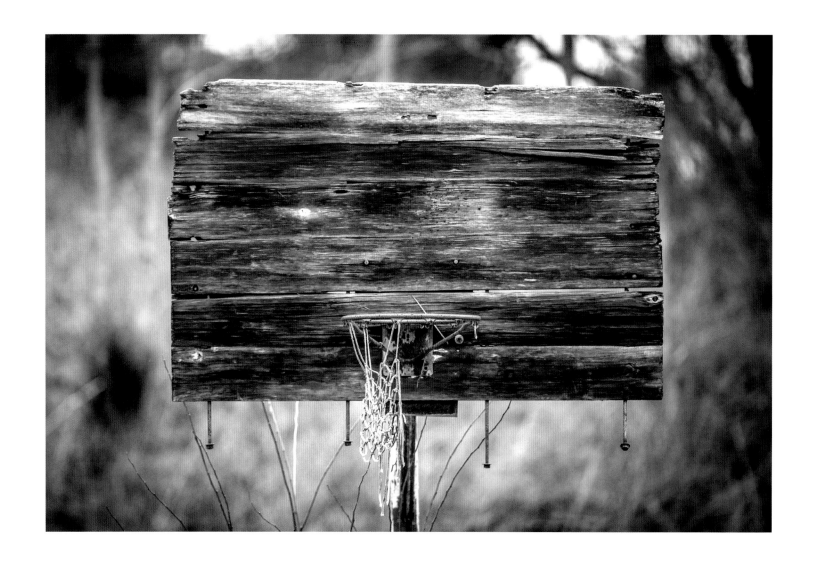

Worn and weathered, a backboard and goal
with a tattered net still stands on the old
Tunnelton High School playground. 2017

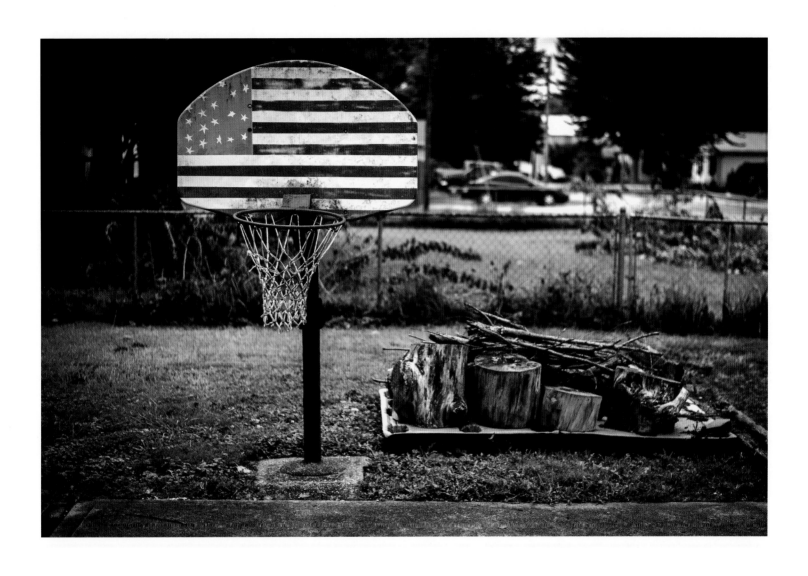

Throughout Indiana there are many iterations of basketball goals in backyards, driveways, and playgrounds. This backboard and goal with a patriotic theme is in Milan. 2016

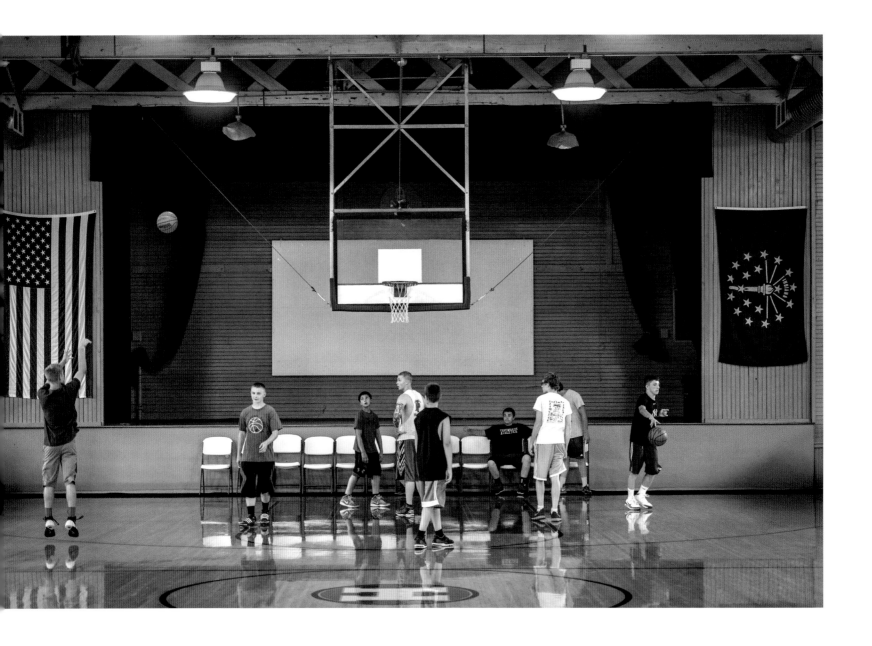

The original Knightstown High School gym was catapulted
to fame when it was cast as the home gymnasium of the
Hickory Huskers in the classic basketball movie *Hoosiers*.
Today it serves double duty as an event center and open
gym, where players often put their scrimmages on hold
for tourists wishing to take souvenir pictures. 2014

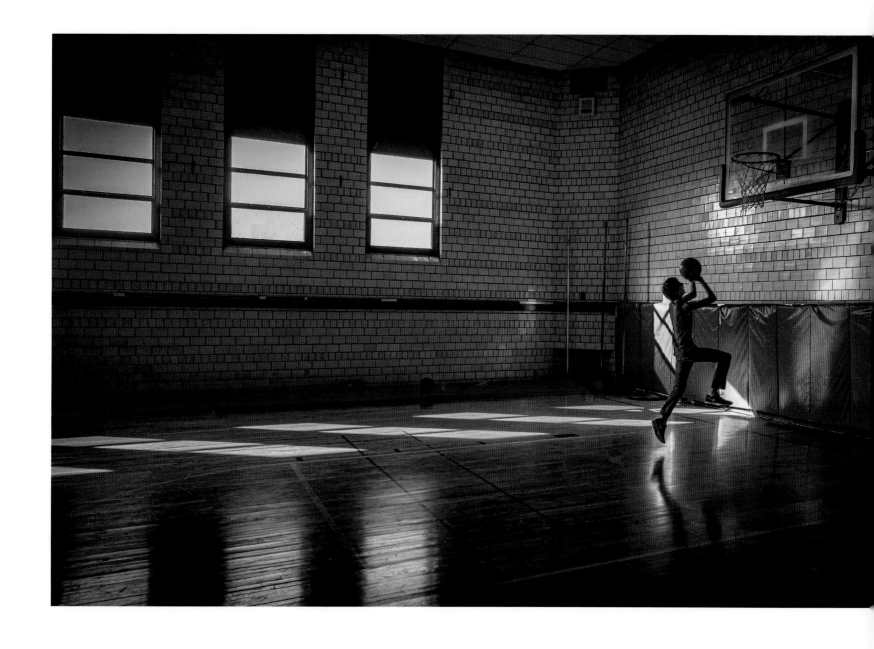

Sunlight pours in through the windows of the Terre Haute Gerstmeyer practice gymnasium as a young player drives to the basket. The practice gymnasium is inside the Howard L. Sharpe Gymnasium and is home to the Terre Haute Boys and Girls Club. Gerstmeyer High School closed in 1971, and the school building was later demolished. 2018

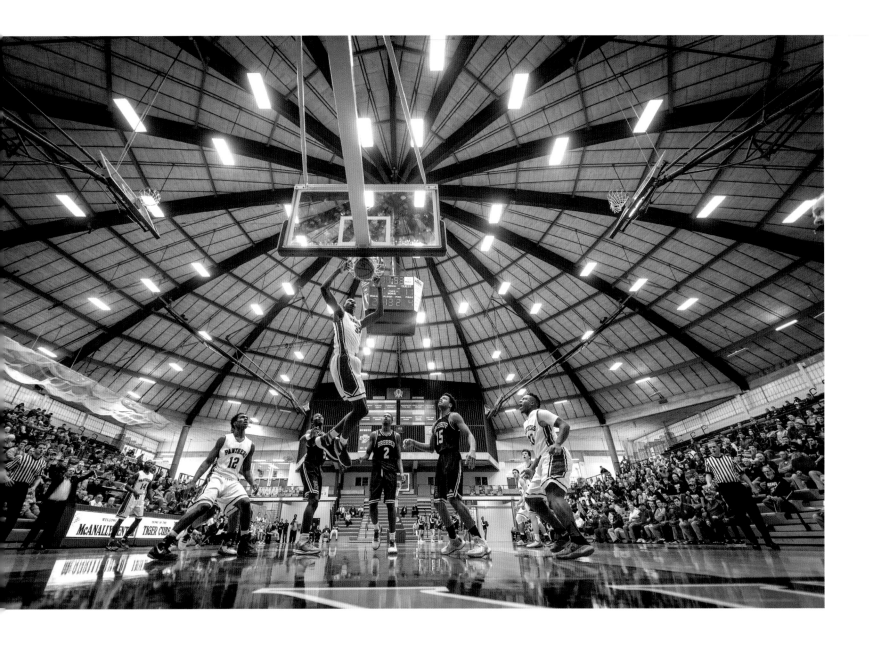

The spacious Greencastle gymnasium, officially the McAnally Center, owes many of its unique design elements to former high school principal Russell S. Hessler. The former woodshop teacher turned administrator led the charge to update the original 1969 décor with color coordinated bleachers and a new gym floor design, including a University of Georgia style G at center court. Hessler paid the copyright fees for a new Tiger Cubs logo from his own pocket. 2016

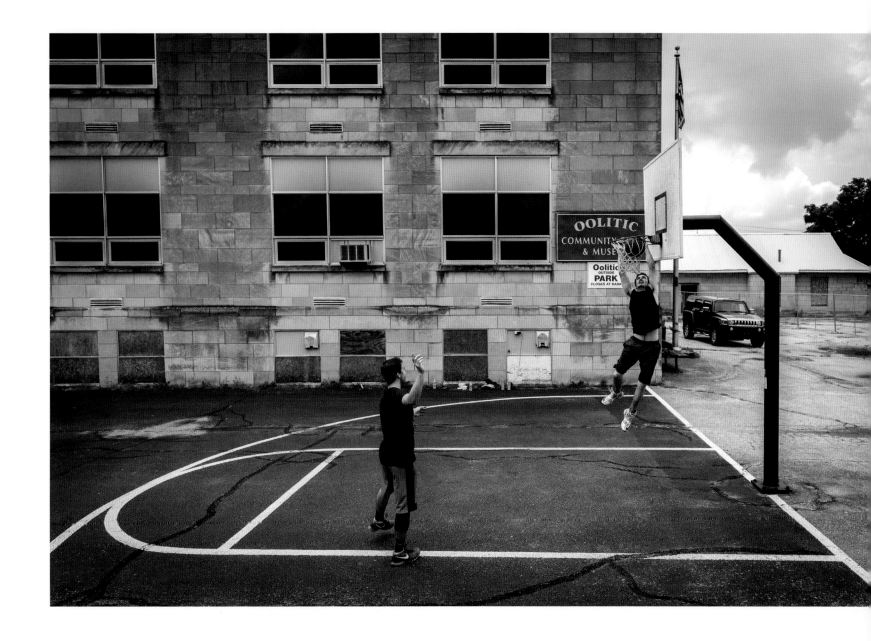

Two locals show their alley-oop passing and dunking
skills outside the old Oolitic High School. The gymnasium
now serves as an event center and host for some
recreational league games. It was Indiana Basketball
Hall of Fame member Danny Bush's high school court,
where he tossed in many of his 1,462 career points. Bush
went on to play college basketball at Indiana State and
coached fellow Hall of Famer Damon Bailey. 2016

Offered more as a suggestion than a critique "Have you been to the Wigwam yet?" is the most common question we've been asked. Longtime Anderson High School scorekeeper Ron David summed up life as an Indian fan when he told us, "The only way to get on the season ticket list was when a current ticket holder died." The grand gymnasium, one of the state's largest, closed in 2011. Since then, development and repair to the structure has been slow to satisfy local residents hopeful that the game will return to the old fieldhouse.

Ron David lived the story of Anderson's rise and fall as a basketball town, where three successful city high school teams were often ranked among Indiana's best. "When General Motors left Anderson we lost more than a large employer. Many workers were transferred or moved on, taking their families and considerable economic impact with them. We never recovered from that loss."

After a fire destroyed most of Anderson High School, but spared the gymnasium, the school corporation was forced to make the difficult decision to consolidate schools. Declining enrollment in all three Anderson high schools was the proverbial nail in the coffin. Now the Anderson Indians occupy what was once Madison Heights High, along with the remaining students from Highland High.

When we photographed the Indians' gymnasium in 2015 we found empty hallways and abandoned trophy cases. The magnificent old gym floor was covered by a layer of ash-like paint chips that rained down from the ceiling above. But sitting in the empty bleachers, rows above the playing surface, one could still imagine game night—a house full of fans living and dying with each shot from their beloved Indians.

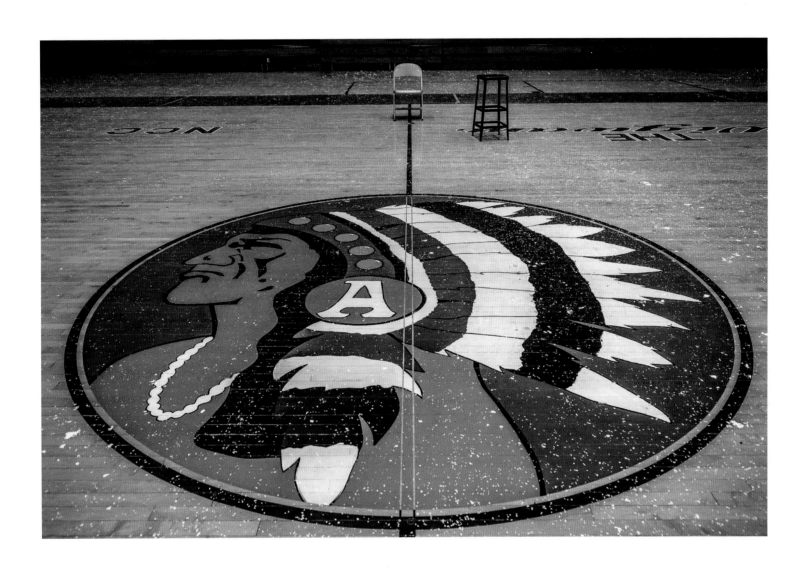

The Indians logo at center court is sprinkled with paint
chips that continue to fall from the ceiling. 2015

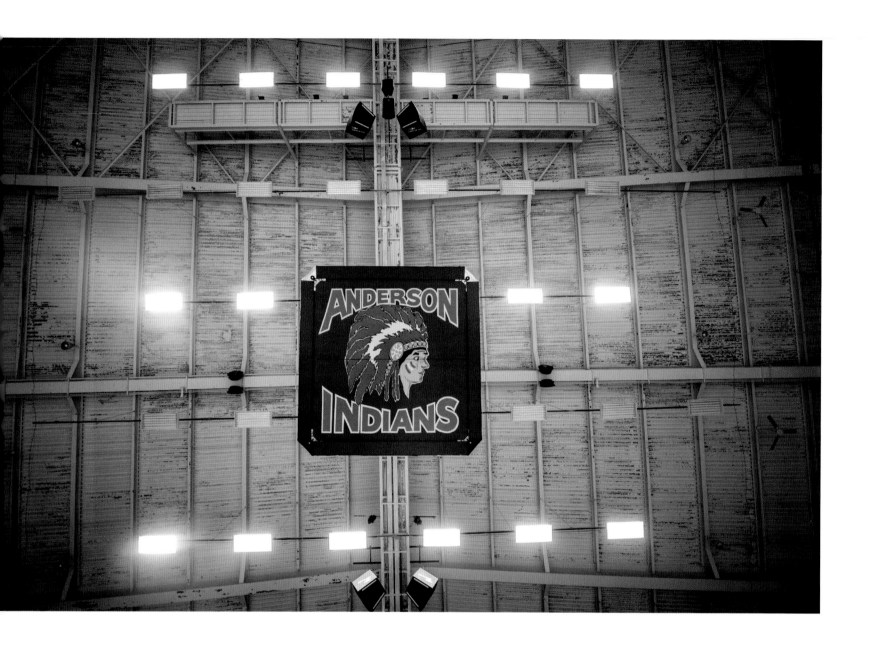

The Anderson Indians logo adorns the
 bottom of the center court scoreboard. 2015

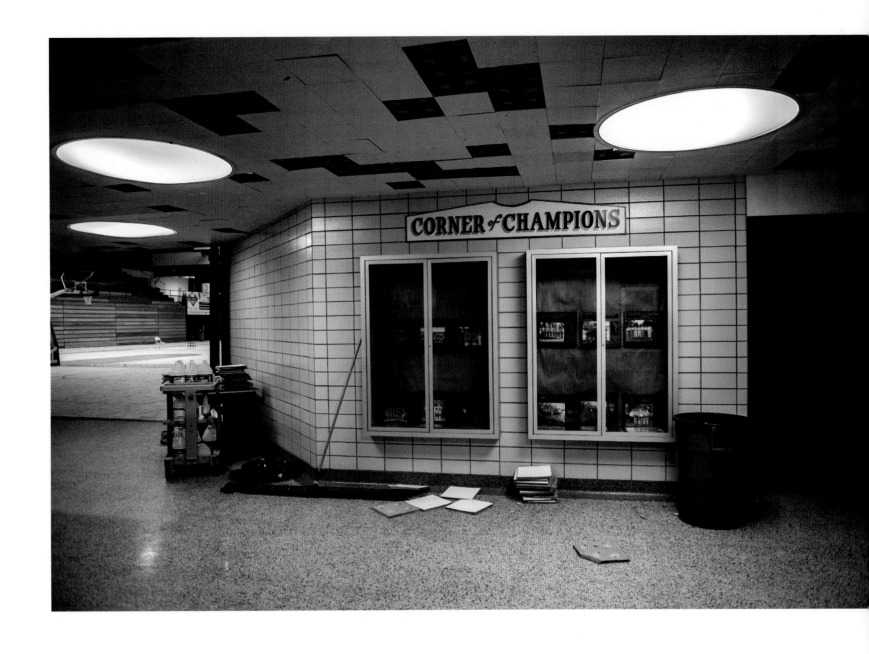

When the building closed some trophies
and team photos were left behind. 2015

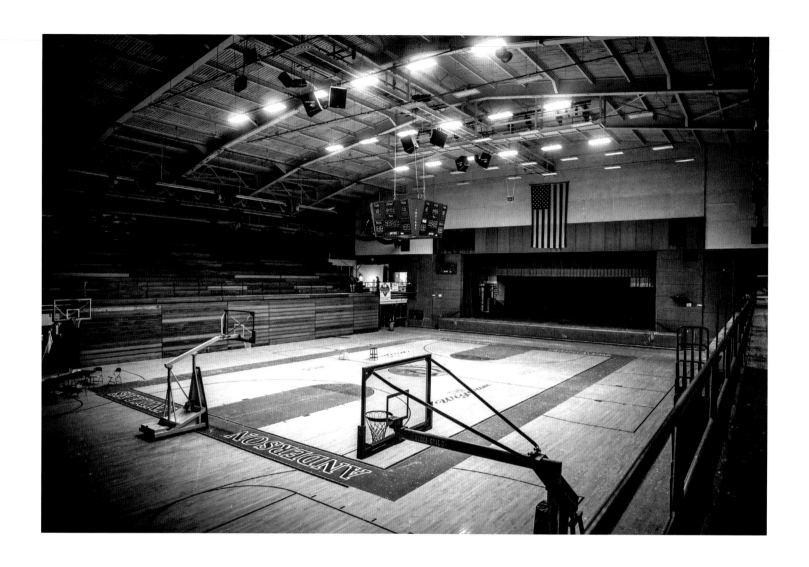

The old gymnasium interior appears much as it
did before it closed, but close inspection reveals a
warped playing floor, blamed on leaks in the roof.
Owners of the building have assured Anderson
leaders that the roof has been repaired. 2015

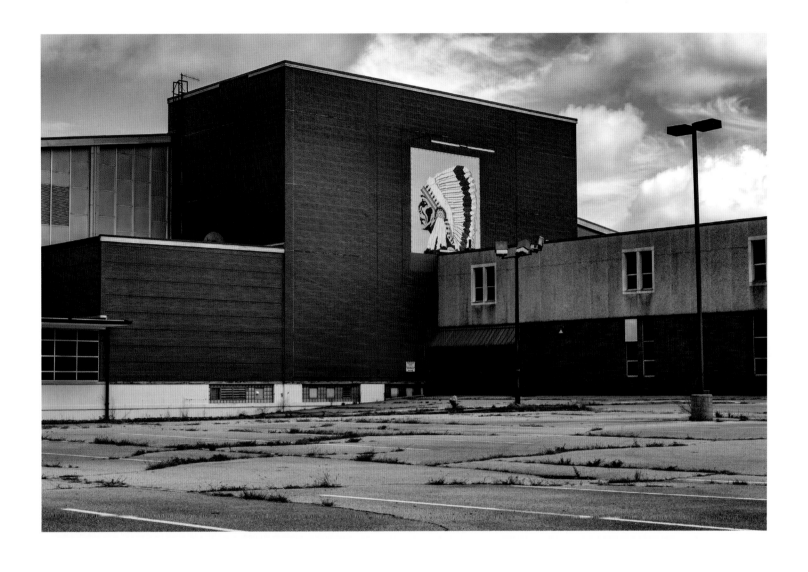

The Indians' gymnasium remains vacant in downtown
Anderson. City and school officials continue to work with
the owners of the building on plans for development. 2015

Like Anderson, Gary has felt the impact of harsh economic times that decimated its economy and school enrollment. Named for US Steel founder Elbert Henry Gary, the city has seen its steel industry dwindle to a fraction of its size in the mid-1960s and its population drop by over 50 percent during the same time period. In late 2018, the Gary School Corporation put thirty-three buildings up for sale, including Emerson, Lew Wallace, and Horace Mann. Many of these buildings, now abandoned and without electricity, are targets for vandals and victims of the Region's harsh winters. Leaky roofs and broken windows have unfortunately become the norm.

Earl Smith Jr., a member of the Indiana Basketball Hall of Fame and a 1952 graduate of Gary Roosevelt, returned to Gary to teach and coach in several high schools. He was the first African American head coach at Froebel, Emerson, and Lew Wallace. Later he became the Gary School Corporation athletic director. His teams won 323 games in 26 seasons and many conference titles and state tournament games. They reached the Elite Eight twice. In the fall of 2018, Smith stood in a second floor classroom at now abandoned Emerson High School and looked out through a broken window at what is left of Gary's steel industry, "My father walked several miles to and from work every day and passed through those steel mill gates to make a living and put five of us through grade school, high school, and college. It breaks my heart to see what this place has become."

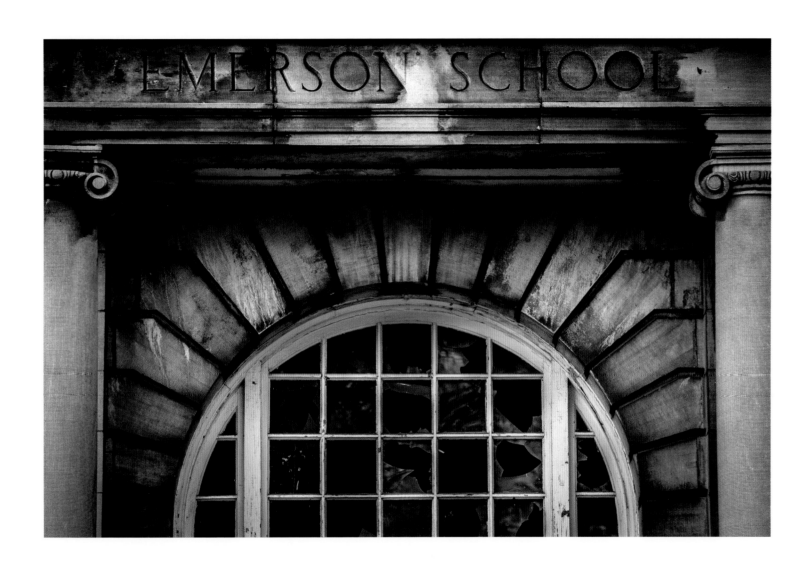

The façade of Gary's historic Emerson High School. 2018

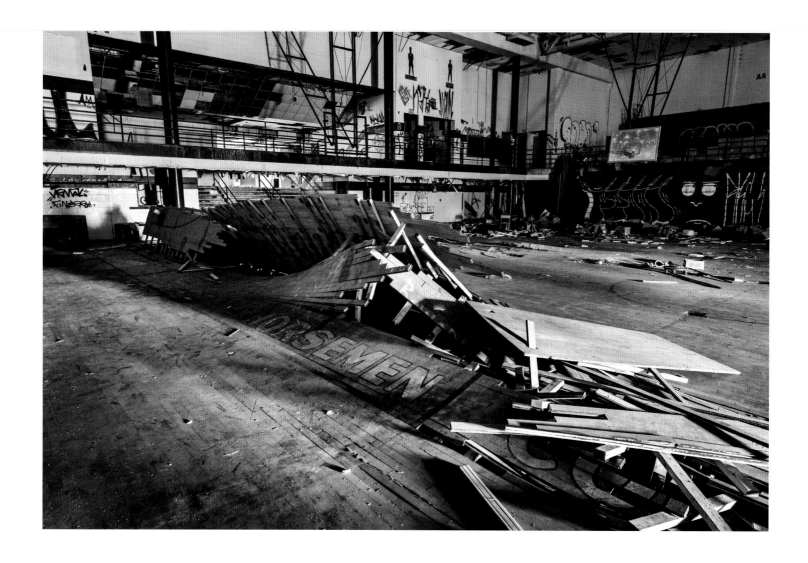

Damage inside the Horace Mann High School gymnasium
is revealed in this 30-second time exposure. The building,
owned by the Gary School Corporation, is shuttered and has
no electricity. Vandals, the passage of time, and exposure to
the elements have taken a toll. It is believed the floorboards
were pushed upward by ice dams under the playing floor
that formed in the extreme cold of Gary's winters. 2018

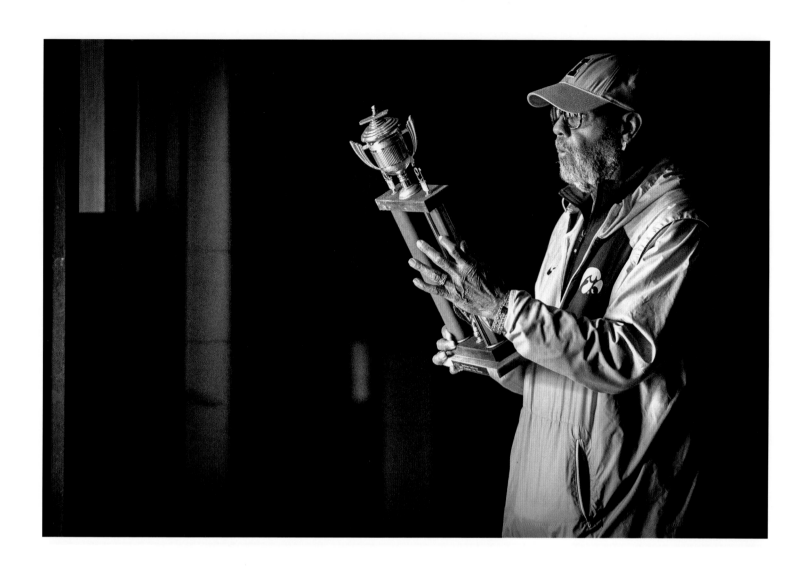

Earl Smith Jr. holds a broken trophy left behind when
Gary's Lew Wallace High School was closed. 2018

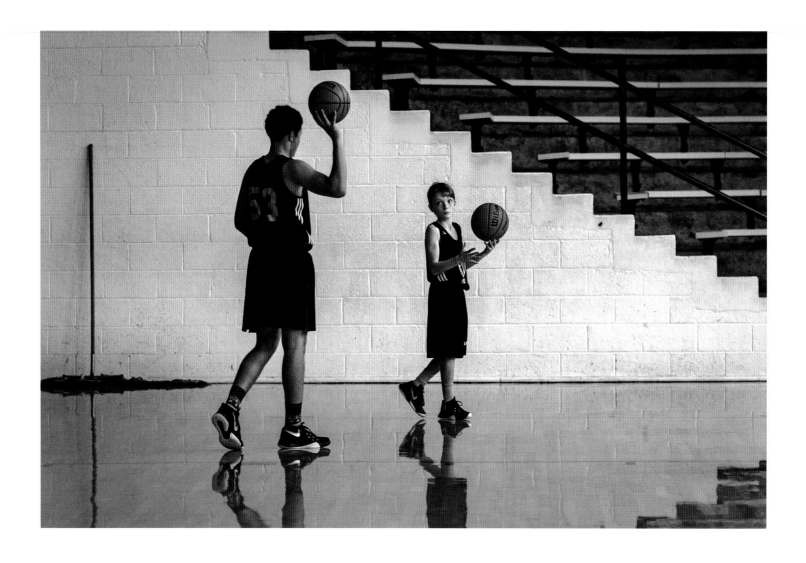

High school basketball is not a game exclusively for the tall
or the experienced. At a Lapel High School practice, Indiana
Hall of Fame Coach Jimmie Howell welcomes players of
all sizes who want to work hard to hone their skills. 2015

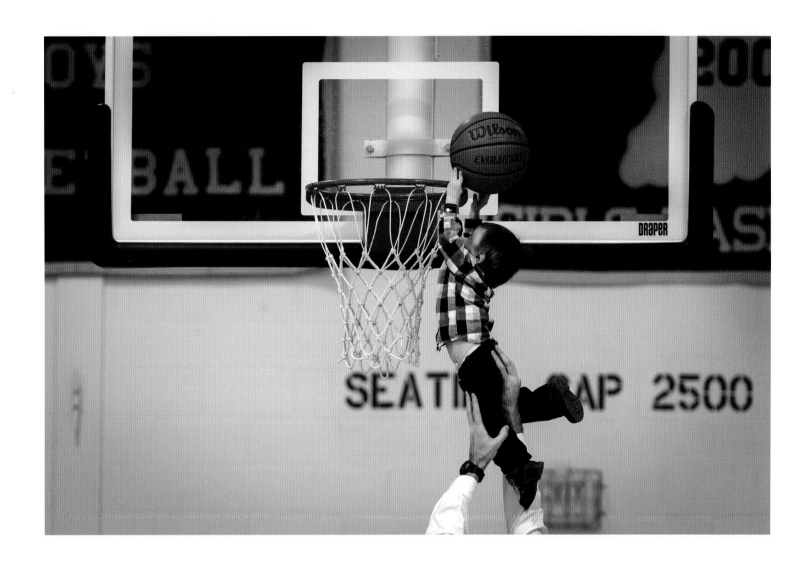

Introduction to Indiana's game begins at an early age. Shenandoah freshman coach Mike Dickerson lifts up his son Mitchell, two years old, to take a shot following a varsity game. 2016

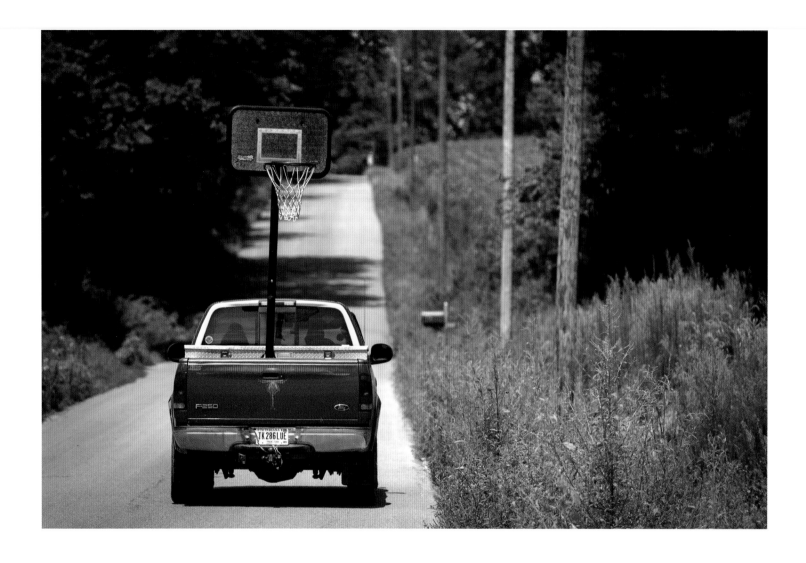

Only in Indiana will you find a red pickup hauling a basketball goal down a country road. Proud grandparents bought a second-hand basketball goal as a birthday gift for their grandson. We've traveled over fifty thousand miles on Indiana highways chasing Indiana's game, and we know the next great basketball story is just down the road. 2017

At Daleville High School the giant mural of the team's
mascots, the Broncos, provided an interesting
backdrop for a pregame shootaround. 2016

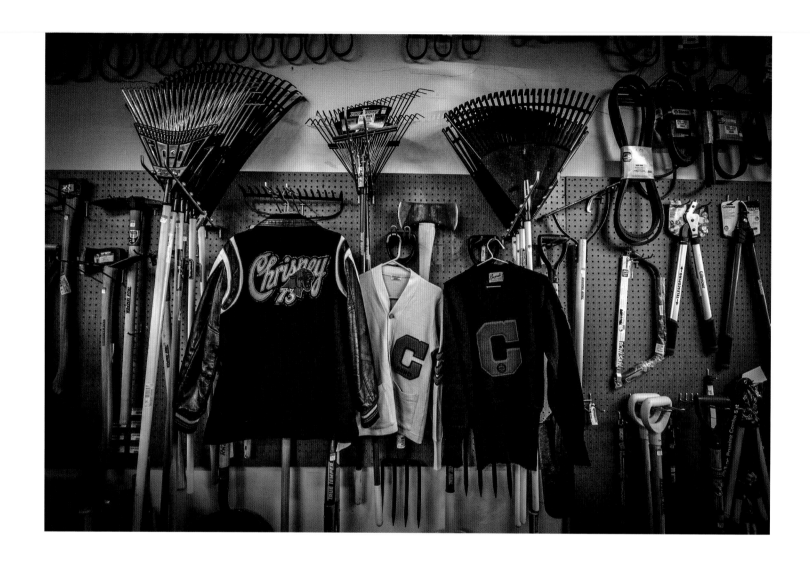

In Chrisney the Town and Country Hardware store
also serves as a collection point and display area
for Chrisney Wildcats memorabilia. The last class
graduated from Chrisney in 1973, when the school was
consolidated into Heritage Hills High School. 2018

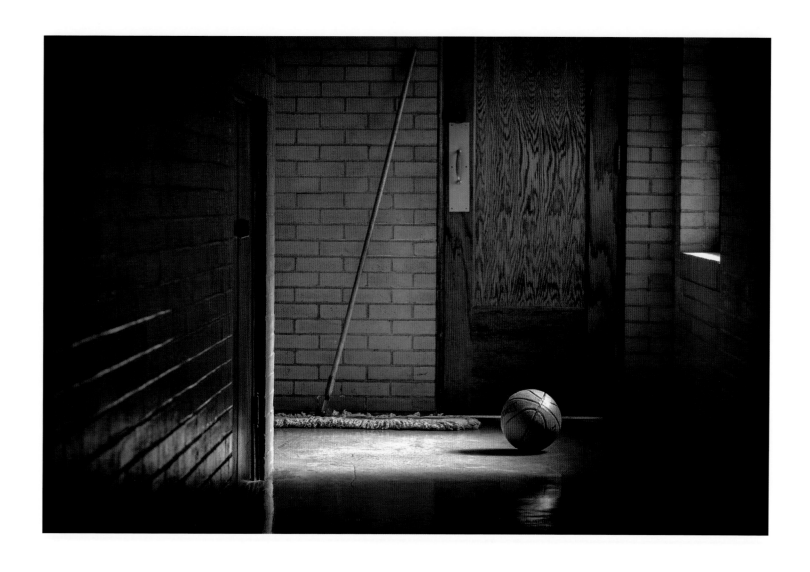

In the hallway of the Ferdinand gymnasium, now part
of Forest Park High School, a basketball and a gym
floor dust mop complete an idyllic scene. 2017

I stopped in my tracks when I saw this youngster searching his backpack in a Rockville High School hallway during a break in youth league games. His juxtaposition with the sign in the background provided a moment of reflection. I, too, was a small-town kid with big dreams and my work on this project fulfilled another of those dreams.

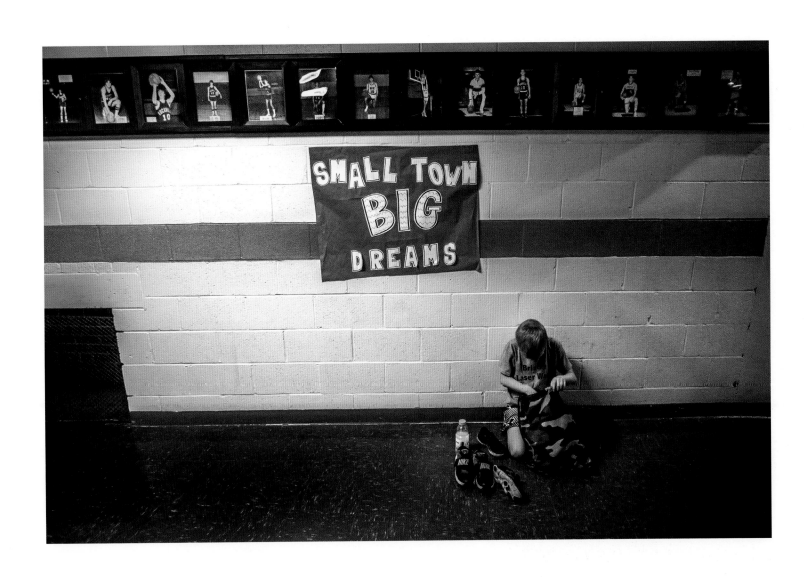

Acknowledgments

As simple as our original goal of "photographing a few old Indiana high school basketball gyms" seemed, the reality of bringing it to fruition has been quite different. Without research and the hard work of others who preceded us, our journey to find Indiana's game and where it is played would not have been possible. Chris May, the executive director of the Indiana Basketball Hall of Fame, directed us to scores of former players and coaches who have given us insight and guidance. Three wonderfully written books acted as guides on the road: *Historic Hoosier Gyms* by Kyle Neddenriep, *The Hoosier Hysteria Road Book* by Dale Lawrence, and *Hoosiers All* by Emerson Houck. Former Indiana Historical Society director John Herbst believed our project was important enough to be included in the Society's 2016 bicentennial exhibits, and James Estrin, senior staff photographer at the *New York Times*, supported our inclusion in the *New York Times Lens* blog. Our friends at Roberts Camera in Indianapolis have given us both technical and financial support. Finally, our families have forgiven our many absences, understanding the importance of this photographic project.

A technical note—all of the photos in this book were produced with 35mm digital SLRs, using "found" available light. Very little manipulation was done to the final photographs in processing.

—CHRIS SMITH and MICHAEL E. KEATING

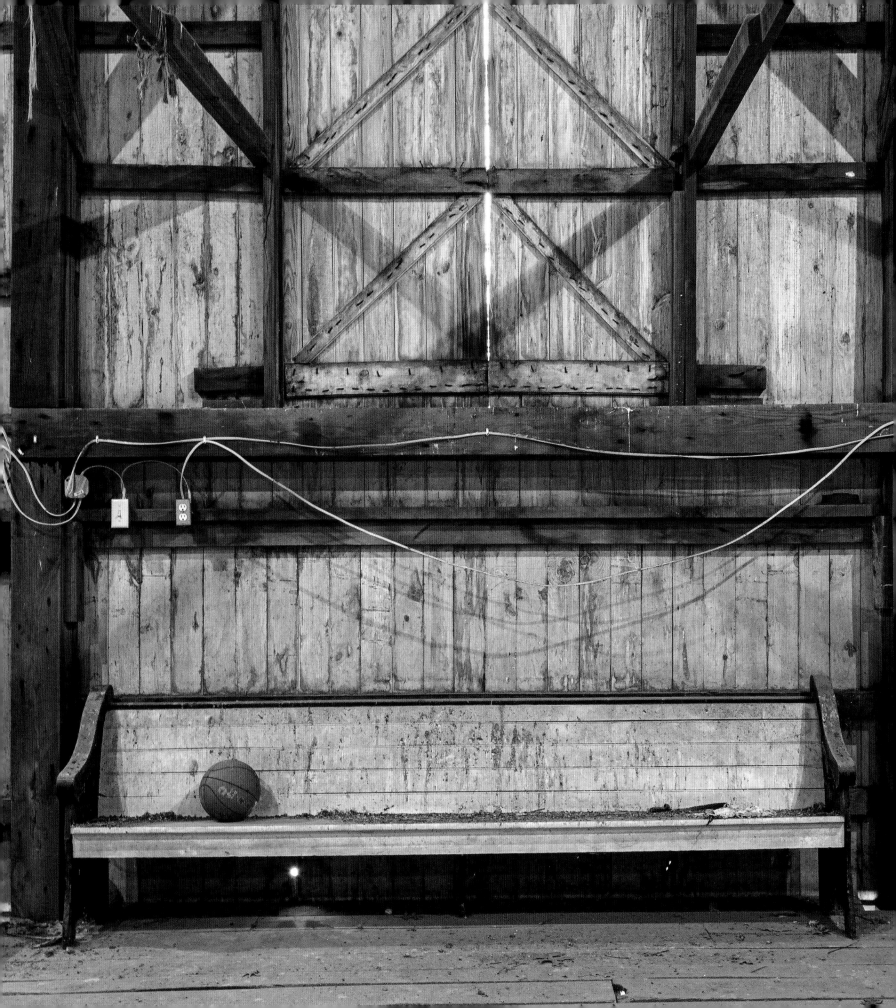

For more than thirty-five years **Chris Smith** has travelled the United States and Caribbean making images for Fortune 500 companies and editorial outlets like the *Wall Street Journal*, *National Geographic Traveler*, and *Smithsonian Magazine*. He also teaches photography at Northern Kentucky University and in 2013, inspired by a photograph of his father's 1937 basketball team, began work on the Hoosier Hardwood Photo Project. He lives on a farm in southeastern Indiana with his wife, Elise, not far from their two daughters, Kaitlin and Maggie.

Michael E. Keating is a photojournalist whose career spans five decades. A Perry County, Indiana, native, Keating worked for newspapers in Cannelton, Tell City, and Evansville and was named Indiana News Photographer of the Year in 1977. Keating joined the staff of the *Cincinnati Enquirer* in 1978 where his prize-winning work garnered local, regional, state, and national recognition. Keating won an Emmy for a collection of videos in 2009 and earned another nomination in 2018 for a documentary short on the creation of a sculpture of Pete Rose in a headfirst slide. He is the author of *Cincinnati Shadow & Light*. He lives with his wife, Sarah, in the greater Cincinnati area. They have two grown children.